Practical Calligraphy

15 TECHNIQUES, 24 PRACTICE EXERCISES AND 12 ALPHABETS

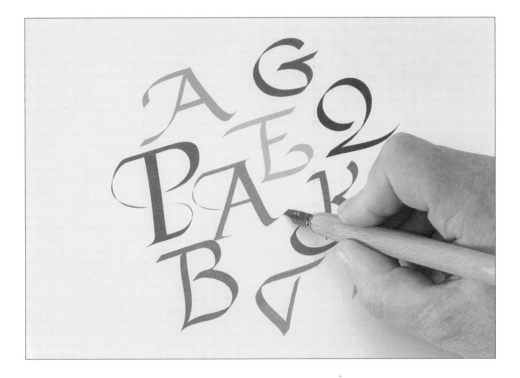

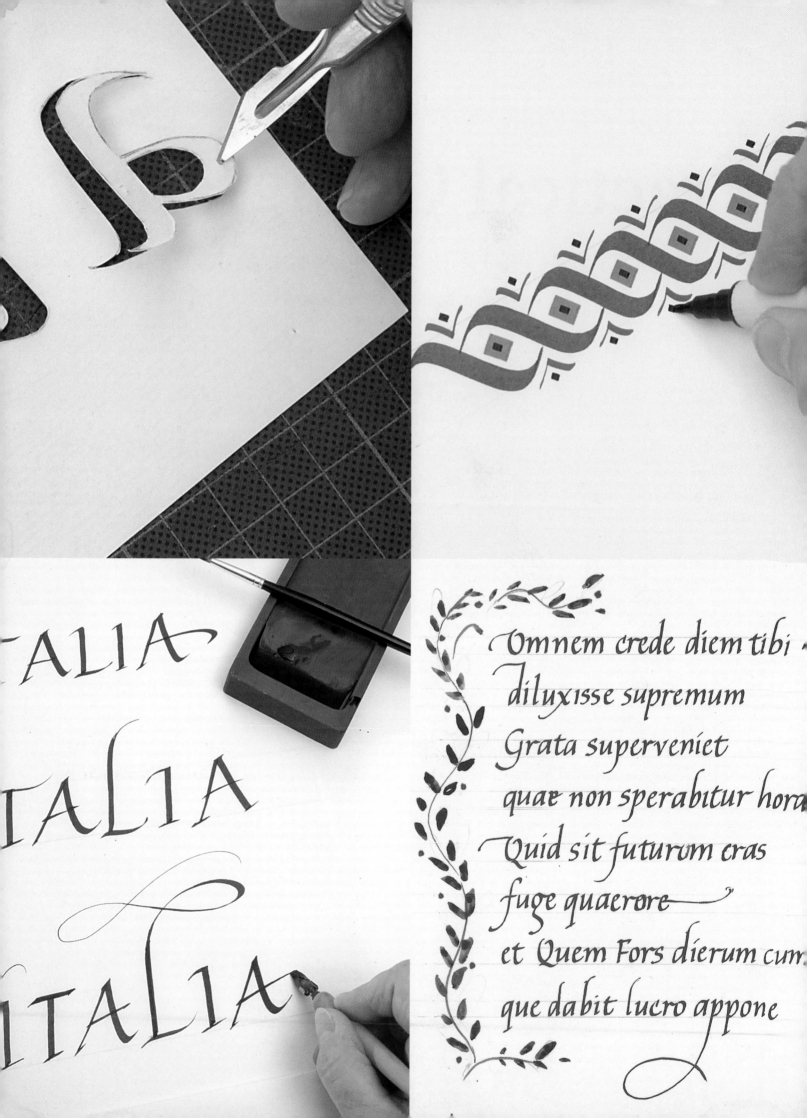

Omnem crede diem tibi
diluxisse supremum
Grata superveniet
quae non sperabitur hora
Quid sit futurum cras
fuge quaerore
et Quem Fors dierum cum
que dabit lucro appone

Practical Calligraphy

15 TECHNIQUES, 24 PRACTICE EXERCISES AND 12 ALPHABETS

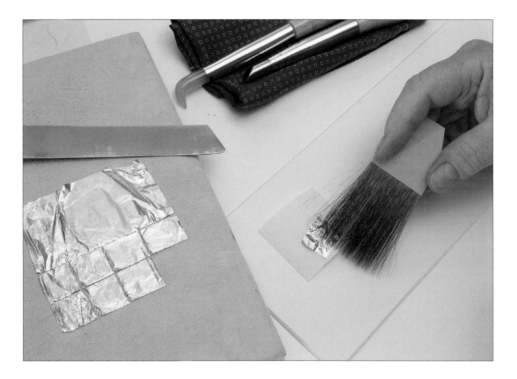

All the basics shown step by step: equipment and materials, scriptwriting, embellishments and digital methods, with 600 photographs and illustrations

Janet Mehigan

southwater

This edition is published by Southwater

Southwater is an imprint of Anness Publishing Ltd
Hermes House, 88–89 Blackfriars Road, London SE1 8HA
tel. 020 7401 2077; fax 020 7633 9499
www.southwaterbooks.com; www.annesspublishing.com

If you like the images in this book and would like to investigate using them for
publishing, promotions or advertising, please visit our website www.practicalpictures.com
for more information.

UK agent: The Manning Partnership Ltd, 6 The Old Dairy, Melcombe Road, Bath BA2 3LR;
tel. 01225 478444; fax 01225 478440; sales@manning-partnership.co.uk

UK distributor: Grantham Book Services Ltd, Isaac Newton Way, Alma Park Industrial Estate,
Grantham, Lincs NG31 9SD; tel. 01476 541080; fax 01476 541061; orders@gbs.tbs-ltd.co.uk

North American agent/distributor: National Book Network, 4501 Forbes Boulevard, Suite 200,
Lanham, MD 20706; tel. 301 459 3366; fax 301 429 5746; www.nbnbooks.com

Australian agent/distributor: Pan Macmillan Australia, Level 18, St Martins Tower,
31 Market St, Sydney, NSW 2000; tel. 1300 135 113; fax 1300 135 103;
customer.service@macmillan.com.au

New Zealand agent/distributor: David Bateman Ltd, 30 Tarndale Grove, Off Bush Road,
Albany, Auckland; tel. (09) 415 7664; fax (09) 415 8892

Publisher: Joanna Lorenz
Editorial Director: Helen Sudell
Project Editor: Emma Clegg
Photography: WG photo
Designers: Jane Lanaway and Kevin Knight
Cover Design: Balley Design
Art Director: Michael Whitehead
Production Controller: Christine Ni

ETHICAL TRADING POLICY
Because of our ongoing ecological investment programme, you, as our customer, can have
the pleasure and reassurance of knowing that a tree is being cultivated on your behalf to nat-
urally replace the materials used to make the book you are holding. For further information
about this scheme, go to www.annesspublishing.com/trees.

© Anness Publishing Ltd 2008

A CIP catalogue record for this book is available from the British Library.

Previously published as part of a larger volume, *The Practical Encyclopedia of Calligraphy.*

 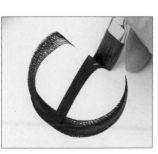 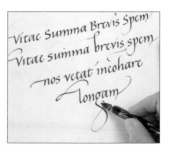

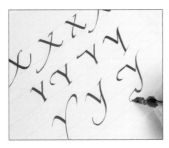

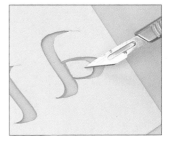

Contents

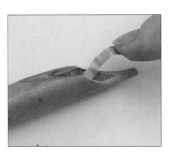

Introduction

Calligraphy is a fascinating and absorbing skill, which is as fresh and inventive today as it was at the time of its origin in the earliest human civilizations. This book draws from a rich calligraphic tradition, as well as from modern technological advances, in order to inform and inspire all those with an interest in beautiful lettering. The book provides instruction in the basic techniques and alphabets with practical exercises to reinforce knowlege. A variety of projects are designed to further the skills of the budding calligrapher as well as the more experienced lettering artist.

In order to fully appreciate the letterforms we use today, it is important to understand their origins. The book begins with an insight into the development of writing, its historical roots, and the practical uses to which it has been put. In the past, the calligrapher diligently recorded history, literature, documents and charters, but with the invention of printing by moveable type, his role was to change forever. Today, calligraphers, lettering artists and illuminators throughout the world are regarded not just as craftsmen but as artists. As well as taking writing to superb technical levels incorporating both new and old technologies, they also use words and calligraphic marks as images in their own right, creating a significant and exciting new art form.

A comprehensive section in *Getting Started* is devoted to details of materials and equipment needed to get going in calligraphy. In addition, there is an introduction to basic penmanship, and guidelines for layout and design – a useful reference for later work. Twelve calligraphic scripts or hands to be practised are presented in the *Alphabets* section, along with in-depth explanations of the scripts based on historical examples. For each script or hand, instructions are given on how to form the letters, which groups they fall into and how to avoid common mistakes. The exercises contained in this section will help you to develop a feel for the flow of the scripts and in time, select a script that complements the meaning of your text.

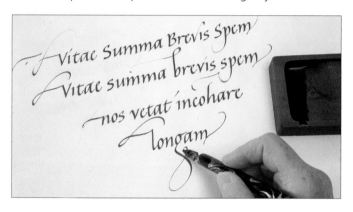

Tools of the trade ▼
A selection of the many dip pen nibs available for calligraphers. A variety of writing tools are used, but dip pens will give crisp and sharp letterforms. They can be used with a slip-on reservoir.

Sloping drawing board ▼
It is more comfortable to write on a sloping board. It keeps your back straight and helps to relax your shoulders and writing arm. It also makes the flow of ink more controllable.

Writing tools ▲
Almost any writing tool that makes a variety of strokes is suitable for calligraphy and there are many types available. A dip pen is charged with ink, and recharged often during writing.

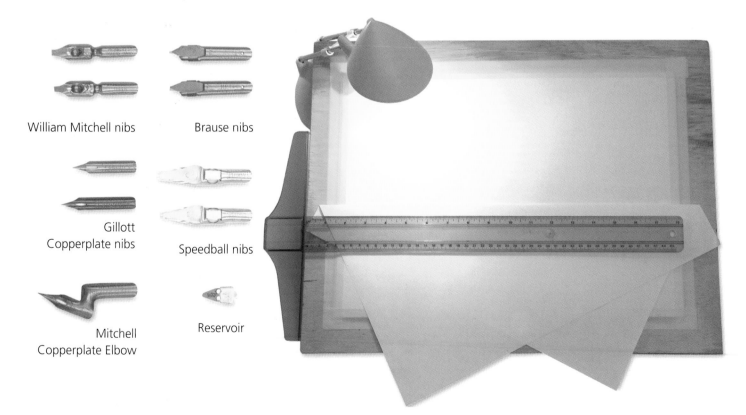

William Mitchell nibs

Brause nibs

Gillott
Copperplate nibs

Speedball nibs

Mitchell
Copperplate Elbow

Reservoir

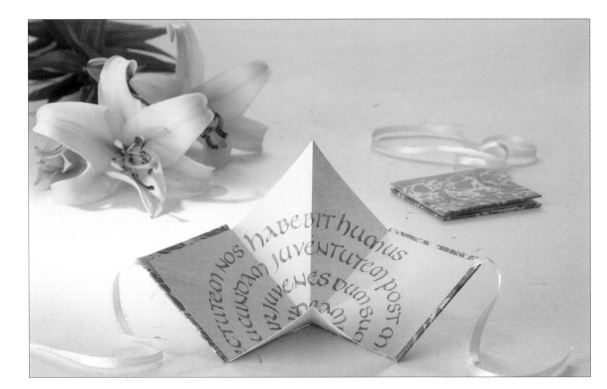

◀ **The perfect gift**
Calligraphic techniques can be employed to create a range of beautiful gifts and keepsakes such as this lotus book with a spiral script.

Creative projects to do ▼
Brown paper is transformed into stunning gift wrap with decorative lettering in white gouache paint.

Although mastery of the basic letterform is arguably the most important aspect of calligraphy, it is when this is combined with other skills that the true possibilities of calligraphy are revealed. The *Techniques* section features numerous ways to turn a piece of writing into a work of art, including an explanation and examples of brush lettering – which is a script in its own right. There are insights into useful skills including the use of colour washes, bookbinding techniques, cut letters and gilding. Also included is a section on digital calligraphy. Each technique is accompanied by practical, step-by-step exercises. Meanwhile, a *Gallery* of modern work offers inspirational ideas and illustrates the possibilities that are within reach of today's calligrapher.

The final section of this book is devoted to practical applications for calligraphy in the form of *Projects* – using both traditional and digital calligraphy. The projects begin with the least complicated tasks to inspire and promote confidence. For those with more calligraphic experience, the book moves on to projects that require greater competency. The most demanding of these are near the end of the book and cater for the accomplished calligrapher.

First, you need to practise the letterforms. Before embarking on a project, it is advisable to practise the chosen script until it can be written with some fluency and spontaneity – that is, until you can make letter shapes without continually referring to the alphabets. Good calligraphy relies primarily on well constructed letter shapes, secondly on freedom of execution and finally on individual expression.

Alternative scripts may be used on any of the projects given – change them to suit your own strengths. Work carefully from the step-by-step sequences trying not to cut corners. It is also worthwhile developing individual ideas and ways of working. However your skills develop, you will find calligraphy an immensely satisfying and rewarding pastime.

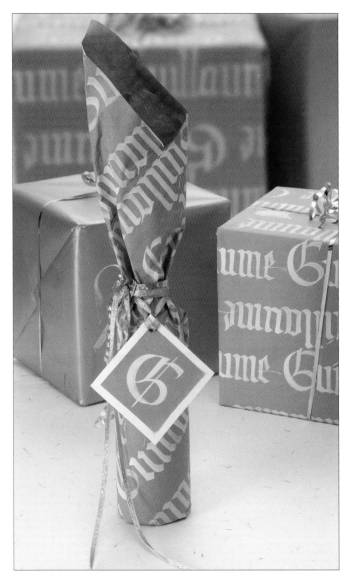

The origins of calligraphy

Writing is so basic that most of us take the written word for granted and barely take time to consider its fascinating origins and development. We look at hand-written, printed and computerized letters and only see the message or information that is conveyed. Yet words completely surround us in our everyday lives: they are used in road signs, advertisements, books, newspapers, magazines, television, computers, packaging, commodities and design. The list is endless and we could not function without these arranged alphabetic elements to express complex thoughts, ideas and information.

Early pictorial forms

The history of pictorial symbols is a long and complicated one beginning over 20,000 years ago with the cave paintings of early stone-age man, some wonderful examples of which are to be found in Lascaux in France and Altamira in Spain. These paintings may have been made to signify the triumphs in hunting animals, or perhaps executed for more subtle reasons, but what we can say with certainty is that they show humans were able to communicate their ideas by use of line and colour, thus presenting us with the first pictorial statements. These forms evolved over time, assimilated and modified by the social and technical changes that inevitably occurred. There are many gaps in our knowledge as we only have the evidence before us that has survived the ravages of time – the rest is conjecture.

The first writing system

In 3500BC the Sumerians, who lived in the fertile valley between the River Tigris and the River Euphrates (called Mesopotamia by the Greeks and part of modern Iraq today) represented the earliest civilization with evidence of a well-developed writing system. The Sumerians were highly organized, used domesticated animals for farming and irrigated land from the rivers. They invented the use of money and recorded business and agricultural transactions of everyday life on clay tablets, which were often baked hard in the sun to create a permanent record for future reference. The Sumerians used about 2,000 symbols, pictograms and drawings that represented objects. These eventually developed into ideograms, which were more abstract, representing words or sentences. Eventually the sounds of the

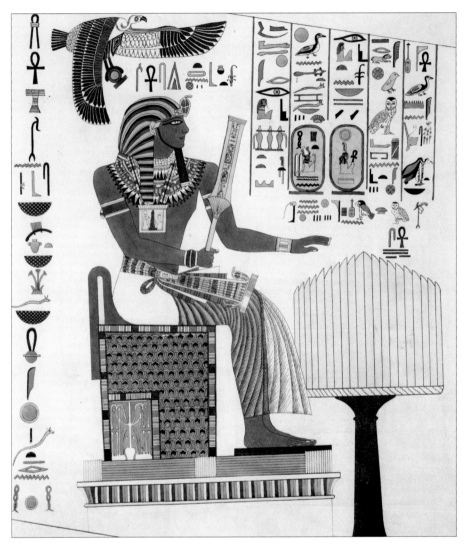

words themselves came to be used. The use of symbols or phonograms reduced the need for complicated illustrative text and reduced the number of symbols in the writing system to 600. The Sumerians used cuneiform script (from the Latin *cuneus* and *forma* – 'wedge-shaped'), which was inscribed on damp clay tablets with a sharpened wood or reed stylus. Over 20,000 tablets of this script have been preserved. Cuneiform was subsequently adopted by the Babylonians in 1720BC when they overran the Sumerians (and later by the Assyrians in 1200BC who succeeded them), eventually becoming a

Egyptian Hieroglyphics ▲
Illustration of a mural from the Tombs of the Kings of Thebes (Valley of the Kings) depicting Hieroglyphics (1550–1070BC).

syllabic alphabet. In the Egyptian civilization another type of picture writing was emerging: Hieroglyphics (from the Greek word *hieros* meaning 'sacred' and *glyphein*, 'to engrave'). About 700 characters were used, in the form of simplified pictures of animals and everyday objects. Simpler forms, beginning with hieratic writing, were developed and used with reed brush or pen on papyrus or linen.

First alphabets

Papyrus, from which the word paper derives, was grown in abundance in the fertile soil along the Nile. The stems were cut lengthwise in thin slivers and laid alongside each other. Another layer was placed at right angles on top of the first. When both layers were beaten, the inner pith bound them together to form a writing sheet. This was then laid in the sun to dry. By the year 2000BC writing was common all over western Asia, but it was the Phoenicians (who lived along the eastern Mediterranean coast near Byblos, now Lebanon and Syria) that gave us the rudiments of our own Western alphabet. The very word alphabet derives from the names given to the first two letters (*aleph* – 'ox', and *beth* – 'house'). The Phoenicians were outstanding seafarers and travelled throughout the Mediterranean from its eastern shores to Spain, North Africa and even to Britain. They traded wool, metals, gems, grain and livestock and took papyrus to the Greeks.

By 850BC the Greeks had adopted the alphabet. By 400BC a standardized alphabet, Ionic, had been developed. The Ionic alphabet had 24 signs, each representing a single consonantal sound in abstract form.

The Etruscans of Tuscany, northern Italy, invaded southern Italy in the 7th century BC, taking with them the Ionic Greek alphabet. They too were great traders and skilled craftsmen, and derived their alphabet from their neighbours in Greece. When the power of Rome eventually superseded their rule over 300 years later the Romans had also absorbed this alphabet modified with Latin.

The Roman alphabet

The alphabet used by the Romans contained 23 letters. 'I' and 'V' were dual purpose letters, serving also as 'J' and 'U' respectively, and 'W' did not exist. The letters 'Y' and 'Z' were used rarely, only in Greek place names. The letters 'J', 'U' and 'W' were added in the Middle Ages.

Roman Capitals were used in official inscriptions and were the original

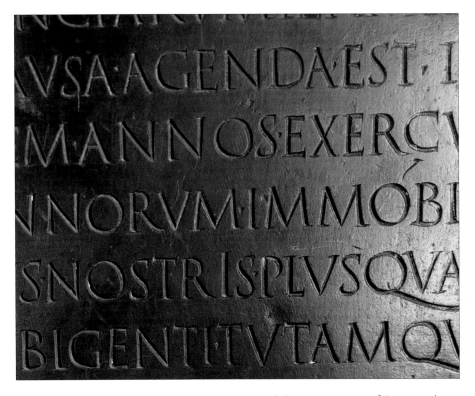

Roman Capitals ▲
Detail from the 'Claudian Table', written in bronze in Roman Capitals in the 1st century AD, and found in France.

models from which all formal Roman letterforms have descended. By the 1st century AD the Roman alphabet styles, of which there were many, had spread throughout the whole area of the powerful Roman Empire, from the Euphrates to northern Britain.

The Roman scripts have been in existence in the Western world for 2,000 years, and although their visual form has varied over time, the basic underlying letterforms have remained consistent. The Romans had the benefit of many alphabets at their disposal. They used cursive scripts for everyday wax tablets and papyrus scrolls, Rustic Capitals for manuscripts, documents and notices and for carving into marble or stone, and Roman Inscriptional Capitals for sign writing and incising on to monuments.

Roman Inscriptional Capitals (Imperial Capitals) were used both in brush form and on carved monuments, the most famous being the magnificent capitals on Trajan Column, AD113, commemorating the military victories of the Emperor Trajan. There are many examples of incised letters on the

remaining monuments of Rome and other western cities that were part of the great Roman Empire. These elegant letters were first painted with a brush and then chiselled expertly into the stone or bronze. Many inscriptions would have been filled with colour – often minium (an orange-brown colour reminiscent of burnt sienna), which over time has disappeared.

All subsequent Western scripts have evolved from the original Roman scripts. Rustic Capitals were written as a book hand during the 1st century AD and continued to be used up until the 6th century. Painted Rustic Capitals can be found on the ancient walls of Pompeii advertising the virtues of election candidates and announcing gladiator contests. Rustics were also used as display capitals up until the late 12th century as part of the 'hierarchy of scripts' on manuscript pages.

Square Capitals, written as a book hand, were evident by 4th century AD. Only two known examples of early Square Capitals written with a pen survive, and both manuscripts are texts of Virgil. Square Capitals are closely related to the Roman Inscriptional letters but the pen formation appears complex and time consuming, which may be why there is little evidence of their general use.

Scrolls and codices

Although parchment, prepared animal skin and other materials were used by scribes, undoubtedly the most common writing material used up until the 3rd century AD was papyrus. Papyrus scrolls, however, became increasingly expensive to import from Egypt. They were also brittle to handle, had an uneven surface, and only one side could be written upon. They were thus gradually replaced by the codex (book) and the use of animal skin. Parchment (sheep skin) and vellum (calf skin) became the standard writing surface, in the Western world for books, and the quill pen, usually goose, became the writing tool. The goose quill was easier to obtain than the reed in most of the Roman Empire and easier to use with ink on skins. The letter shapes produced with a quill pen on a smooth animal skin became rounder, finer and more fluid.

Uncials and Half-Uncials

From the 4th century AD the preferred writing style for religious texts was Uncial, composed of rounded curves, like the Roman architecture of the time. The letters were capitals, although on some variations it can be seen that letters 'D', 'H', 'I' and 'P' show the first suggestions of minuscule ascenders and descenders – the result of writing with a pen at speed. The evolution of these letters occurred over a long period of time, and was influenced by many social and religious changes that took place during this period. Uncials remained the main hand for books until the 8th century and for headings up until the 12th century. Their origins are to be found in the integration of Roman Capitals with scripts from North Africa and the surrounding Mediterranean. Many variations were produced, which subsequently spread throughout Europe. The script was brought to Britain by Augustine's missions between AD550 and 600.

Half-Uncial is an 18th-century name given to a script first used in the 6th century. It is composed of a mixture of characteristics of both capital and minuscule alphabets and is often used with Uncial and Rustic Capitals. The letter shapes are probably written with a 'right oblique' pen nib to enable the scribe to write the more flattened angles of the letters with confidence.

Insular Half-Uncial

The Christian communities of Wearmouth and Jarrow in north-east England were founded by Benedict Biscop in AD674 and 681. On his many visits to Rome he returned with manuscripts from which the monasteries developed their own Roman Uncial script. Three huge bibles were commissioned, one for each monastery and one for the Pope: *The Codex Amiatinus.*

Insular Half-Uncial derives its name from the Latin for 'island'. The Insular Half-Uncials of Britain were first used in Ireland and brought to northern England by the monks where the script predominated until the 10th century. The Lindisfarne Gospels and Book of Kells are two fine examples. The St Cuthbert (formerly Stoneyhurst) Gospel was written by a scribe of the Wearmouth and Jarrow monasteries at the end of the 7th and the beginning of the 8th century. It was laid in St Cuthbert's coffin, and discovered in 1104 when his tomb was opened so that his relics could be transferred to a new shrine. It is a good example for a modern Uncial hand as the pen angle is consistent, with little pen manipulation. As more and more books were produced, writing became less formal, and with speed, ascenders and descenders became progressively longer creating the beginnings of the first minuscule writing.

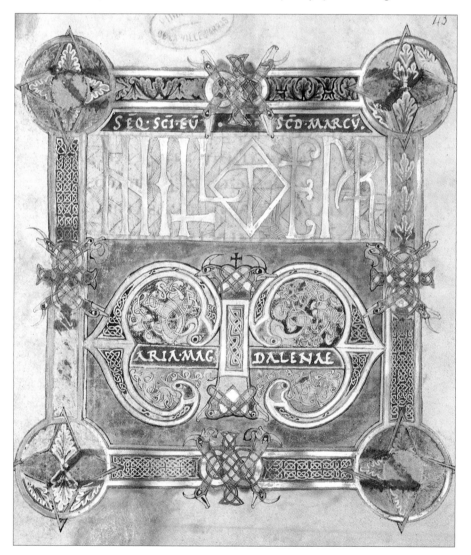

◀ **Gospel with gold Uncials**
Extract from a 9th-century gospel from Saint-Vaast, with Uncials written in gold on vellum.

Carolingian minuscule

Charlemagne was crowned King of the Franks in AD768 and during his 46-year reign he created a Christian Empire that stretched throughout Europe – from the Baltic to Italy, Spain and Germany. Pope Leo III made him Emperor of Rome in AD800. Charlemagne ruled successfully, and encouraged the spread of learning throughout his kingdom. He united France, Germany, northern Spain and northern Italy and was a devoted Christian and a skilled administrator. He issued a decree to reform all liturgical books and to this purpose invited all learned men to his court. These scholars were set the task of accurately revising bibles, gospels, liturgical books and works from the classical writers using only authentic sources from the libraries of Rome. Among the many he appointed was Alcuin of York, an eminent scholar, the Librarian of York Cathedral and also head of the York Scriptorium, to become Master of the Court School of Aix-la-Chapelle (Aachen). For ten years Alcuin directed the revival of classical culture inspiring the Carolingian Renaissance until he retired, becoming abbot of St Martin's Abbey at Tours in AD796 where he continued the work he had begun.

The script used at the Court of Charlemagne was written at speed with an elegant forward slant, full of rhythm and beauty. This was Carolingian or Carolingian hand, and was used into the 11th century. By the middle of the 9th century, Tours had become renowned for the richly illuminated bibles using this hand. The Moutier Grandval Bible (AD840), written in St Martin's Abbey, was one of nearly a hundred produced at the scriptorium along with other liturgical and classical texts. Also from Tours came the First Bible of Charles the Bald, Charlemagne's grandson, commissioned by Abbott Vivian to present to the King in AD846. The use of 'hierarchical scripts' in texts, featuring the use of Roman Capitals, Rustics or Uncials for page titles and chapter openings was highly developed during this period and the letter 'i' is not dotted.

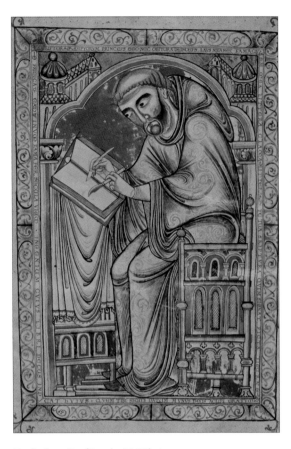

Eadwine Psalter (c.1150) ▲
Influenced by the Carolingian hand, Benedictine monks such as Eadwine were also painters and illuminators. (f.283v)

English Carolingian minuscules

It was after the Danish invasions of the 9th century that Carolingian script finally reached the shores of England. There was a significant increase in the production of lavish books at English monasteries, which was at its peak in the 12th century. There were libraries and scriptoria at Durham, Peterborough Abbey, Canterbury and Winchester. A beautiful example of Carolingian script is contained within the lavishly illuminated Benedictional of Aethelwold, written in southern England for Aethelwold the Bishop of Winchester during the late 10th century. The Ramsey Psalter, also written in southern England between AD974 and 986, probably in the Cathedral Priory of Winchester, is another example of English Carolingian script. This was the distinctive manuscript on which Edward Johnston chose to base his 'Foundational' script in the 19th century.

Second Bible of Charles the Bald ▲
A large decorative initial letter followed by Uncial 'Display' capitals marks the beginning of this paragraph. (AD846)

Versals

The earliest manuscripts contained continuous writing in capital letters with few spaces. Later, larger pen-drawn Roman Capitals were used to give importance to headings and to mark the beginnings of verses. It was the Carolingian scribes of St Martin's and other scriptoria that perfected the use of Versals in manuscripts. The elegant proportions of these majestic built-up pen letters show that they were based on the monumental lettering used on Roman inscriptions of the 1st century and in the earlier Roman manuscripts of the 6th century. These outstandingly beautiful letters can be found throughout the Benedictional of Aethelwold and in the Second Bible of Charles the Bald as well as in many other Carolingian manuscripts. Many of the Versals were penned in gold. Later 'Lombardic' Versals in red, blue and green can be found in the Winchester Bible of AD1160.

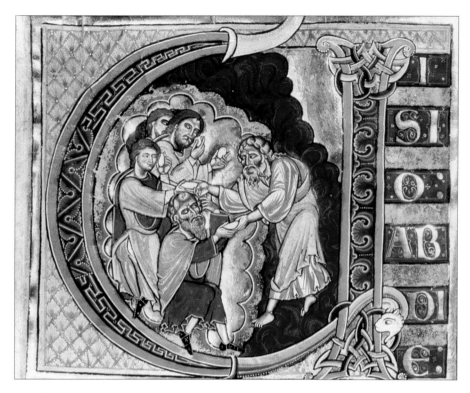

Gothic

At the end of the 11th century the written Carolingian script became more compressed and slightly more angular, eventually evolving into Gothic Black Letter. During the transitional period from Carolingian to Gothic two notable books were written in England: The Arundel Psalter (at Christ Church Cathedral Priory, Canterbury 1212–23) and The Winchester Bible (Cathedral Priory, Winchester, 1160–75). The Winchester Bible is the biggest of the 12th-century bibles surviving today. The writing is regular and beautifully executed, virtually by a single scribe, and the Romanesque gold and painted illuminations throughout are breathtaking. The 48 large illuminated initials were made by several artists. In both of these manuscripts the compression of the Carolingian hand towards Early Gothic script can be seen.

There was a great demand for books not only from the Church but from universities, rich merchants and aristocrats, on philosophy, medicine and poetry. By the 13th century, craft workshops had been established to meet the demand and cities such as Bologna, Paris, Winchester, Oxford and York were employing professional scriveners, colour men and associated

The Winchester Bible (1160–75) ▲
The Book of Obadiah (f.203v). An illuminated and historiated initial letter 'V' – illustrated by a scene of taking food to the hiding Prophets in the cave (3 Kings 18.4).

artisans. The trend towards compressed letter shapes was probably influenced by artistic fashions and innovations, but is also likely to have resulted from the need to economize on the cost of materials such as skins, as well as a reduction in the size of the individual books. Many of these books would have been used by the laity and scholars of cathedral schools and universities. These people required books that were easily transportable, rather than huge tomes. Not only did the writing become compressed but many abbreviations were to be found in the text rendering them difficult to read. Gothic, a term also applied to the architecture of the period, was written in a great variety of styles, both formal and informal, and its use spanned over three hundred years from the late 12th century through to the Renaissance of the 15th century continuing into the 16th century. The characteristics of Gothic script are lateral compression, heavyweight pen strokes and angular shapes. Earlier Gothic Quadrata was less compressed and

more graceful, retaining some of the roundness of earlier Carolingian scripts, and with diamond-shaped terminations to the letters. There were often fine pen hairlines attached to letters adding to the graceful appearance of a manuscript, such as in the Metz Pontifical (Fitzwilliam Museum, Cambridge), written and illuminated in northern France about 1300.

Textura, written between the 13th and 15th centuries, is the most widely known of the Gothic scripts because its dense grid-like appearance is so easily recognizable. The spacing between the letters in Textura is no more than the width of the letter stem, which created a heavy even black and white texture to the page. The script was slow to write and difficult to read.

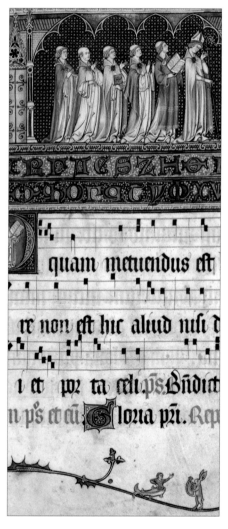

Metz Pontifical ▲
Written on vellum in Gothic script, in the early 14th century, this is an elegant French liturgical manuscript. The script used is Gothic Quadrata.

The Gothic Prescissus (with 'flat feet' letters) was written during the 13th to 14th centuries. The script consists of very compressed letter shapes with pen manipulation to create 'flattened feet' or straight endings to the lower stem on certain letters; notably 'a', 'i', 'f', 'n', 'm', 'p' and 'q'. The stems begin with a diamond 'head' or top, which adds to the heavy texture of the writing. The flat feet would have been constructed with a twist of the pen to flatten the angle or filled in at the end with the corner of the nib. The Queen Mary Psalter and the Luttrell Psalter are written in this script. The Luttrell Psalter was written and illuminated for Sir Geoffrey Luttrell in Lincolnshire between 1335–40, and depicts scenes from everyday life in the lavish marginal decoration.

Rotunda Gothic

In Italy and Spain a more rounded Gothic script evolved. Rotunda was used for very large manuscripts for the Church where it accompanied musical notes. Rotunda was also used in the small Books of Hours, which were gaining popularity at that time. Gothic continued in Germany as a modern hand in a more rounded version through to the last century.

Batarde

During the 14th century, the French cursive Gothic known as Batarde was developed. This was a vigorous flowing script used extensively in the Books of Hours. It was introduced into England in the late 14th century as Bastard Secretary. Books written in this hand for rich merchants were full of border decoration and small miniature paintings, which were becoming popular. The hand was variable depending on where it had been written. Generally executed with a slight forward lilt it was an expressive hand and full of vitality. From the middle of the 15th century the most beautiful specimens of this script are known as Flemish Bastarda, written by Flemish calligraphers and illuminators who produced hundreds of handwritten and illuminated books containing lavishly

Decorative border ▲
Detail of a decoration from a 14th-century manuscript, now to be found in the British Museum.

painted miniatures and richly decorated borders and initials. These devotional and liturgical manuscripts provide valuable evidence of the secular life and culture of the Middle Ages.

Renaissance scripts

The 15th century marked the beginning of the Renaissance, a cultural movement that was to spread throughout western Europe during the 16th century reviving a great interest in classical learning and

Luttrell Psalter (1335–40) ▼
Scenes of everyday life, with text in Gothic Prescissus. The text stands flat and unserifed on the baseline (f.84).

the artistic culture of Rome. It was a time of new education and new freedoms. The Humanistic Script of the Italian Renaissance was the last development of script before printing. It reached its peak of perfection as a result of the efforts of Poggio Bracciolini (1380–1459). Born in Terranuova, Tuscany, Bracciolini travelled widely in Europe as a Papal official and rediscovered classical Latin manuscripts in monastic libraries which were later translated. In addition, he not only trained scribes but wrote texts himself. His script was based on the Carolingian hand for its simplicity and purity, which harmonized with the ideals of the Renaissance. This script soon became an excellent model for the metal fonts of the printing press.

The Italian Humanist scribes also revived the Roman Square Capitals which, in turn, were based on the Roman Inscriptional letters. Many of the manuscripts written in Italy from 1450 onwards contained these elegant letters. The Paduan scribe Bartolomeo San Vito (1435–1512), who worked in Padua and Rome, created his own distinctive style by alternating coloured capital letters with gold letters to add to the richness of the text. The letters were well spaced and the accompanying Italic letters beautifully executed.

Italic

In its simplest form, Italic, or Chancery Cursive (*Canellaresca Corsiva*) is a descendant of Humanist minuscule. It was invented by Niccolo Niccoli in 1420 to replace Humanist hand, which he found too slow. Within 20 years his new script had been adopted as the official hand of the Papal Chancery.

Ludovico degli Arrighi was born at the end of the 15th century in a small village in Vicenza. He began to study calligraphy and typography at a very early age, and by 1522 he had written a manual, *La Operina,* which he was able to publish. Within this publication were the rules of how to construct Chancery script, its oval forms, the slant of the letter and the correct ascenders and descenders. The fine script that he created is a model that is still used today for Italic calligraphy. The advent of printing and movable type meant that scribes such as Bernardino Cantaneo, Giovanni Francesco Cresci and Palatino were all able to publish writing manuals, in addition to Arrighi.

German manuscripts dating from about 1400 show a slightly different hand which is now called Fraktur. It was a cursive hand like Batarde but written upright with the heaviness and rigid feel of Textura Gothic.

Craftsmen and scribes in particular were not generally paid well for their art during this time, although there were some notable exceptions, such as the Limbourg Brothers, who wrote and illuminated the *Tres Riches Heures* for their wealthy and influential Patron the Duc de Berry in 1409.

The arrival of the printing press, pioneered by Johann Gutenberg of Mainz around 1450, saw an increase in the speed of book production, but a decline in work for the scribe, although decoration was still added by hand.

Copperplate

After the Renaissance, writing with the edged pen declined. With the advent of printing and the printed manuals of fine writing, which had been etched into the copper plates for the printing examples, a new pen hand was ready to evolve.

It was the writing masters of Flanders and the Netherlands that developed the use of Copperplate in the early 16th century. Calligraphy was taught in primary schools and it was not long before many gifted calligraphers emerged. Among the great masters, one of the most copied was Van den Velde, who was born in Antwerp in 1569 and died 1623. He taught at a Latin school in Rotterdam and published several books containing his calligraphic work. Most of Van den Velde's books were printed using copper plates. Holland was thriving commercially and when some of the Dutch calligraphers established themselves in London, English calligraphers found that they could address themselves to rich Dutch traders who were wealthy enough to give them lots of work. In 1651 the domination of Holland's commercial fleet declined and the English navy expanded. This brought about more work for English calligraphers. The first English writing manual appeared in 1571. By the 17th and 18th centuries English Round hand (Copperplate) was well established. George Bickham's *Universal Penman*, engraved and published in 1741, includes the work of 24 eminent English calligraphers.

The development of modern scripts

William Morris (1834–96) was one of the most important artistic, literary and political figures of the late 19th century. A prolific designer, typographer and calligrapher, he founded the Arts and Crafts movement in a bid to improve art and design during the Industrial Revolution, when it seemed that fine art had been lost to the mechanics of manufacturing. Among his close friends was William Richard Lethaby, architect, designer and Principal of the Central School of Art. When Edward Johnston, one of the most famous pioneers of modern calligraphy, went to London he was introduced to Lethaby.

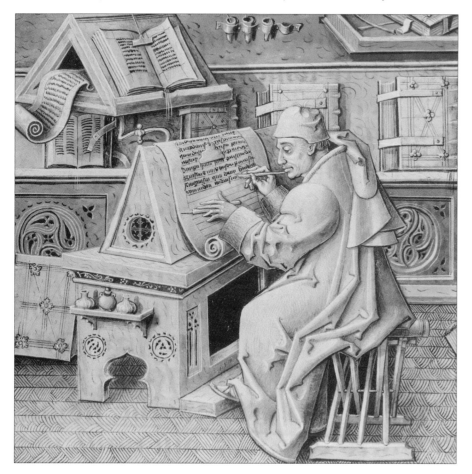

15th-century scribe ◄
Flemish author, scribe and translator Jean Miélot (fl.1448–68), in a scriptorium typical of the period.

He commissioned Johnston to write a manuscript, and when it was completed he asked him if he would teach at the Central School. Johnston was given access to the manuscripts at the British Museum, and his study of these led to his development of the Foundational hand. The more Johnston learned, the more he could teach his students. At about the same time a revival of calligraphic skills was occurring in Austria, led by Rudolf von Larisch (1856–1934) and in Germany led by Rudolph Koch (1874–1934). So began the 20th century revival of calligraphy.

Neuland

One of the most iconic typefaces of the early 20th century is Neuland, designed and cut by Rudolph Koch for the Klingspor Foundry, Germany, in 1923. Today, Neuland has become a popular alphabet to write with an edged pen because of its fairly simple execution and modern appearance. It is written with two pen angles, horizontal and vertical, to maintain the almost even weight of its letterform. It is a sans serif letter and only simple rules of execution are needed for its formation. Neuland provides a good opportunity for calligraphers to write in a modern interpretive way using heavyweight letters that create texture.

The future of calligraphy

A new interest in calligraphy appeared in the 1970s with Ann Camp, Ann Hechle, Donald Jackson and Sheila Waters in England, and Hermann Zapf, Werner Schneider, Friedrich Poppl, Gottfried Pott, and Katharina Peiper in Germany, plus Villu Toots from Estonia to name just a few. In America the revival of interest in calligraphy was due to William A. Dwiggins, James Hayes, Arnold Bank and Lloyd Reynolds among others. The list of influential calligraphers today from Europe, American and Australasia is endless and impressive. The art of calligraphy is flourishing!

The role of the calligrapher in the 21st century is to continue to enrich letterforms. Most calligraphers now

William Morris designs ▼
Ornamental initial letters from the *Kelmscott Chaucer*, published at the end of the 19th century.

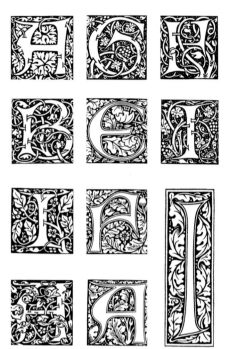

Modern techniques ▼
21st-century copy of an illuminated initial 'V' showing Jeremiah receiving the word from God, from the Book of Jeremiah (f.148) from The Winchester Bible (1160–75).

have at their disposal the ability to assimilate scripts from historical manuscripts, but that does not mean that they must stringently copy them. Rather, calligraphers should study them carefully, practise them diligently, adapt them sensitively and adopt their own creative styles. It is important to understand the tools and materials (including new technology), colour, design, space, rhythm and all the individual marks and gestures that can be made.

In the new millennium, technology for creating, designing and reproducing letterforms, calligraphy and illustration for advertising, commissions or personal pleasure, is developing at an ever-increasing rate. There are computer programs that can completely change the written word, twisting and altering it at a touch of a button. With the application of different tools the whole concept of creating exciting letterforms and creative, expressive lines becomes exhilarating. Results can be stunning. However, this new technology does not mean that traditional skills are no longer necessary – in fact, there is even more of a need to ensure that our basic learning of letterform and calligraphy remains sound.

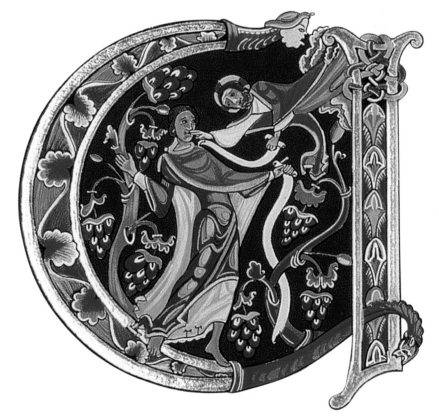

Getting Started

Putting pen to paper, or beginning any form of calligraphy practice, requires some simple yet essential preparation. This section outlines the materials and equipment you will need to get started, explains the best way to set up your working space and teaches the fundamentals of penmanship, layout and design. As your enthusiasm grows, so will your interest in trying variants on the basics and this may require a variety of equipment. Visit a local supplier for art materials and before you buy be sure that the materials on offer will meet your needs. Use calligraphy suppliers' websites for details of more specialist tools.

Pens

There are many different sizes and shapes of calligraphy pen, although the nearest supplier may only have a limited range. Check the pen has a wide nib at least 2mm (5/64in) in size. Left-handers should look for square-ended or left-oblique nibs.

Many calligraphers prefer a metal dip pen because it can be used with all kinds of paints and inks mixed to different colours and consistencies. While its name implies that it is dipped in ink, this is not always the case; feeding it with a paintbrush of mixed gouache paint allows good control of paint flow and consistency of colour density. The best metal nibs are modelled on the profile of the traditional quill, combining flexibility with sharpness. The dip pen is the nearest convenient equivalent to the quill, saving modern calligraphers the time and skill needed to cut and maintain that revered ancestor.

Pen sizes vary enormously, allowing large poster writing with perhaps a 2.5cm (1in) pen that demands a bold arm movement across the page; in contrast, small, delicate writing in a manuscript book would instead need a tiny nib, maybe just 1mm (3/64in) wide or smaller, and if choosing to write elegant Copperplate, then a flexible pointed nib is the only answer. In general, however, and certainly when starting out, it is best to begin in the middle range of these extremes, and study the letterforms at a size that allows you to see all the detail of construction, before going too small; a nib about 2.5mm (7/64in) is ideal. Other pens available to the calligrapher include larger poster pens, automatic pens, which come in many sizes, and ruling pens.

Felt-tipped pens and fountain pens are the most convenient of all calligraphic tools. They are available in bright colours and provide instant results with non-clogging inks. As the dye-based inks may fade in time they are best for practice and for short-term projects where the results will not be exposed to light for too long. The nibs flow well across smooth paper. Felt-tips will soften and lose their sharpness over time, so replace them frequently and before the writing suffers.

Pen manufacturers have not standardized their size coding, making instant comparisons difficult. One maker's smallest size is size 6, with its largest size 0, whereas most other makes increase their numbers with their size. This discrepancy only becomes apparent when working with different makes, so start with one complete set or just be prepared to make visual comparisons. Do not order by size number alone.

Dip pens ▶

A handle and a range of differently sized nibs make up the dip pen. There are several manufacturers. Some nibs have an integral reservoir, others have a slip-on version. Whatever pen collection is chosen, there will be a variety of nib sizes available, although the sizes may vary between manufacturers. Some makes are slightly right oblique, which will not suit left-handers, who should look out for square-ended or preferably left-oblique versions. Copperplate nibs are fine and can have a very distinctive elbow shape. For large, bold writing, explore the fun of enormous pens; they use a lot of ink, and dipping may be preferable to feeding with a brush.

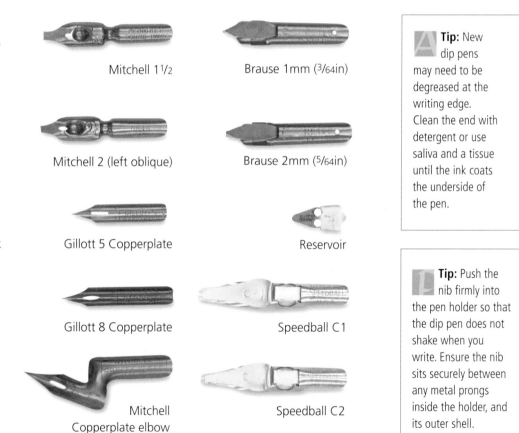

Mitchell 1½

Brause 1mm (3/64in)

Mitchell 2 (left oblique)

Brause 2mm (5/64in)

Gillott 5 Copperplate

Reservoir

Gillott 8 Copperplate

Speedball C1

Mitchell Copperplate elbow

Speedball C2

Tip: New dip pens may need to be degreased at the writing edge. Clean the end with detergent or use saliva and a tissue until the ink coats the underside of the pen.

Tip: Push the nib firmly into the pen holder so that the dip pen does not shake when you write. Ensure the nib sits securely between any metal prongs inside the holder, and its outer shell.

Handle of pen

Larger pens ▶

There are nibs that are designed for the large writing found on posters, which are sometimes called poster pens. Automatic pens can be moved in any direction with continuous ink flow, and produce both very thin and contrasting thick lines. Each pen nib has a serrated side and a smooth side, and is used with the smooth side against the paper. It can be used either full width, or when worked in can also produce lines by turning on its thin edge. Ruling pens were traditionally used for drawing straight lines against a ruler, but calligraphers also use them for freer writing and wider versions have been invented specifically for creative calligraphy. The screw adjustment allows for cleaning and for varying line width.

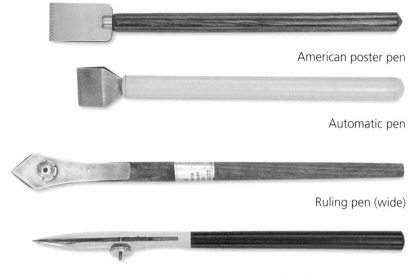

American poster pen

Automatic pen

Ruling pen (wide)

Ruling pen (technical drawing pen)

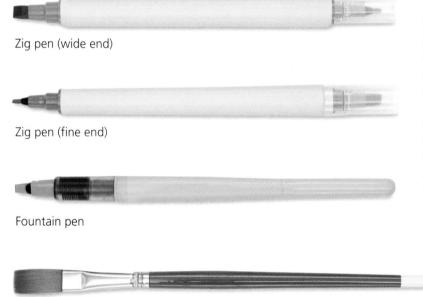

Zig pen (wide end)

Zig pen (fine end)

Fountain pen

Broad-edged brush

◀ **Other types of pen**

Personal taste will determine the other types of pen used. Felt-tipped pens are especially useful for quick work, and will travel well in a pocket. The ones with a nib at each end, in different sizes, are especially useful. Fountain pens are convenient; the ink is in cartridges so refilling is quick. Choose a make that supplies a flushing tool for washing out if the colours are to be changed frequently. Broad-edged brushes need to be nylon for springiness, not sable (too floppy) or bristle (too stiff).

> **Tip:** If reading the nib size is a problem when changing nibs, buy a handle for every nib and label the handle with a sliver of paper fixed with transparent sticky tape.

Caring for your pens

Dip pens will last a very long time if they are cleaned after use. Do not allow them to rust. Store the spare nibs in a container that will allow some air circulation in case any are damp from cleaning. If nibs are kept attached to their handles, check them to see they have not rusted in. Store pens flat while drying, to prevent water causing rusting.

Materials
- *Water pot*
- *Old toothbrush*
- *Kitchen paper*

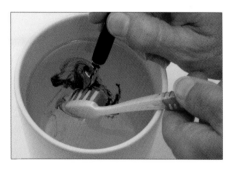

1 Clean the nib (while still attached to the handle) over your water pot, using a toothbrush, or water will run up the handle and cause rusting.

2 Once the nib has been cleaned, dry it (and the reservoir, if is a slip-on one) using kitchen paper.

Inks and paints

There are many inks available to the calligrapher. The most important quality of an ink or paint in the pen is that it should flow easily and not spread on the surface. Density of colour and light-fastness are important factors for finished work. Thus many calligraphers use Chinese or Japanese stick inks, or gouache paint, both of which are dense and opaque, or watercolours for more transparent effects. Bottled fountain pen inks are good for practising as they flow well. Waterproof inks are not recommended in the pen as they clog, and do not give sharp writing. They are better used much diluted for background washes. For beginners, fountain pens with broad calligraphy nibs provide inks in convenient cartridges and with a continuous flow. Felt-tipped pens are very successful for practising and have a range of calligraphy nibs. In both cases these inks are dye-based so they are free-flowing and translucent, but may fade on exposure to light.

Black inks

For black ink, Japanese or Chinese stick ink is recommended, purchased from a reliable source. Inks supplied for the tourist market will be for novelty value, not for ink quality. Be aware that whereas many stick inks are manufactured for the quality of their greys, Western calligraphers value black opacity in their inks. Some ink is supplied with helpful shade cards showing how black it is, and whether when thinner it is blue-grey or warm-grey. An alternative bottled version, known as Sumi Ink, is available for those who need their black ink constantly or instantly available.

Japanese stick ink ▼
Ready-to-use, Japanese stick ink comes, either in a bottle (water it down a little), or matured in a stick for grinding.

> **Tip:** When starting a new tube of gouache, you should discard the first squeeze of paint if it oozes any transparent liquid, as this can interfere with smooth writing qualities.

Gouache

Designers' gouache is an important choice when using colour. Gouache is opaque, so the colour will show up when writing on coloured backgrounds. Most colours are lightproof so ideal for finished pieces that will be on display. The choice of colours is vast, but by experimentation with mixing, only six colours are needed. They are: two reds – a pinkish one (magenta) and an orangey one (scarlet); two blues – ultramarine (makes purple with magenta) and cerulean, or a cheaper phthalo blue (makes bright greens); and two yellows – lemon (for bright greens) and a warmer hint of orange yellow. Imitation gold paint is most successful for calligraphy in gouache form; bottled versions will be fine for other applications but separate too quickly for pen work.

Colour wheel ▶
The three primary colours are red, yellow and blue. They are the only colours that cannot be made by mixing two other colours. The three secondary colours are green, orange and violet and they are each a mixture of two primary colours. The secondary colours are positioned between the colours

from which they are made. The six tertiary colours (red-orange, red-violet, yellow-green, yellow-orange, blue-green and blue-violet) are made by mixing a primary colour with an adjacent secondary colour. The tertiary colours are positioned between the primary and secondary colours from which they are made.

Tubes of gouache ▼
Designers' gouaches come in tubes. Squeeze out 1cm (1/2in) in a palette and add water by the brush full until a single (light) cream consistency is achieved, or until it flows well in the pen.

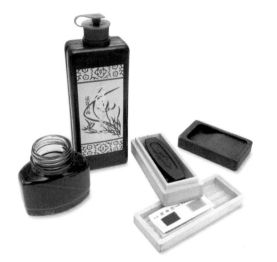

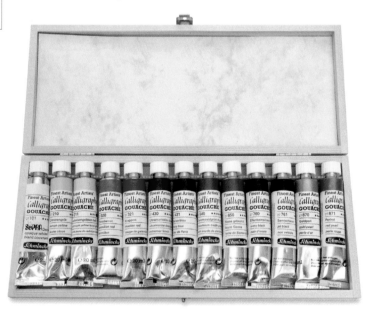

Watercolour paints

These paints are transparent and economical to use. Their transparency makes them ideal for use on white paper, which shows off their true colours. Watercolour paint can be effectively used when writing one letter on top of another. If a wet letter touches another the colours will blend. Writing in watercolour is easy to do because the paint flows easily from the pen. However, care should be taken when writing in watercolour on to coloured paper as its transparency will encourage it to disappear. As with gouaches, only six colours are required if they are mixed. In some watercolour paintboxes the selection has already been made.

Other types of paint

Bottled acrylic inks are ideal for making wash backgrounds for calligraphy. This is because they dry waterproof, making a non-porous surface on which to write. Do not try putting acrylic ink in the pen, however, as it will not give sharp writing and the pen will need to be cleaned before it dries. Casein-based paints are bright colours that behave like household emulsion (latex) paint. Use these only as backgrounds. 'Bleedproof white' is like a gouache in a bottle and is very opaque. Once water is added it works well in a dip pen fed with a brush, producing very sharp writing.

Bottled acrylic ink ▼
This type of paint works well for creating wash backgrounds.

Mixing watercolour paint ▼
Watercolours come in tubes and in pans. Tubes are useful when mixing up a large quantity, perhaps for a series of background washes. Brushes for fine painting need to keep their fine point, with no stray hairs. Choose size 0 or 1, springy acrylic or more absorbent sable.

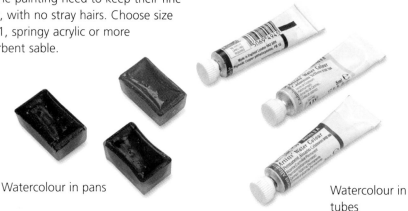

Watercolour in pans

Watercolour in tubes

Practice exercise: **Using an inkstone**

An inkstone is a small sloping block with raised sides and a slightly abrasive surface. The ink is rubbed down with a stick and water to produce ink in small quantities as needed. In this way the calligrapher controls the density of colour and texture. The consistency of the ink can be controlled by fixing the amount of water and the rubbing time.

Materials
• *Water: distilled or boiled tap water*
• *Inkstone and stick*
• *Brush*
• *Cloth*

1 Put a few drops of water on the flat surface of the inkstone with a brush.

2 Rub the ink stick firmly in a circular motion for a minute or two to mix some of the ink with the water.

3 When it feels sticky, use a wet paintbrush to move the ink into the trough and repeat the grinding with fresh water until you have sufficient. Do not leave the stick to soak, or it will crack; dry it with a cloth.

Papers

There are many different papers on the market. They are intended more for watercolour artists than for calligraphers, so it is helpful to know which papers are most suitable for writing. A large supply of practice paper is probably the best investment, in order to try out designs and revise the writing many times before using 'best' paper.

Practice or layout paper conveniently comes in pads, in several sizes. Choose a size that has enough space to do paste-ups and expansive writing. Layout paper is very white and is about 50gsm (23lb). This is thin enough to see through and to have a grid of ruled lines placed underneath as guidelines. Photocopy paper is a good alternative that is available from office suppliers, and comes in large packs. It is 80gsm (39lb) making it thicker than layout paper, and therefore it may not be possible to see fine lines drawn underneath.

Paper for a final, 'best' piece needs to be thicker. Thicker paper will wrinkle less when written on, and will not be so easily bruised – thin paper poorly handled will show every little crease, and may take on more creases when erasing lines. A first 'best' paper might be cartridge, as this is available in pads and is very inexpensive. Choose at least 150gsm (71lb) and look for acid free, so it will not go brown.

Better quality papers have some rag content, with various surface treatments and a wide sizing range, which affects the absorbency. Thus, blotting paper is unsized. Hot-pressed watercolour papers are suitable for calligraphy as they have a very smooth surface and are well-sized so the ink will stay where it is placed, resulting in sharp writing. The paper accepts paint well when drawing or painting additional features. Choose 200gsm (95lb) or thicker, if planning to get the paper wet. Craft suppliers usually stock hot-pressed watercolour paper in a limited range. Internally sized print-making paper has a softer surface, accepts writing very well and is popular with calligraphers, but care should be taken when using an eraser because this disturbs its surface.

Papers with a texture, such as the more popular 'not' (meaning 'not hot-pressed') and 'rough' watercolour papers can impart an interesting broken effect to large writing but are an impeding factor when trying to write in small pens. As a general rule, look for smooth surfaced papers. These surfaces are, however, ideal for background washes as the texture gives added character. With experience, it becomes worth searching out more specialist suppliers with a wider range of papers that have different characteristics.

Types of paper ▼

From left to right: layout paper is thin, white paper used for practice. Cartridge paper is an inexpensive high-quality paper. Hot-pressed watercolour paper is a good quality paper used for finished work, while watercolour paper comes in a variety of qualities and may be textured.

Tip: If paper is absorbent and makes the ink bleed, try spraying it first with a cheap hairspray.

Other papers

There is a whole range of coloured papers which are useful for making small artefacts and for taking the place of coloured washes. Some surfaces have a 'laid' effect of parallel lines; one side will be smoother, check to see which is easier for writing. Pastel papers – bright and subtle colours for use with pastels – accept ink very well (but not small writing). Investigate handmade Indian papers – not all accept ink without bleeding but some are fun to try.

Layout paper

Cartridge paper

Hot-pressed watercolour paper

Textured watercolour paper

Practice exercise: **Removing a mistake**

It is worth investing in thicker, good quality paper for important work, as small corrections can be made by scraping and smoothing down.

Materials
- *Good quality paper*
- *Dip pen*
- *Ink*
- *Scalpel or craft (utility) knife*
- *Putty eraser or similar*
- *Fixative or hairspray*

> **Tip:** Always store paper flat. Try not to over-handle it as damage can occur easily, making tiny creases that are impossible to remove.

> **Tip:** For washes, if paper is under 300gsm (142lb) stretch it. Soak it in water for 5–10 minutes, then smooth over a board with a sponge, before securing the edges with brown tape.

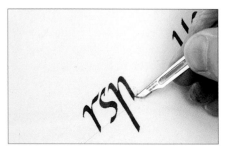

1 If a mistake has been made, all is not lost. First wait for the ink to dry completely.

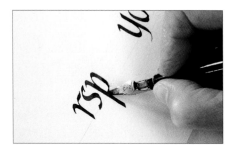

2 Gently scrape with a curved blade to remove the error.

3 Lift off residue with a putty eraser or similar. Rub the surface with a hard smooth object or your fingernail to repair the surface, and lightly spray with fixative or hairspray to seal it.

4 Rewrite when the repaired surface is completely dry.

Other types of paper ▼
Pastel papers such as Canson mi-teintes are heavy French papers in a series of colours, with a 'vellum' texture on one side and smooth on the other. Canson Ingres papers are a lighter weight than the mi-teintes and come in a series of colours. Khadi are heavy Indian handmade papers in a huge range of qualities and textures.

Vellum ▼
Writing material made from animal skins is called vellum. It costs more than paper, but offcuts can be found in specialist stores. This type of material is valued for prestige items such as illuminated manuscripts as it behaves well with gesso gilding. If you are using vellum for illumination it should need no extra preparation, but a final sanding with 400 grade 'wet and dry' abrasive paper may be necessary for sharp writing.

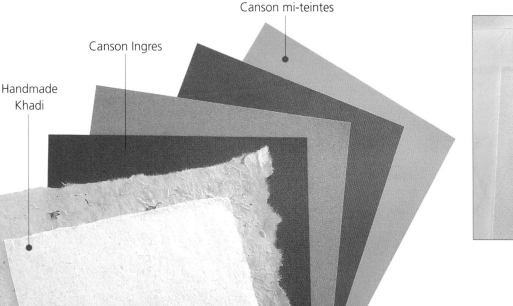

Canson mi-teintes

Canson Ingres

Handmade Khadi

Abrasive paper block and vellum

Gilding materials

Gold leaf has a special attraction for calligraphers because it adds a sumptuous touch to lettering. It is useful to accumulate all the accoutrements available for developing this branch of decoration.

Loose leaf and transfer gold

A sheet of gold is thinner than paper and as delicate to handle as gossamer, so it is supplied interleaved in books of 25 leaves. The most flimsy to handle is the loose form ('loose leaf'). There is another version attached to a backing paper; most suppliers call this form 'transfer gold' but be aware there are differences between countries on this labelling. Gold leaf should be at least 23¼ carat as lower carats could tarnish with time. Gold also comes in two thicknesses, single and double (or extra thick). Double is useful for building up layers after the first layer has stuck to the base glue; layering will add depth to the shine. Gold leaf needs to be treated with care as it is expensive. It can be obtained from specialist art suppliers.

Other golds

Dutch metals or schlag are made from brass and other metals and are thicker, so they will not behave in the same way as gold leaf. They are much cheaper than gold and are available in unusual colours. They need to be applied with acrylic glues.

Gold and silver powders need to be mixed with glue and painted; imitation gold gouache can be very successful and works well in the pen, whereas bottled gold inks are only good for painting. Real gold for painting or writing comes as a tablet, originally supplied in a small shell and known as shell gold.

Loose leaf and transfer gold ▲

Laying gold leaf or gold transfer is a very delicate process as it is a fine, clinging material that needs to be placed on an adhesive background. Loose leaf or transfer gold is ideal for decorating a page with a highlighted initial letter or filling in an ornament.

Shell gold

Gold powder

Gold gouache

Tip: It is useful to experiment with other forms of metallic leaf that are available. These include palladium leaf, derived from platinum, and silver leaf.

Dutch metals

Gesso

Gold leaf needs a glue base in order to attach it to paper or vellum; the form familiar from historical illuminated manuscripts is gesso, which gives a cushioned or raised effect. The ancient skills for making and using gesso have been passed down through generations and remain the most successful and yet the most exacting of techniques. The gesso used for gilding is not the same as that manufactured for gilding wooden frames – the latter are oil-based and would stain paper or vellum. Gesso used in calligraphy may be applied with a quill or a brush. The substance has a slightly sticky surface once it has been activated.

Gesso is an ideal choice of platform for creating raised gold – by placing golf leaf on top of a raised surface to create a very shiny three-dimensional effect. It can take a while to prepare gesso if created from its raw materials but the results are well worth the effort.

Gesso ▶
Essentially a mixture of plaster and glue, gesso is solid but fairly flexible when dry. It is the ideal base for gold decoration, providing an even surface for gilding to take place.

Gesso

Other glues

A number of other glues can be used for gilding. Gum ammoniac is a traditional sticky plant residue, sometimes available ready made. Modern glues include PVA or 'white glue', and acrylic gloss medium – a vehicle intended for extending and imparting shine to acrylic paints – but ideal as a glue base for gilding. Acrylic gold size stays sticky when dry (like adhesive tape), and is useful for sticking the Dutch metals.

Bases for gilding ▼
PVA (white) glue, acrylic gloss medium and water gold size can all be used as bases for gilding.

PVA glue

Water gold size Acrylic gloss medium

Tools

A number of tools are needed for successful gilding, including a small pair of scissors (keep them polished and clean or they will stick to the gold), tweezers and a burnisher. Special burnishers are available with different shaped ends for polishing the gold and persuading it to stick in awkward corners. Agate burnishers, which are 'dog-tooth' in shape, are the most commonly available; their tips must be protected in a soft sleeve to prevent scratches, which would damage the gold. Psilomelanite burnishers have generally replaced the more valued haematite burnishers – a lipstick-shaped tool and the highest prized tool for getting the gold to stick and obtaining a good shine when polishing. Laying of the gold and the initial polishing is generally done through a sheet of glassine paper, which is a shiny paper sometimes seen in photograph albums. A dry, soft brush is useful for removing the excess gold leaf surrounding a gilded letter.

Tip: Take care when handling the flimsy gold leaf. Clean your scissors with silk before cutting so that the leaf does not stick to the scissors.

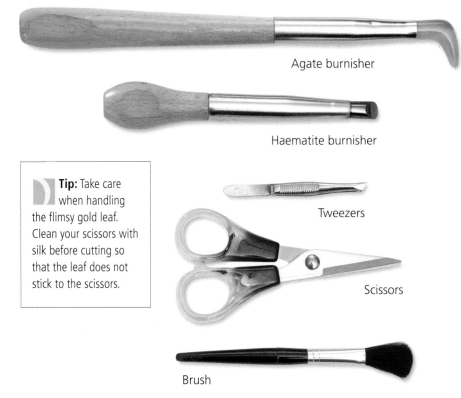

Agate burnisher

Haematite burnisher

Tweezers

Scissors

Brush

Setting up

To get the best results from calligraphy, a comfortable work surface is needed and a desk with a slope is the best option. Choose a chair that is the correct height so that it will support your back. A relaxed posture will encourage a consistent ink flow. Once you begin work, remember to take frequent breaks. You may find it helpful to do some stretches during this time.

The drawing board

Make a drawing-board out of a sheet of plywood, or MDF (medium-density fiberboard). Do not use hardboard as this will bend. Have it cut to size, if possible at approximately 60 x 45cm (24 x 18in). Customize this to your own needs by applying a padded writing surface. The simplest method is to iron at least six sheets of newspaper to remove all creases, attach this to the board with masking tape, then attach a final white cover of cartridge paper, or better still, white blotting paper. Tape the paper all around the board with masking tape, but ensure the tape does not go over the edges of the board, as this could hinder the use of a T-square.

There are many ways of positioning the board. It can be positioned on a table of comfortable height, propped up with some books. Alternatively, two boards hinged together with piano hinges can be used, so that the book props provide infinite adjustment without slipping.

If the single board slips on the table, try attaching it at the base with white-tack or a strip of non-slip rug underlay. If a steeper board is preferred, position the narrow side on your lap, rest it on the table edge, and adjust the distance between chair and table. If possible, sit near a window or good light source, with the light coming from the left if right-handed, or from the right if left-handed. For evening work, a lamp that can be adjusted to spotlight the writing area would be a major advantage. If intending to work at night using colour, consider using a daylight bulb as it will show the colours in a more realistic light.

The final refinement of the board is made by attaching a guard sheet. Take a strip of paper – fold a sheet diagonally to make it wider if necessary – and attach it left and right of the board so that the top edge sits where you would be writing. This ensures your hand will always rest on the guard sheet and not on the writing paper, preventing the paper from becoming greasy. If you forget to use a guard sheet, it may become harder to write – as you meet the greasier part of the paper, the ink will resist.

Prepared drawing board ▼

Whether using a simple sheet of wood, or a commerically produced drawing board, it needs to be well padded, with the padding taped down. Note the gap between the tape and the edge, allowing the T-square to operate. Attach the guard sheet or keep it free.

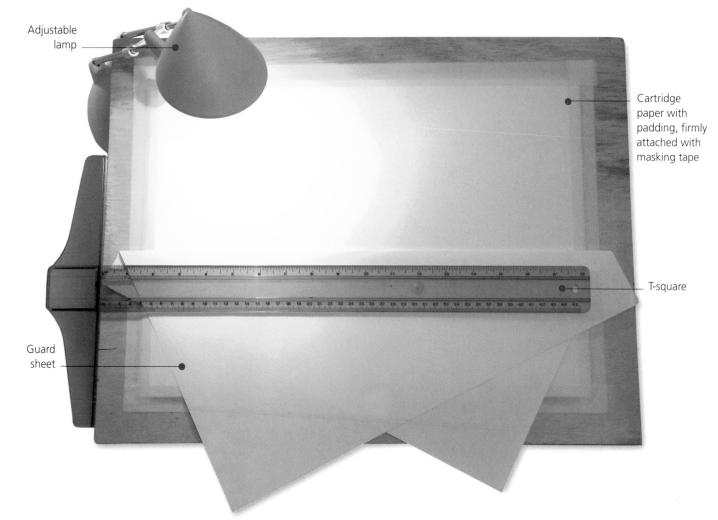

Adjustable lamp

Cartridge paper with padding, firmly attached with masking tape

T-square

Guard sheet

Useful tools

A ruler with clear markings for the accurate mark-up of lines is one of the most essential items. A metal edge is also a useful tool. A ruler or metal edge can be used when cutting paper; work on a self-healing cutting mat or use thick cardboard. Bone folders may be used for scoring and making crisp and accurate folds.

A T-square is a useful, time-saving luxury, as line markings need only be made down one side; parallel lines can then be ruled across. This is why the edge of the board should not be inhibited by masking tape. A set square (triangle) can be used to rule right angles and helps maintain pen angles of 45, 30 or 60 degrees. A protractor is used for measuring letter angles.

Masking tape can be used to attach paper to a sloping board to prevent it from sliding off. Tape can also be stuck in place to preserve a clean strip of paper when using colour washes.

It is useful to have a supply of 2H and 4H pencils for ruling lines and HB pencils for making notes. It is important that the pencils used for ruling lines are well sharpened. Always keep a soft eraser at hand.

> **Tip:** Using scissors, cut a bottle-sized hole in a small bath sponge to keep your ink bottle safe from tipping. If ink does spill, some will be absorbed by the sponge.

Basic techniques

These are techniques that you are likely to use repeatedly. It is important to do them correctly to avoid damaging materials and equipment.

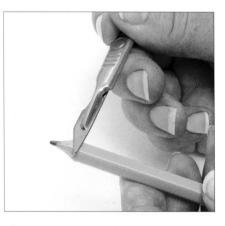

Sharpening a pencil ▲
Hard pencils (2H, 3H, 4H) will stay sharp for longer than soft pencils. Soft pencils (HB, B, 2B etc.) will break under pressure and become blunt quickly. A standard pencil sharpener will do most of the job (if it is new), but the final touch is to shave away the tip with a craft knife.

Cutting paper ▲
Always use a sharp blade. If it is blunt the blade will need to be pressed harder and the chances of it slipping are higher, with possible resultant injury. Cut against a metal ruler, or a plastic ruler with a cutting edge. Use a cutting mat or thick cardboard, such as the back of a layout pad. Cut with several light strokes rather than one heavy one, and arrange the paper so you can make cutting strokes towards your body. Cutting from left to right is less controlled and the knife may slip.

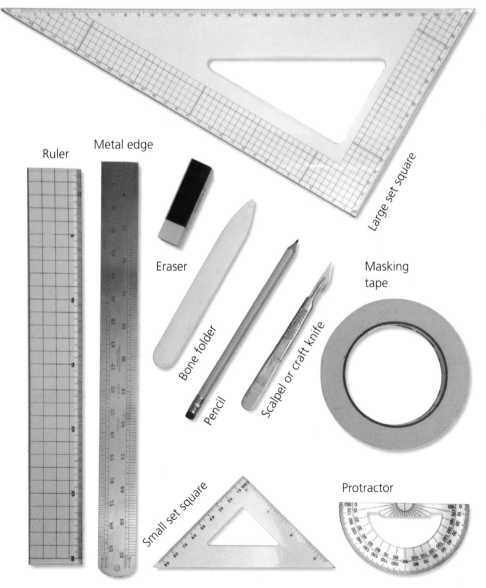

Ruler

Metal edge

Large set square

Eraser

Bone folder

Pencil

Scalpel or craft knife

Masking tape

Small set square

Protractor

Basic penmanship

Once all the necessary equipment has been assembled, you can prepare to begin your calligraphy. To produce good work a relaxed posture is needed, as well as an arm position that encourages a steady flow of ink. Spend some time adjusting your position so that you are comfortable – learning calligraphy should always be an enjoyable experience, but it also requires much concentration. Work is more likely to be successful if calligraphy is practised on a regular basis and all the equipment is kept in one place. You may prefer to work on a drawing board resting on a table top, or secured to the edge of a table. Alternatively, the drawing board can be rested in your lap, or flat on a table, resting your weight on the non-writing arm so you have free movement with your pen. Remember to lay padding underneath your paper as this will help the flexibility of the nib, and prevent it from scratching on the paper. Make sure that the writing sheets are fixed to the board securely. Light should fall evenly on the working area, and although daylight is best, an adjustable lamp will illuminate the page.

Terminology

Calligraphy uses special terminology to describe the constituent parts of letters and words, and the way they are written. The style or 'hand' in which the writing is created is composed of letterforms. These are divided into capital, or upper-case letters, and smaller, lower-case letters (traditionally called majuscule and minuscule). Text is usually written in lower-case letters because they are easier to read than solid blocks of capital letters. The x-height is the term used for the height of the full letter in capitals (the space an 'X' occupies) and for the main body of the letter for lower case, excluding ascenders and descenders. In lines of text, the gap between x-heights, which accomodates ascenders or descenders, is known as the interlinear space. The spaces enclosed within letters are called counters.

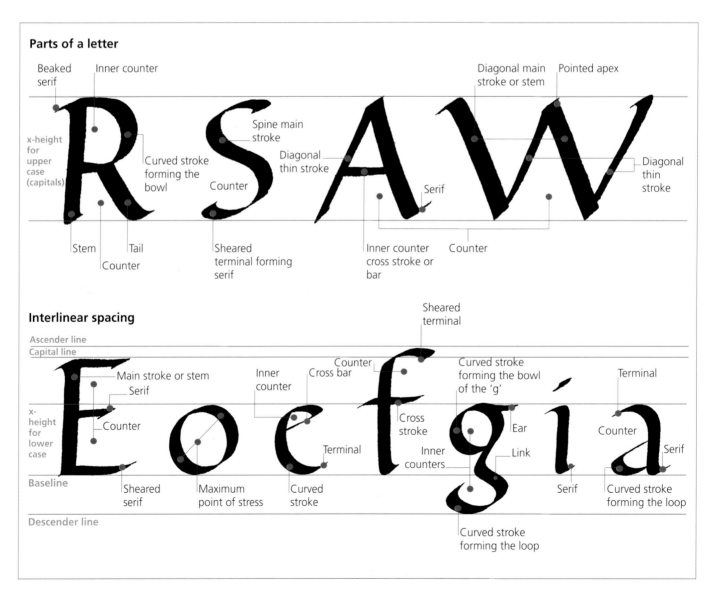

Parts of a letter

Beaked serif
Inner counter
Diagonal main stroke or stem
Pointed apex
x-height for upper case (capitals)
Spine main stroke
Curved stroke forming the bowl
Diagonal thin stroke
Counter
Serif
Diagonal thin stroke
Stem
Tail
Counter
Sheared terminal forming serif
Inner counter cross stroke or bar
Counter

Interlinear spacing

Sheared terminal
Ascender line
Capital line
Main stroke or stem
Serif
Inner counter
Counter
Cross bar
Curved stroke forming the bowl of the 'g'
Terminal
x-height for lower case
Counter
Cross stroke
Ear
Counter
Terminal
Inner counters
Link
Serif
Baseline
Sheared serif
Maximum point of stress
Curved stroke
Serif
Curved stroke forming the loop
Descender line
Curved stroke forming the loop

Essential techniques

The techniques detailed below are essential to creating good calligraphy. Carrying them out properly will ensure that letterforms are properly proportioned, well spaced and at the correct angle. It is important to practise some of these, such as using a broad nib and holding the pen at a constant angle, before you begin to write letters and words.

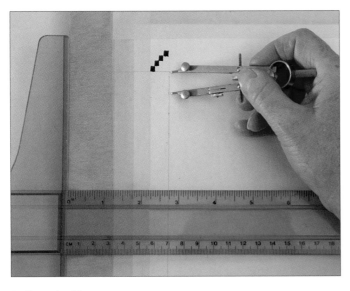

Using a broad nib ▲
A broad nib, pen or brush is the essential tool for calligraphy. When the pen is held in the hand it forms an angle to the horizontal writing line, known as the pen angle. It takes some adjustment to use this sort of tool after using pointed pens and pencils. It is helpful to pay careful attention to just keeping the whole nib edge against the paper when writing to avoid ragged strokes. Try some zig-zags – aim to create the thinnest and thickest of the marks by moving the pen along its side and along its width to appreciate its extremes.

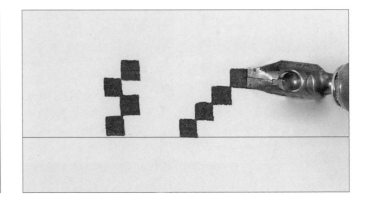

Measuring nib widths ▲
Whatever nib size is used, the height of the letter is determined by using a 'ladder' of nib widths. A baseline is ruled first and a broad-edged pen held at right angles (90 degrees) to the line. A clear mark should be made, long enough to be a square. The pen is moved upwards and marks are drawn so that they just touch; forming a 'stairway' shape or a 'ladder'. An alphabet exemplar will indicate the number of nib-widths needed for the x-height of a hand. Use that measurement for ruling all the lines.

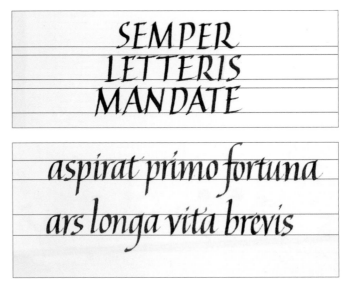

Ruling the lines ▲
The standard method is to mark repeat measurements (taken from the nib width exercise above) down both sides of the paper, then join them up with a ruler. Another way is to use a scrap of paper with a straight edge, mark a short series of accurate measurements and transfer these across (this is not suitable for measurements below 4mm (5/32in) but is accurate enough in larger sizes). Marking down just one side of the paper is sufficient if using a T-square. Attach the marked sheet to the board top and bottom to prevent movement. The T-square is used to rule parallel lines across the page.

Leaving enough spaces ▲
Take the measurement of the required number of nib-widths for the x-height. For lower case letters such as Italic, rule all the lines to this measurement and leave two gaps between x-heights, to allow for ascenders and descenders. When ruling up for writing entirely capitals, it is sufficient to use a single gap, or even less, as there are no extensions.

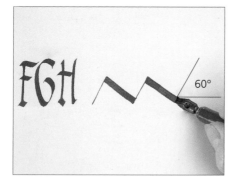

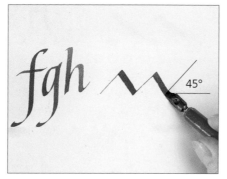

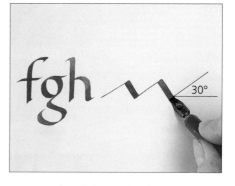

Pen angles ▲

Holding the pen at the same angle to the writing line for every letter is an essential discipline to create letters that work well together. Each alphabet

exemplar indicates what angle is necessary, as they vary in different script styles. Resist the temptation to move the wrist as in standard writing. As the letter is completed, check it is still at the

same angle – it is easy to change without noticing. Zig-zag patterns, made at whatever pen angle is indicated for the chosen alphabet style, can be a useful warming-up exercise.

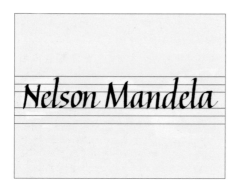

Allowing for the capitals ▲

When you are writing mostly lowercase with the occasional capital, rule the lines as for lower case, and gauge by eye how high to write the capital – often it is just two nib widths higher than the lower-case x-height, which will be lower than the height of the ascenders.

Left-handers

Left-handed calligraphers need to make some adjustments in holding the edged pen to mimic the natural position of the right-hander.

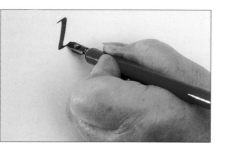

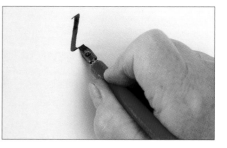

The left-hander should sit to the right of the paper, and tuck the left elbow into the waist, so that the wrist can be twisted a little to the left to hold the pen at the required angle. There are

left-oblique nibs available to minimize the amount that the wrist needs to be bent, but if left-handers can cope with a straight-edged nib they will have a greater choice of nibs available to them.

Letter spacing ▶

Once you start to write words, it is important to be aware of letter spacing and awkward combinations. Aim to create an overall balanced texture in a page of writing. With lower-case letters, the space is generally regulated by a need for rhythm and an evenness of downstrokes, particularly noticeable in Italic and Gothic. Watch for rogue letters that already have a gap – they can cause problems when combined with the gap of an adjoining letter (such as with 'r' and 'a' in Foundational).

awkward combination of letters leaves a big space

place the letters close together to create a more natural space

▼ The letter spacing below is helped to be more legible by spacing out the letters according to the shape and relationship of letters to each other.

Unspaced ▼

Spaced ▼

'DO' – two curves together require closest spacing

'IN' – two uprights adjacent – give these the most space

Alphabets

It is best to start by simply learning the alphabets and focusing on gaining a sound grasp of the principles. It is easy to get confused and create muddled hybrid letterforms when jumping from one style to another before understanding the family characteristics.

Learning the alphabets ▼

Study the proportion of the letters, their height and the width of the body of the letter. Capitals and lower-case letters are included for each alphabet where appropriate. Calligraphers normally establish the body height of the lettering by the number of pen widths it should contain. For example with Foundational hand, use four nib widths for the x-height, while the ascenders and descenders should be less than three quarters of the x-height (two or three nib widths). The capital letters should be just two nib widths above the x-height and do not look right if they are any higher. Serifs can embellish the end of the letter.

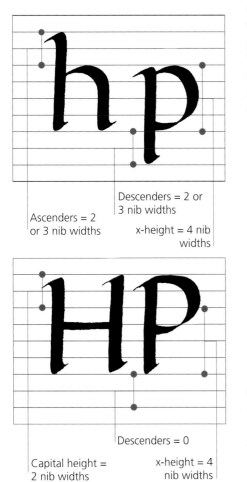

Ascenders = 2 or 3 nib widths

Descenders = 2 or 3 nib widths

x-height = 4 nib widths

Capital height = 2 nib widths

Descenders = 0

x-height = 4 nib widths

Basic strokes ▶

Every alphabet has a few basic strokes that are common to several letters. We think of them as 'family' characteristics, and understanding them is key to being able to accurately reproduce the alphabets. Thus in Uncials (capitals), many letters conform to the very rounded shape of the 'O'; in Italic, the branching nature of 'A' and 'N' is repeated in many other letters. In lots of cases, the family characteristics are also repeated in inverted versions. Thus, 'u' and 'n' in lower-case forms are upside-down versions of each other – so note how the arches are the same, and check you are properly reproducing this formation yourself. Note, too, whether upside-down ascender letters become their descender counterparts when inverted, and likewise check if your own rendering acknowledges this.

Uncial letters based on the 'o'.

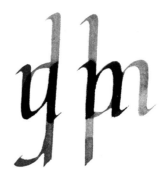

Inverted characteristics of 'u' and 'n' in other Italic letters.

Forming strokes

When writing with a normal pen, it can easily be moved round the page. When writing with a calligraphy pen this is not possible because the nib resists against the paper and may cause an ink blot or mark. This is the reason why letters are made by lifting the pen between writing separate strokes. For example the letter

'o' has a pen lift, and two strokes. Other letters of the alphabet are made up of one, two, three or four strokes. The pen strokes make writing in calligraphy much slower than normal writing. Pay close attention to the shape of the letter, and write slowly to start with.

One stroke

Two strokes

Three strokes

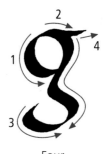

Four strokes

Numerals

Numbers are frequently written at the same height as capital letters, with no extensions, and these are called 'ranging numerals'. They fit into the same x-height as capital letters. 'Non-ranging' numerals are modelled on the lower case x-height, with 0 and 1 confined to the lower-case x-height, whilst the others extend in imitation of ascenders and descenders, with even numbers above the line and odd numbers below. Numerals should match the family characteristics of the letters they accompany.

Layout and design

The skill of how and where to place a piece of text or an illustration on a page is paramount. Deciding how the work is displayed, how much space there is for margins or how text is aligned, is as much a skill as the calligraphy itself, and good design can really transform the appearance of a piece of calligraphy. A good formula for the measurement of margins is to make the top margin twice the size of the largest interlinear space in the finished design, the side margins about 1¹/₂ times the size of the top margin and the bottom margin twice the size of the top margin. The design of the page is influenced by letterform size and the length of the written line. Other factors to be considered are the amount of colour or illustrative content, the creative stamp the calligrapher wishes to place on the design, and the function or purpose of the final artwork. It is extremely important to plan the design of a piece thoroughly before you start writing the text.

Different styles of layout

The ideas shown here offer some layout options that could be used for a piece of simple text. These designs can easily be altered or combined to produce many artistic variations. Think about the meaning of the text and the flow of the words and how this could be reflected in the layout of the piece.

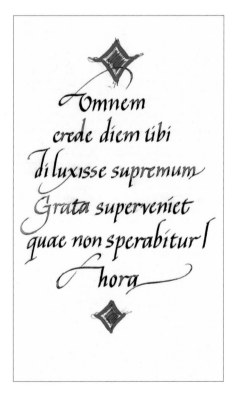

Centred ▲
This is a centred layout that features a small design top and bottom. This is an acceptable standard layout because it looks balanced and is very suitable for both long and short lines of writing. However, producing a centred piece of work requires both accuracy and patience because the length of the individual lines must be established first before the layout can be finalized.

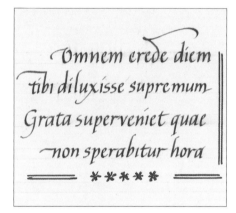

Aligned left ▲
This text has been aligned or ranged left with a margin, which has a decorative design of foliage. The text is slightly ragged on the right-hand side, but because the lines are around the same length the space on the right hand is acceptable. Left alignment is commonly used, particularly in practice work, as it requires very little line adjustment and planning. The text always starts in the same place.

Asymmetrical ▶
This is an asymmetric layout, which looks centred on the paper but the lines are of varying lengths. This is a useful layout for poetry or prose that has extra long lines which need to be incorporated into a space. The top line and the bottom line are centred, and the intermediate lines are ranged from right to left in a way that makes the whole piece look balanced.

Aligned right ▲
This text is right aligned, or ranged right. The layout is not often chosen as it is difficult to achieve – but can be effective when used with short lines. The ending of each line must be accurate for the text to align. Right aligned text is often used with other right-ranged elements such as illustrations or photographs.

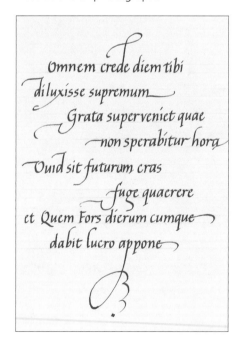

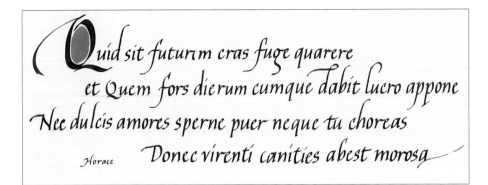

◀ **Focal point to the left**

This is also an asymmetrical layout with a focal point to the left, which carries the weight and colour of the image. It gives a feeling of freedom to the writing. This layout can create atmosphere and give a feel to the design in hand. However, its use is entirely dependent on the individual calligrapher's feel for balance and the shape of the composition.

Marking up

Making a rough or mock-up of the layout is a good method of transcribing the text and finalizing the design. This is called 'cut and paste' or 'paste-up'.

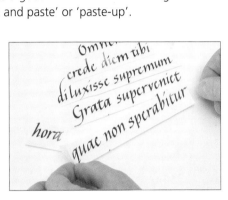

1 Choose the preferred text, the letter size and the script that will be used. Measure the pen nib widths and rule up the page. Write the text carefully. If a mistake is made write the word again correctly and proceed with the rest of the text.

2 Cut the text into strips and place into a layout. Remove any incorrect words and replace with the correct text. Paste the strips into an ordered layout using re-positional tape or glue. Do not use a ruler or lines at this stage – just use your 'eye' to place the strips.

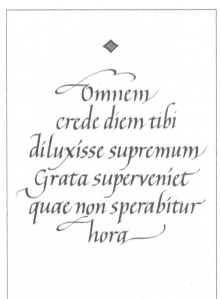

3 Measure the distances between the baselines of the writing. They will vary from line to line but not significantly. Choose the most suitable distance (interlinear space) which should not be too close or too spaced as the text will not read well. Once the distance from baseline to baseline has been chosen, rule up a sheet of practice paper with all the required baselines, equidistant from each other.

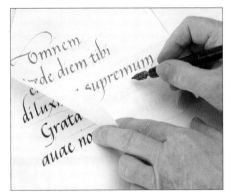

4 Overlay your paste-up work with the newly lined paper and write it out once more. Refine the letterforms and adjust the spacing.

Tip: Always write the first 'practice' text in dark coloured ink so that it is easily seen through the practice paper.

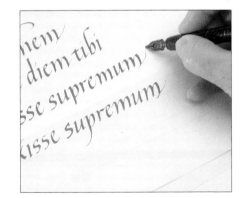

5 This is the penultimate piece of work. Rule up on good quality paper using this last sheet as a line guide. You are now ready to write. Fold over the written piece line by line, to place as a guide under each new writing line. This ensures no spelling mistakes are made and each line that you write will start and end in the correct place.

6 The finished calligraphy can be decorated at the top with a little gilded diamond.

DEFG 1 2 3 4 5 6
KLMN 7 8 9 10
QRSTU Æ Å Ø Œ Ü É
WXYZ& &¡?ß

MRSEH 1 2 4 0 0 E

Alphabets

One of the joys of calligraphy is being able to choose a script that in some way expresses the meaning of the text. Hundreds of beautiful calligraphic alphabets have been developed over the centuries, and in this section 12 of the most popular are presented in detail. To enable you to accurately construct the individual letters, the alphabets are demonstrated in upper and lower case along with helpful markers to indicate the direction and order of the strokes used. Calligraphy, however, is not just a matter of mechanically following rules – it requires a feel for the style and flow of the scripts, and following the exercises that accompany each alphabet will help you to develop this. Practise the scripts, taking care to avoid the common mistakes, until you can write them fluently.

Foundational hand

The Foundational hand, also known as Round hand, was devised by Edward Johnston (1872–1944) following his studies of medieval manuscripts in the British Library. He based this hand on the writing of the Ramsey Psalter – an English Carolingian script with well-formed and consistent letterforms that was written around the end of the 10th century.

The Foundational hand is based on the circle made by two overlapping strokes of the pen. This cursive hand is written with a constant pen angle and few pen lifts. It is this constant angle that produces the characteristic 'thick' and 'thin' strokes of the letterforms.

In the 9th and 10th centuries either Uncial or Versal letters would have been used at the beginning of the Carolingian scripts on which Foundational hand is based. However, Roman Capitals are now used in conjunction with the Foundational hand. These capitals are based on the carved inscriptional letters used in Ancient Rome and their elegant proportions relate to the geometric proportions of a circle within a square. The Foundational alphabet can be divided into several groups, and the circle within a square construction is used as the guidelines for the proportions of the letters within each group.

Circular letters follow the circle, rectangular letters are three-quarters the width of the square and narrow letters are half the width of the square. The only letters that do not fall into a group are the two wide capital letters 'M' and 'W'. The central part of the letter 'M' is constructed in the same way as 'V' and the legs extend right into the corners of the square. The letter 'W' is constructed as two 'V's side by side, making a very wide letter that extends beyond the boundaries of the square.

The basic rules

Foundational hand is a formal, upright script where each letter is made up of two or more strokes, which means that it has more pen lifts than a cursive script. The constant pen angle of 30 degrees controls the distribution of weight, creating thick and thin strokes. This pen angle must be maintained throughout in order to create good, rounded letterforms and strong arches.

The letters should be evenly spaced for easy reading. An important characteristic of this hand is that the top curves of 'c' and 'r' are slightly flattened to help the eye travel along the line of writing.

LETTER HEIGHT
The Foundational letter height is four times the width of the nib. Turn the pen sideways to make squares with the nib, then rule the lines that far apart.

LETTER SLOPE
Foundational letters are upright and should not lean.

PEN ANGLES
Hold the nib at a constant angle of 30 degrees for all letters except for diagonals, where the first stroke is made with a pen angle of 45 degrees.

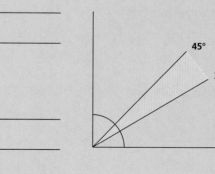

Practice exercise: **Foundational hand**

Almost all the letterforms of this hand relate to the circle and arches, so practise by drawing controlled crescent moon shapes, beginning and ending on a thin point. Once this has been mastered, these semicircles can be attached to upright stems to create rounded letterforms or they can be extended into a downstroke to form arches. Begin high up and inside the stem to produce a strong rounded arch. Rounded serifs are used on entry and exit of strokes.

Group	Strokes (1st = red, 2nd = blue, 3rd = green)

Round or circular

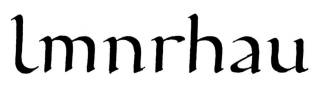

Note where the thin parts of the letters are. The first stroke of these letters should be a clean semicircular sweep, producing a shape like a crescent moon. Start at the top and move the pen downwards. The left and right edges of the pen form the circles.

The letter 'o' is made by two overlapping semicircular strokes which produce the characteristic oval shape of the counter.

The back of the 'e' does not quite follow the circular 'o' but is flattened so it appears balanced. The top joins just above halfway.

Arched

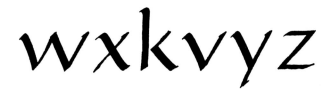

The arch joins the stem high up. Beginning with the pen in the stem, draw outwards in a wide curve, following the 'o' form. Start the letters with a strong, curved serif and end with a smaller curved serif. Keep the pen angle at 30 degrees throughout.

Draw an arch continuing into a straight stroke. The bowl of the letter begins halfway down the stem with the pen at 30 degrees.

The 'u' follows the same line as an 'n' but upside down, producing a strong arch with no thin hairlines. Add the stem last.

Diagonal

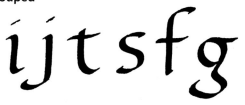

For the first stroke, hold the pen at the steeper angle of 45 degrees. This will prevent the stroke from being too thick. Take care not to make any curve on this stroke. Revert to a pen angle of 30 degrees for the second stroke.

Start the ascender three nib widths above the body height. The second stroke is made in one continuous movement forming a right angle.

The pen angle is steepened for the thick stroke and the strokes should sit upright. The second stroke begins with a small, hooked serif.

Ungrouped

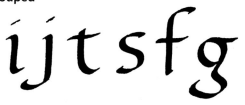

Keep the pen angle at 30 degrees for these letters. Remember to follow the smooth shape of the 'o' when drawing curves, rather than simply flicking the pen. Crossbars should sit just below the top line, and should protrude to nearly the width of the curve.

The base of the first stroke curves to relate to the 'i'. The second stroke begins with a small serif and neatly joins to this base.

Start just above the top line. The crossbar forms the second stroke and is made by placing the nib at an angle just below the top line.

Foundational hand

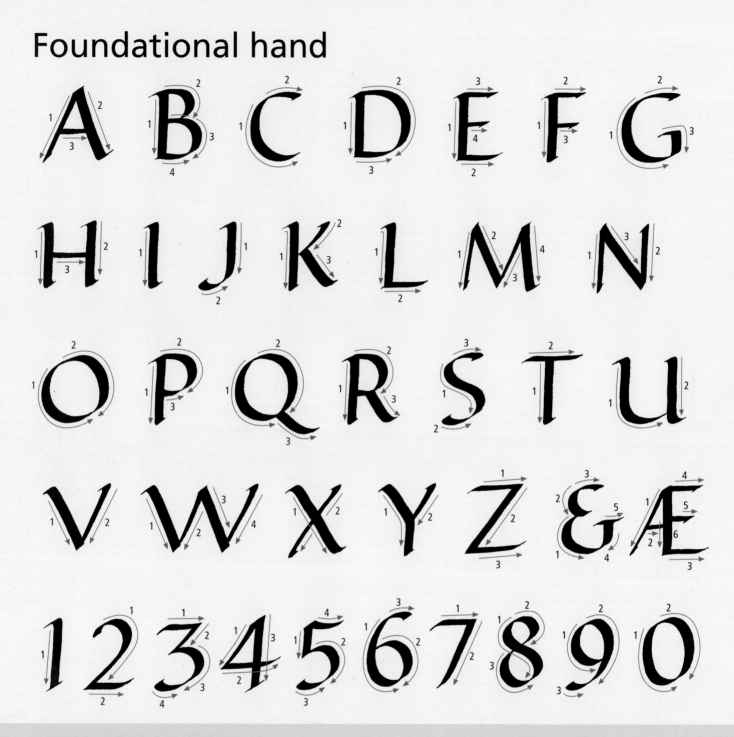

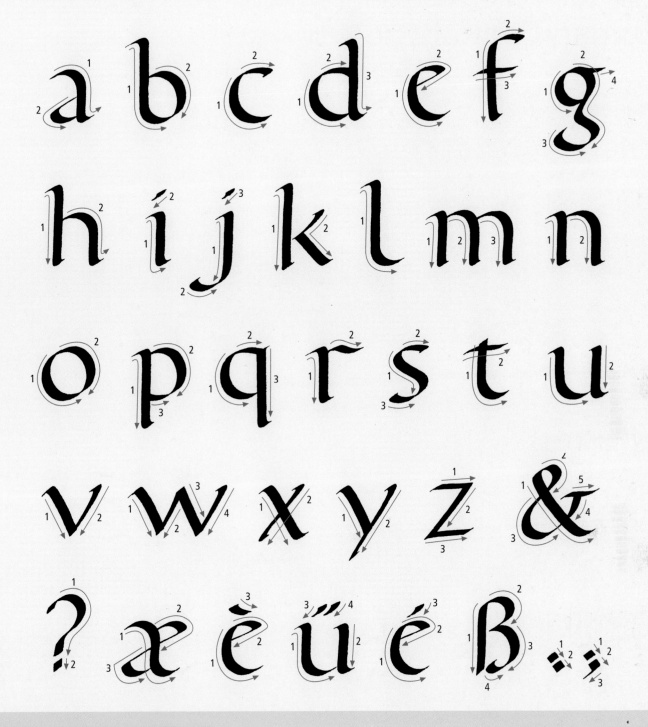

COMMON MISTAKES – LOWER CASE

A common mistake is to give letters the wrong shape. This is usually caused by not following the shape of the 'o'. As a result, the bowls of the letters will be too small, and arches will be weak and uneven.

Both arches should be evenly spaced.

The bowl is a little too small.

The top curve should be slightly flattened.

The bowl is too small.

The bowl is too small.

The stroke is too wide and unevenly spaced.

Roman Capitals

Roman Capitals are arguably the most important early ancestors of Western calligraphy. Two thousand years old, and originating from the beautiful letters inscribed in stone or marble in ancient Rome, they are now revered as classical models. Even today, the work of Roman craftsmen still exists throughout what used to be the Roman Empire for all to see.

The version of Roman Capitals shown here is lightweight, with small, elegant serifs. The letters maintain the classical Roman proportions, but are modelled on a more recent pen version developed in the medieval period by the famous Italian scribe Bartholomeo San Vito.

The Roman Capital letterforms are based in structure on the geometric proportions of the circle and the square. They can be divided into four groups: the circle within the square, three-quarter width, half width and the whole square or larger. It is helpful to try out these proportions first in pencil, making just skeleton monoline letters, perhaps on graph paper. Try them in width groups (as shown opposite) to familiarize yourself with the proportions before you begin to write using the edged pen. When you do write with the edged pen, ensure that you maintain the pen angle at 30 degrees. This angle can be flatter for the serifs if aiming for elegance. The serif endings may need to be finished off by using the corner of the nib. Diagonal strokes demand a 45-degree pen angle.

Close attention must be paid to the height and width of the letters if they are to be recreated with their true proportions. The letters need some space around them, so avoid crowding them too closely together.

The basic rules

It is important to retain good pen control when writing Roman Capitals. In general, maintain a constant pen angle of 30 degrees. There are, however, a few exceptions to this rule that add elegance to the letterform. The upright strokes in 'N', and the first stroke in 'M', need a steeper pen angle of 60 degrees in order to make a thinner stroke. 'Z' needs a stronger diagonal stroke than 30 degrees will confer, so cheat and flatten the pen completely for a thicker stroke. You may find that in order to blend the serifs into the uprights, your pen needs to be well filled with ink; this helps the strokes flow together. In order to create serifs, a pen angle of 5 degrees may be adopted. Several different types of serif can be produced, requiring different levels of competence.

LETTER HEIGHT
The letters shown here are eight nib-widths, giving light elegance. You could try seven or even six nib widths, but take care not to allow the serifs to become too dominant.

LETTER SLOPE
The letters are upright, and should have no forward slope. Check that letters have not developed a lean by looking at the writing upside down.

PEN ANGLES
Thirty degrees is maintained overall, maybe a little flatter for elegance of serifs, a little steeper for the uprights of 'N' (to make them thinner) and flatter for the diagonal of 'Z' to make it thicker.

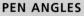

Practice exercise: **Roman Capitals**

Unlike all lower-case (minuscule) hands, Roman Capitals rely for their elegance on their geometry, and in particular on their widths relative to the circle and square. These widths are the basis upon which the groups of letters are formed. It is important to have a sound understanding of how Roman Capital letters are constructed before embarking upon reproducing the whole alphabet. An edged or broad pen may be used when writing this script.

Group	Strokes (1st = red, 2nd = blue, 3rd = green, 4th = mauve)

Circular

All are formed as all or part of a circle. Make sure that your circle really is round and not oval, and that the letters that belong to this group have a round shape overall. 'D' is difficult to make rounded – you may find it helps if you pencil in the circle first.

This letter is made in two 'half-moon' strokes pulled downwards and joined at the thin points.

This letter has more parts; ensure it echoes the 'O' in shape, and blend the last stroke into the bottom without leaving a thin stroke.

Three-quarter width

HAVNTUXYZ

In geometric terms, these letters occupy the area where a circle in a square meets the two diagonal lines that cross it – equal to three-quarters of the width of the square. All the letters in this group occupy the same width – three-quarters of their height.

Make a confident curve finishing on a thin stroke, and bring the second stroke down to make an overlapped join.

Judging the distance between the two uprights will need practice; ensure the crossbar is a little above the centre.

Half-width

BPRKSELFIJ

These letters are grouped together because, in geometric terms, the major part of the letter occupies just half of the square. In the case of 'R' and 'K', the tails of the letters will extend beyond the half of the square, and the letter 'I' is narrower than this.

The top serif is made as part of the stroke that carries on to make the curve. The tail does not start from the stem, but from the curve.

The top stroke starts as a serif to the left, and continues across with a slight twisting of the pen. Repeat for the central crossbar.

Broad-width

There are just two letters remaining: 'M' and 'W'. They are not upside-down versions of each other, so do not overdo the very slight splaying of 'M's legs. In geometric terms, 'M' mainly fits the shape of a square, whereas 'W' is two 'V's, making it very wide.

Make the first stroke with a steeper pen angle for a fine line; try not to allow the outer strokes to splay too much.

Put two 'V' shapes together, blending the joins by careful overlapping, especially at the bottom points.

Roman Capitals

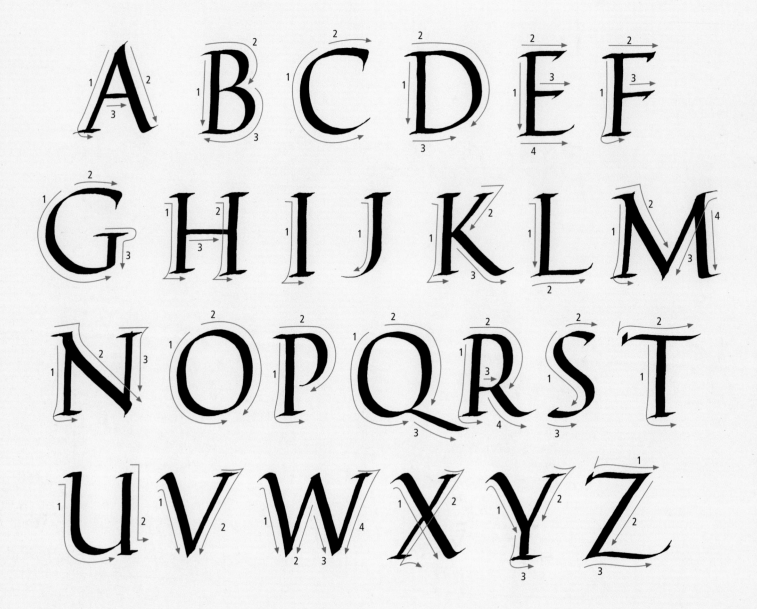

COMMON MISTAKES – CAPITALS

Mistakes of proportion are the most common problem with Roman Capitals, so you may prefer to trace the letters the first time, to help get the 'feel' of the balance of forms.

Bottom bowl should be larger than top, for visual balance.

Too narrow, this looks like half a circle – it should have a straight top to assist in gaining the width.

Too long; the horizontals should be a similar width.

Too wide; this is a half-width letter.

If the first stroke is sloping too much, the whole letter becomes an upside-down 'W'.

Crossbar too low; throws the letter out of balance.

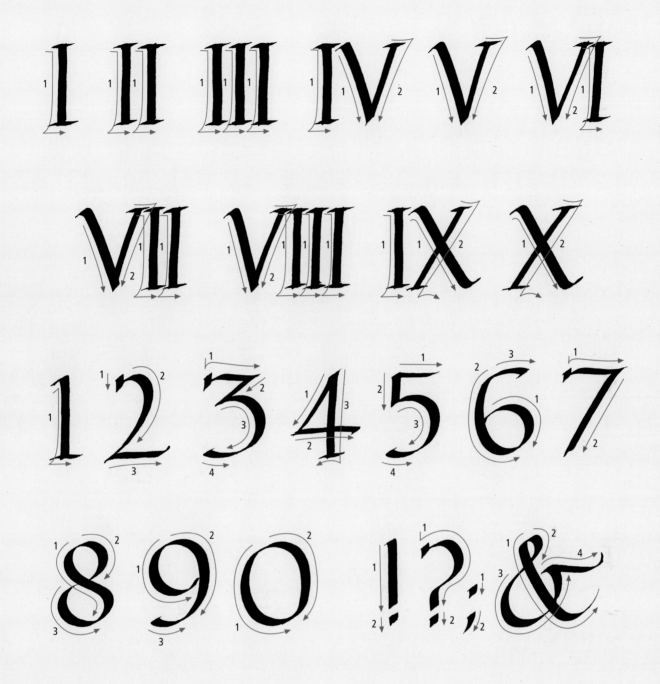

COMMON MISTAKES – NUMERALS AND SYMBOLS

Originally, of course, only Roman numerals would have been used with Roman Capitals. For speed, some writers join all the top and bottom serifs into horizontal bars. Arabic numerals were assimilated into the alphabet at a later date. They should generally be bottom-heavy so that they look balanced.

Divided too low, bottom bowl too small.

Top heavy; larger bowl should be at bottom for visual balance.

Top and bottom bowls too similar, make top bowl smaller.

Crossbar too high; makes it very small.

Small bowl, with lower stroke extending too far to bottom left.

Leaning backwards; start the first diagonal more upright.

Uncial hand

This script has a long history, developed around the 4th century AD or earlier. It is composed entirely of majuscules (capitals) which have no corresponding minuscules (lower-case letters) to accompany them. Minuscule forms had not yet evolved when Uncial was developed, but the few letters which extend above or below the body height ('D', 'H' and 'Q' for example) are the first signs of ascenders and descenders to come.

The precise origin of Uncials is uncertain, but they may have originated from north African scripts. They appear to combine Latin and Greek shapes – look at 'A', 'D' and 'E' (version with crossbar), 'H' and 'M', which seem to have Greek parentage. The early versions of Uncial appear to be quick to write, and this will have endeared them to scriptoria where dissemination of religious writings (including the bible) was the focus. They are known as 'book hands', or hands that were specifically evolved to suit writing at small scale.

Uncials became associated with Christianity, as they accompanied the spread of this 'religion of the book'. Luxury books of the time often incorporated very large writing (sometimes for practical purposes of being readable at a distance during a religious service). It is thought the term 'Uncial', which literally means 'inch-high', was an affectionate exaggeration of that size, and in the 19th century that name became the accepted name of the script.

Later versions of Uncial, used from the 7th to 9th centuries, became more complex, requiring twisting or 'manipulation' of the pen to obtain subtle wedged serifs, which would have slowed down the writing speed. Both forms are shown on the following pages, but follow the simple form before attempting the manipulated version, which requires more concentration.

The basic rules

These letters are all very rounded, and may not come naturally to anyone who normally writes compressed forms. If this is the case, draw a row of circles lightly in pencil and write the letters on top, checking that each one maintains the rounded shape. All arches follow the round arches of 'O'. Even the diagonal letters correspond to the circle shape in width (except 'W', which incorporates two 'O's overlapped). Check that you have the pen at a flat pen angle, as steeper angles invite the pen to make narrower marks. Some letters have slight ascenders that are higher than the body height, or descenders that fall below the baseline, but these should be minimal in height, extending only between one and two nib widths. 'I' and 'J' are not dotted, because all Uncials are capital letters.

LETTER HEIGHT
The Uncials shown here are three and a half nib widths high, which provides the historically correct weight. However, they can also be written at four or more nib widths for lighter versions. The extensions are minimal, and must not exceed two nib widths.

LETTER SLOPE
These are upright letters and should not have a slope. Speed of writing occasionally creates a slight forward lean, but this is not good practice, so slow down if a slope creeps in.

PEN ANGLES
A comparatively flat angle is necessary for these letters, between 15 and 25 degrees. Check where your thinnest part in a curved letter comes – it should be very near the top, with the accompanying danger of weak arch joins.

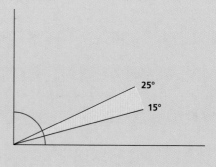

Practice exercise: **Uncial hand**

For this script think 'fat and flat': very rounded, wide letters written with the pen at a very flat pen angle. They are fairly comfortable for left-handers; right-handers should tuck their elbow into their waist if having trouble with this pen angle. Keep checking that the thin strokes are near the top and bottom on curved letters, and that the horizontal strokes are much narrower than the upright strokes on straight letters.

Groups	Strokes (1st = red, 2nd = blue, 3rd = green)

Round or circular

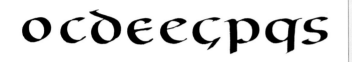

Most Uncial letters are rounded in shape. Try to see the secret 'O' in every letter, but remember that the Uncial 'O' is slightly wider than a circle. It may help to draw pencil circles to write over. There are two 'E's; the first 'E' in this group is Greek in origin.

Make a half-moon curve from top to bottom, then blend in the second curve using a clockwise movement.

Start just like the 'O', then begin the second stroke above the line, completing the 'O' shape. Beware of flattening the right-hand side.

Diagonal

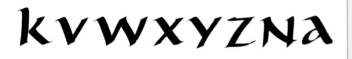

These letters still maintain the width of the 'O'. Watch your pen angle carefully so as not to make the diagonal strokes very much thicker than the upright strokes. The right-to-left diagonals should be thinner than their left-to-right counterparts.

Make the first stroke a diagonal stroke, then, starting inside the diagonal, make a sweeping but tight curve.

Pull the diagonal down at the shallow angle, and bring the second stroke down to overlap for a neat corner; check its thickness.

Arched

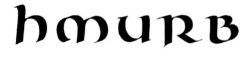

A very flat pen angle puts the thinnest point of a curved letter near the top – just where it would join an upright for an arched letter. This can weaken the letter, so take care to start the curve inside the upright to make it look well attached.

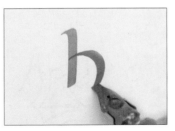

Start the upright stroke above the line, and firmly lock the curved stroke into it by starting within the stem. Note its roundness.

The first stroke is like 'O', the second forms an upright, and the last stroke repeats the curve with a firmly attached branching arch.

Straight

These letters are the simplest, but they are useful for practising writing with the correct pen angle, as you can pay attention solely to attaining the desired difference in thickness between horizontals and verticals.

Start above the line with a minimal serif, and pull down for a strong vertical stroke, changing direction but not pen angle at the base.

Start with the crossbar, as this will help when spacing text. Make a downstroke much thicker than the crossbar with the same pen angle.

Uncial hand

EARLY

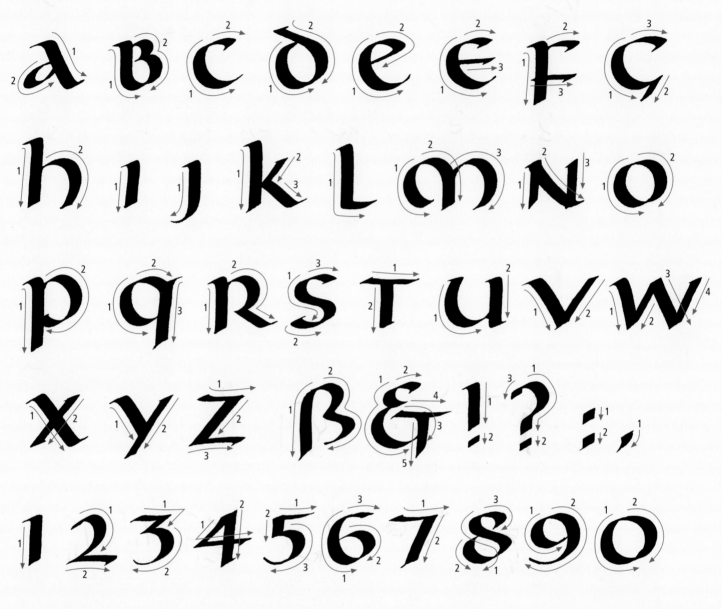

COMMON MISTAKES – EARLY UNCIALS

The main problem encountered with Uncials is not maintaining the roundness of every letter. It is this roundness that characterizes the overall texture in a block of Uncial writing – without it, the text loses its rhythm. Another mistake is to make ascenders too high and to place crossbars too high up the stem.

Diagonal should be straight, resembling the right-hand side of a standard capital 'A'.

Second stroke starts too high and cuts off the top right curve of the 'O' shape it needs.

Left and right 'drooping leaves' should be same distance away from the stem.

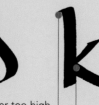

Too narrow, no echo of the rounded letters.

Ascender too high.

Join goes too far into the stem giving a heavy look.

Too narrow, ends curled up enhance this narrowness.

LATE

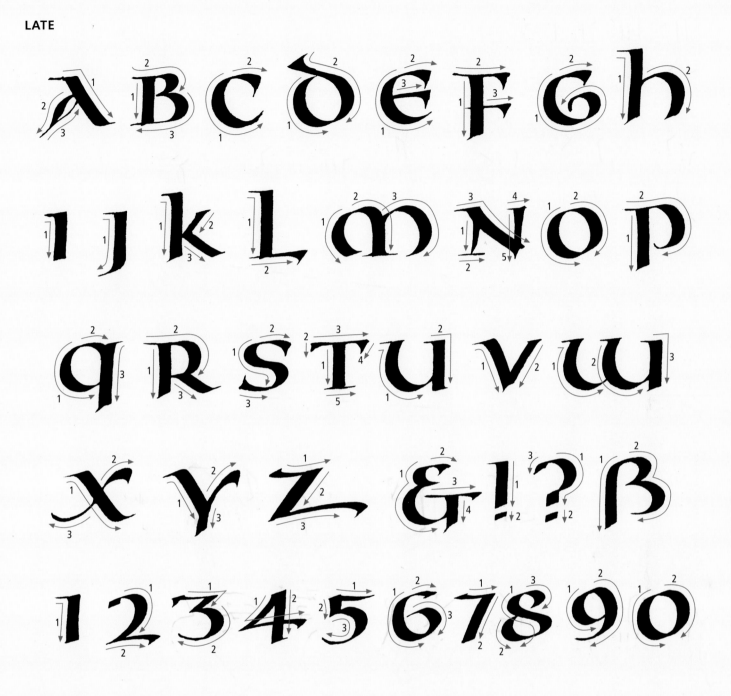

COMMON MISTAKES – LATE UNCIALS

The very flat pen angle is even more essential for these manipulated letters, as it creates contrasts of thickness, but take care with the twisted serifs which are its feature. These wedge shapes are made in a flowing movement twisting the pen from horizontal to near-vertical.

Top-heavy, give it a fatter body and a smaller head.

Too steep a pen angle, so both strokes are very similar in thickness – lacks contrast.

Horizontal stroke uncontrolled and wavy, manipulation required both ends.

Too narrow, not echoing the 'O' in width.

All strokes heavy, the uprights need manipulating for thinner strokes.

Extra serif on left unnecessary and in danger of looking like 'T'.

Gothic hand

Gothic was much despised by calligraphers in the early part of the 20th century, due no doubt in part to the previous generation's mistaken idea that it was first drawn and then 'filled-in'. Many bizarre versions of this writing appeared in the form of loyal addresses and freedoms of the city, which still emerge from time to time in manuscript sales. If influential calligrapher Edward Johnston had given as much attention to the Metz Pontifical as he gave to the Ramsey Psalter, the history of calligraphy might have been very different. Then instead of basing the introduction to calligraphy on the very circular shaped latter, with all the inherent problems of spacing, he could have inspired beginners to obtain the skill needed for control of the broad-edged pen with an easily spaced, simply constructed, straight-sided alphabet. Luckily Gothic, in all its various forms, is far too attractive and decorative a script for it to be consigned to obscurity for any length of time. The American calligrapher Ward Dunham was the champion of 'modern Gothic', a strong fierce hand that dominates all around it, or harmonizes beautifully with a more rhapsodic script, such as a delicate Italic – and where the attribute of script illegibility is shown to be a falsehood.

The defining characteristic of Gothic is the extreme density that has also earned it the name 'Blackletter'. Writing this hand is like beginning a war between the paper and the writing medium, one which the paper must lose. While the upper-case letters in Gothic are more decorative, the lower-case letters are almost geometric; the white spaces inside the letters should be kept the same width as the black strokes and the ascenders and descenders shallow. The sides of Gothic letters are very straight with many lines parallel to one another. Several Gothic letters are produced using identical strokes.

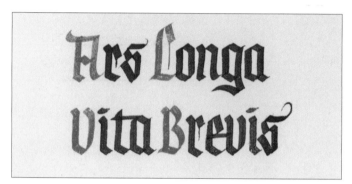

The basic rules

This is a modern version of a Gothic script and it is essential to bear in mind the importance of the writing's dominance over the area it covers, therefore a fairly flat pen angle of 30 degrees should be used. Medieval scribes had no 'official' majuscule letters for their Gothic scripts and so they borrowed heavily from the Roman Capitals and the Uncial forms. When these appeared too lightweight, they decorated them with diamonds, hairlines and small quill flicks to 'fill in' the white spaces. These letters seem over-elaborate for current use. However, the capitals chosen still maintain their link to the Roman and Uncial forms. If preferred, a simple weighted Roman capital is an effective alternative. Gothic majuscules should be used only sparingly. Keep them for the beginning of sentences and proper nouns – written in a block they become completely illegible.

LETTER HEIGHT
The x-height for this script is five nib widths. Height lines should be ruled before practising Gothic.

LETTER SLOPE
The Gothic hand is written without a slope. Gothic letters should remain upright and not be created with even the slightest of slants.

PEN ANGLES
This script is written with a pen angle of 30 degrees. The hairlines are drawn with the pen at an angle of 90 degrees or, for the letters 's' and 'x', with the left hand point of the nib.

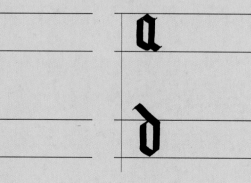

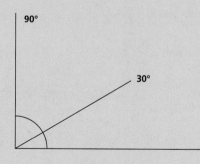

Practice exercise: **Gothic hand**

Practise the dominant strokes of this hand: with an x-height of five nib widths and a pen angle of 30 degrees, draw the pen across and downwards to the right for one nib width. Without lifting the pen, draw it straight down the page for three nib widths and finally downwards to the right again for one nib width. Repeat this exercise several times; there should be only the space of one nib width between the vertical strokes. Do this before practising the letters described below.

Group	Strokes (1st = red, 2nd = blue, 3rd = green)

Oval

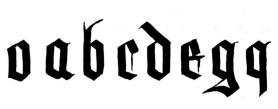

A constant angle of 30 degrees is maintained while writing these letters except for when drawing the hairlines. Vertical lines are created close together.

Both strokes are drawn with a pen angle of 30 degrees. The counter space needs to be the same width as the pen strokes.

The second stroke (the ascender) starts above the x-height and to the left of the first stroke.

Arched

Note that the last stroke of 'n' and 'm' has an upwards curved finish while the last stroke of 'h' curves below the line. The letter 'r' needs its base serif in order to limit the amount of white space around it.

The letter 'n' is made from two strokes that are are almost identical. The second stroke ends with a curved serif.

After the first stroke, draw a hairline at 90 degrees. The third stroke returns to 30 degrees finishing with a nib slide to the left.

Straight

It was only with the introduction of Gothic writing that 'i' and 'j' acquired their dots, to aid legibility. To create the fine hairline for the letter 'x', place a spot of ink within the downstroke before attempting to draw out the line.

Draw the first stroke at 30 degrees, and keep the same angle of pen when drawing the dot.

The first stroke starts as an ascender, finishing as a descender. The second stays above x-height, the crossbar hangs from x-height.

Ungrouped

While these letters relate well to the rest of the alphabet, their complex construction keeps them in this separate category. None are difficult, although at first sight the 's' seems a little daunting.

Make the descender, and repeat the style for the second stroke. The third stroke slides to the right and down to meet the second stroke.

At x-height move one nib width following the path, then straight down. Touch with second stroke, and hang third stroke from x-height.

Gothic hand

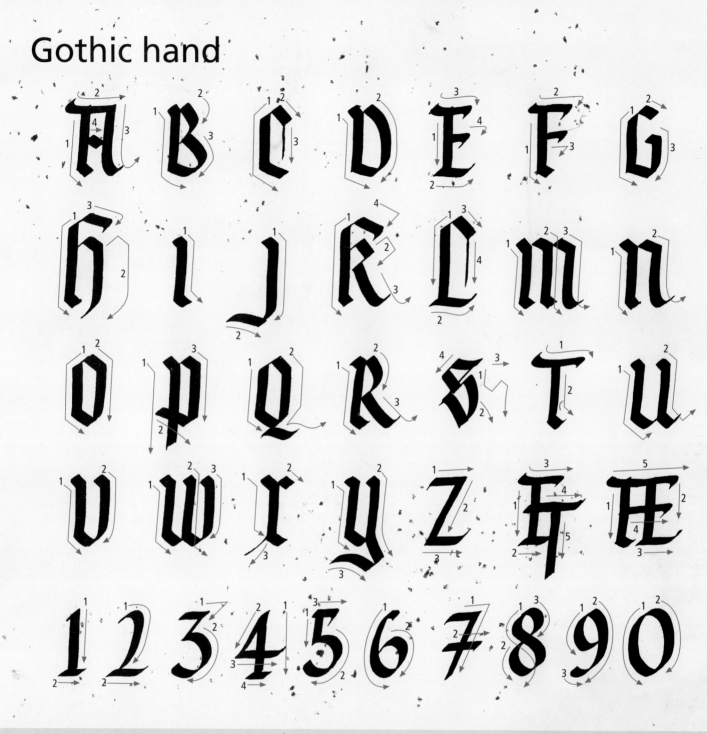

COMMON MISTAKES – CAPITALS

Having mastered the main structural elements of Gothic capital letters, they are not as difficult to recreate as they appear. Unlike, lower-case Gothic, capital letters are spacious and elegant. However, whole words should not be written in Gothic capitals as they are extremely hard to read. Common errors include groups of letters that do not appear consistent, and unbalanced letters.

Too curved – the stroke should be flatter.

Letter is too narrow and should be in proportion to other capitals.

Letter too short. It should be at least one nib width higher than the x-height of the lower case.

The letter is too wide and out of proportion.

Downstroke is curving too soon.

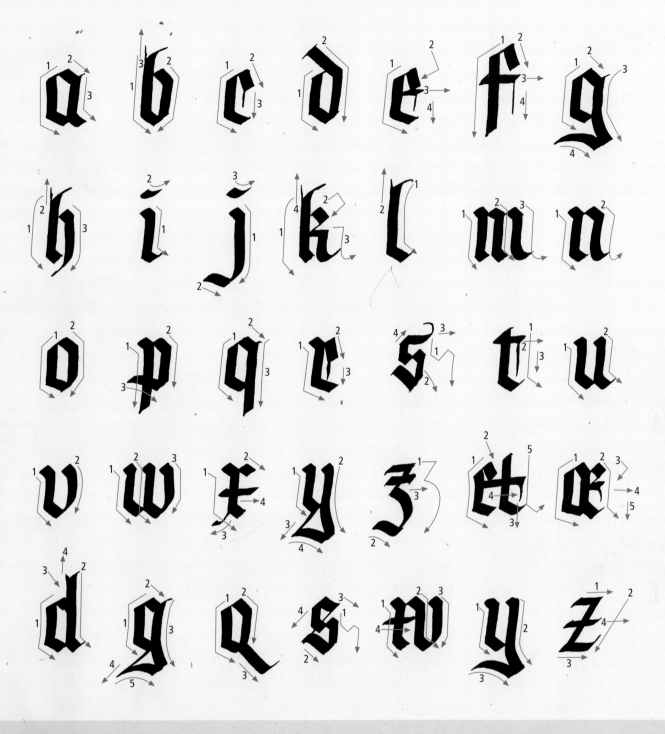

COMMON MISTAKES – LOWER CASE

With lower-case letters, spaces between words and lines should be as small as possible. A common mistake is the inclusion of a thin sideways stroke to make letters wider, or over-extension of ascenders and descenders. It may take time to adjust to such narrow letters without slim strokes and with few curves.

The crossbar is too high – it should hang from the x-height not sit upon it.

The ascender is too short.

Arches are uneven in width.

Letter is too wide, the counter space should be only the width of one nib.

The pen angle is too steep.

Versal hand

The finest historical forms of Versal letters are to be found in 9th and 10th century manuscripts, in particular the Benedictional of Aethelwold, written in the late 10th century. A Versal was a single capital, usually larger than the main text, which marked the beginning of a paragraph or verse. Versals that were written at the beginning of the text to create a heading or to emphasize the importance of the words are called 'display capitals'. Often, freely drawn Uncial letters were used in the same way.

Versal letters in their simplest form are pen-drawn letters based on the proportions of the Roman Imperial Capital. The resulting form, however, is greatly influenced by the use of the pen. Both historical and modern Versals are made up of compound strokes of the pen.

Versal letters should be elegant and lightweight in character and should appear to have been executed effortlessly. Do not make the verticals too thick; remember they are only three nib widths at their widest point. Give the stem an elegant 'waist' but use minimal curving on the down strokes. Keep all serifs fine, with the pen held at either horizontal (0 degrees) or vertical (90 degrees).

Versals can be used for headings or as single initial letters, and they have been traditionally used as the underlying form for decorated and illuminated letters. Versal are extremely adaptable, and can be modernized, used with or without serifs, stretched, compressed, weighted at the top for added elegance or expanded to give heavy weighty letters. When sloped they work well with Italic minuscules.

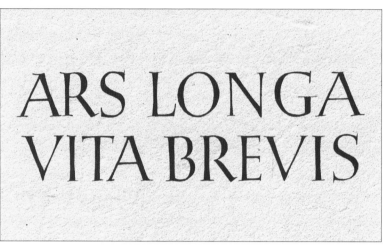

The basic rules

Each main or vertical stem is drawn with two outer strokes and is then filled or flooded with ink using the third stroke of the pen through the centre. The pen should be held so that it makes the widest line for horizontal, vertical and diagonal strokes and the thinnest lines for the serifs (the pen can be turned for the serifs). The letter is built up by drawing each vertical letter stem with the nib held horizontally (0 degrees). The crossbars and horizontal strokes of 'E', 'F' and 'L' use only one stroke with the pen held at 90 degrees to the line (with the pen nib at its fullest width). For the diagonal strokes, the curved strokes of 'O', 'C', 'G' and 'D' and 'Q' and other round strokes, as in 'R', 'P', 'S' and 'B', the pen nib is held at about 20 degrees to the writing line allowing the hand to move easily.

LETTER HEIGHT
Each letter is eight times the stem width. The stem is three nib widths at its widest point. The height of a letter is eight stem widths, which is therefore 8 x 3 = 24 nib-widths high.

LETTER SLOPE
Versals are written upright unless they are being used with Italic, in which case they may be sloped.

PEN ANGLES
Vertical strokes are written with the pen held horizontally to the line (0-degree angle). Horizontal strokes, i.e. crossbars are written with the pen nib held vertically to the line (90-degree angle), curved letters at 20 degrees. To enable you to draw the letter curves, the nib should be held at a slight angle (about 20 degrees).

Practice exercise: **Versal hand**

With the pen held at 0 degrees, draw a series of vertical downstrokes. Practise drawing two of these strokes close together, slightly curving in at the centre, and fill in the gap between them. Keeping the pen at 90 degrees, draw the crossbars or horizontal lines. Finally, hold the pen at a 20-degree angle, and practise drawing semicircular curves and filling them. Skeleton Versal letters are shown to demonstrate the groups of strokes which will be filled in solidly to make the final Versal letter.

Group	Strokes (1st = red, 2nd = blue, 3rd = green)

Straight

EFHIJTL

Hold the pen nib at 0 degrees (horizontal) and draw the downward stem with two outer strokes, slightly waisted, with a third stroke filling the middle with ink or paint (not shown here). Each letter stem should be three nib widths at its widest point.

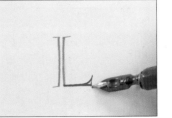

Draw the stem of the letter, waisting it halfway down. Hold the nib vertical to the line to draw a single stroke crossbar. Add serifs.

Draw the stem of the letter. With the nib held vertically (at 90 degrees) draw the crossbar on the top. Finish by drawing the serifs.

Diagonal

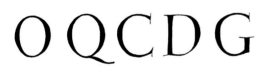
AMNV
WXZK

The vertical strokes are drawn in the same way as the letter stems. The thinner diagonal strokes should be drawn with the nib held at 0 degrees to create the line. The wide diagonals are formed by two strokes drawn with the nib at 20 degrees.

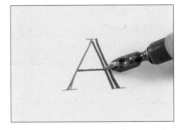

Draw the left and right diagonals with the nib at 0 and 20 degrees respectively. The crossbar is made with the nib held vertically.

Draw two strokes with the nib at 20 degrees for the left diagonal, and one stroke at 0 degrees for the right diagonal. Add serifs.

Round or circular

O QCDG

To enable you to draw the curves of these letters the pen nib should be held at about 20 degrees. This angle allows for easy arm and hand movement. The angle can be altered slightly to build up the curved areas.

Draw the inside oval shape of the letter first with the nib at 20 degrees. Add the two outer shapes second.

Draw the two inside oval strokes first and add the two outer round shapes at 20 degrees. Lastly add the tail using two strokes.

Combination

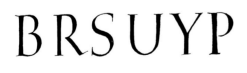
BRSUYP

These letters are written using a combination of two angles to produce the different shapes. The downward strokes are made with the pen nib at 0 degrees and the rounded shapes are created with the pen nib at 20 degrees.

Draw the stem of the letter with the nib at 0 degrees. Change the nib to approximately 20 degrees to add the round shape.

Draw the stem at 0 degrees, the rounded shape at 20 degrees and, finally, the diagonal foot also with the pen at 20 degrees.

Versal hand

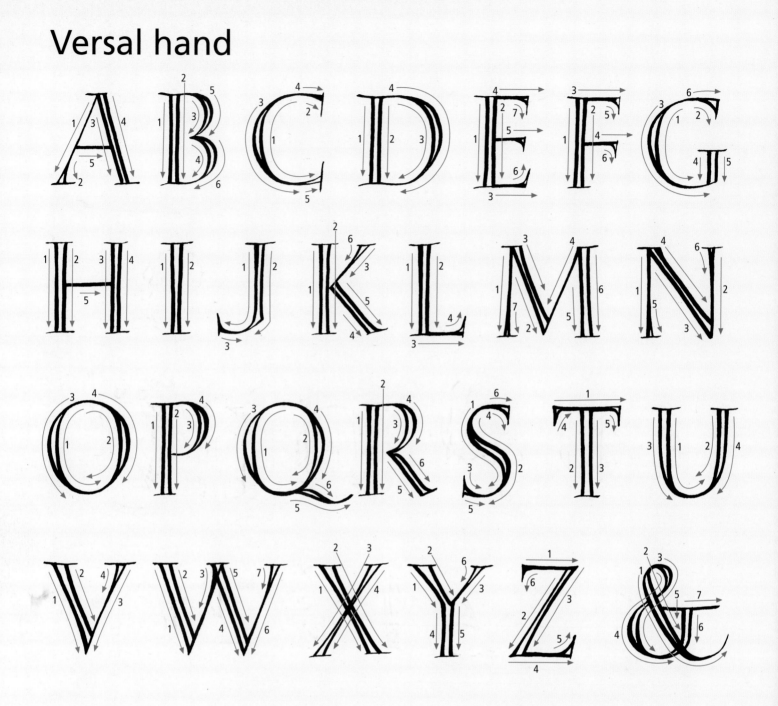

COMMON MISTAKES

The most common mistake made when using Versal hand is to give the letters excessive 'waists' either making the widest parts of the letter too wide, or the narrow parts too narrow. Waisting should be very elegant and subtle, and serifs on crossbars should not be too heavy.

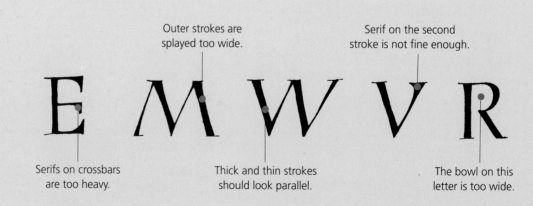

Outer strokes are splayed too wide.

Serif on the second stroke is not fine enough.

Serifs on crossbars are too heavy.

Thick and thin strokes should look parallel.

The bowl on this letter is too wide.

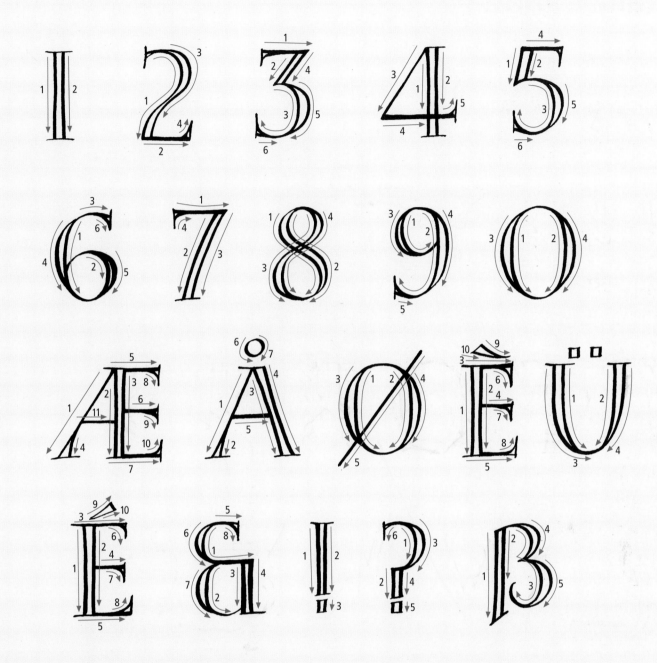

COMMON MISTAKES – NUMERALS AND SYMBOLS

Numbers should not appear too heavy or squat. As with the Versal letters, the lines and shapes should be elegant and rhythmic, and 'waisting' should not be too pronounced. Those numbers and figures that follow a circular shape should be slightly vertically elongated rather than completely round.

This stroke is too heavy.

Too wide and squashed.

Base stoke is too wide and heavy.

Letter has unevenly shaped lower curve.

Centre crossbar is too short: should be level with top bar.

Italic hand

The name 'Italic' reveals this script's country of origin. It developed in Italy during the early Renaissance period of the 15th century. While the arts flourished, calligraphy manifested itself in painted and illuminated books of the period. The Italic hand was adopted by Pope Nicholas V for the papal chancery in the 15th century, and became known as Cancellaresca Corsiva, or Chancery Cursive.

Today, Italic is beloved of modern scribes. It is a flowing script that is created swiftly and demands few lifts of the pen. Italic differs from many other hands, being oval-shaped with a forward slope. It is written using a pen angle of between 35 and 45 degrees, which should remain constant.

This hand is a form of calligraphy that closely relates to handwriting, as the letters are formed with a rhythmic up-and-down movement, occasioned by one stroke developing from where the last stroke ended; this contrasts with Roman Capitals, for example, where each stroke is separate and often starts back at the top of the letter. The Italic script is very adaptable to variations, owing to its branching construction, and is ideal for flourishing (see Flourished Italics). Regular practice is recommended in order to develop a consistency in slope and width, and it is important to master the basic formal version before progressing to more complex Italic forms. In typography, any letterform that slopes is called italic, whereas in calligraphy a letter is only Italic if it conforms to the branching arch that is the defining feature of the Italic hand.

The basic rules

This is a slightly sloping, oval-shaped letterform with springing arches. The arch formation is the most important feature, and it distinguishes Italic from many other hands. You may wish to practise some pen patterns so that you become used to working with a pen angle of 30 to 45 degrees and a slope of 5 to 12 degrees. Practise with a pencil first, to develop the up-and-down rhythm used in 'm's and 'n's, and check where the arch emerges from the stem – it should be halfway. Look closely at 'u' – this needs to be identical in arch formation to 'n', branching halfway from the stem. All the arch shapes of the letters should be asymmetrical, and not too rounded.

LETTER HEIGHT
Five nib widths are the standard x-height for these letters, with ascenders and descenders extending up to five more nib widths above and below, although four is acceptable.

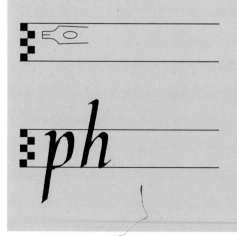

LETTER SLOPE
Between 5 and 12 degrees forward slope from the vertical is average for Italic, just ensure it is consistently the same throughout one piece of work.

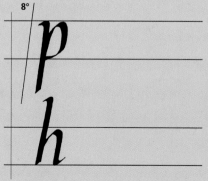

PEN ANGLES
Between 40 and 45 degrees is the recommended angle for Italic lower case. However, it should be 30 degrees for the capitals, as 45 degrees will provide no difference in thickness of horizontals against vertical strokes.

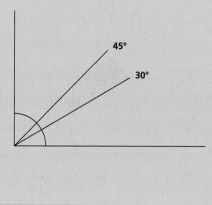

Practice exercise: **Italic hand**

If your pen resists the upward movement of the branching arches, lighten the pressure so that it does not dig into the paper – do not allow the pen to stop halfway. With 'n' and 'm' shapes, the pen moves from one stroke to the next without coming off the paper, and the arch emerges halfway up the stem. If your pen comes off, go back and try it again. When 'n' comes naturally, focus on the branching effect of 'u' and 'a' shapes which are the same format, upside down.

Group	Strokes (1st = red, 2nd = blue, 3rd = green)

Arched

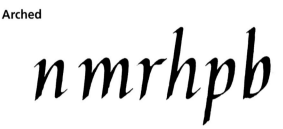

Practise with a pencil first if necessary, to make an 'n' shape without taking the tool off the paper. With 'p', where travelling all the way from a descender is too far, take the pen off the descender and start again on the baseline as if making an 'n'.

Start the ascender above the line, pause at baseline then move uphill, emerging halfway up the stem. Complete the downwards curve.

Make the first stem, pause at the baseline, rise and emerge halfway, make a tight corner down. Repeat stroke ending with an exit serif.

Base-arched

These arches mimic the first group, but are upside down. The adding of a 'lid' can be left to the end. If it helps to maintain a rhythm of up-and-down, keep going without releasing the pen until the end.

A tight stroke curves round and up to the topline. The lid is drawn next. The downstroke carries on where the upward curve finished.

As in 'a', but with an extended downstroke that curves at the bottom. Finish with a horizontal, or add a stroke from the left.

Diagonals

The angle in the top-left to bottom-right stroke needs to be adjusted to prevent it becoming thicker than any upright stroke. Use a steeper pen angle of about 50 degrees. The other diagonal must be thinner – try a 30-degree angle.

Steepen the pen angle to 50 degrees for the first stroke; flatten it to 30 degrees for the second. The descender should not bend.

Make the horizontal stroke then completely flatten the pen angle for a thick diagonal. Complete the horizontal at the usual angle.

Ungrouped

'O' is frequently the governing letter of a hand, but in Italic it takes second place to 'n' and 'a'. However, it is essential to understand the smooth oval shape of the 'o', so that it can be matched to 'e' and 'c'. 'S' should also fit into a secret 'o' shape.

Start with a half-moon beginning and ending at the thinnest point. The second curve blends into the bottom curve.

Start below the topline and flow left and right of two imaginary circles. Add end strokes with serifs that are straight rather than curved.

Italic hand

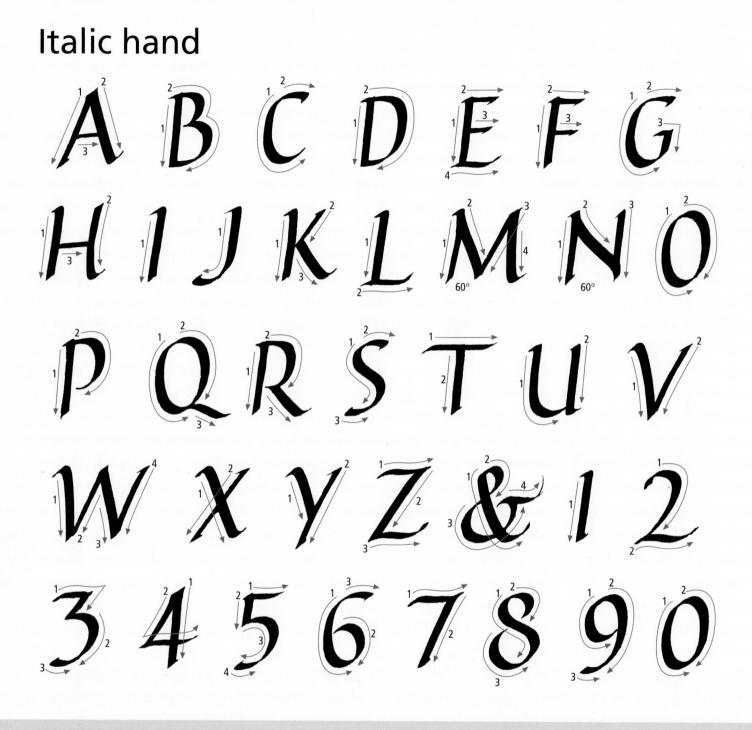

COMMON MISTAKES – CAPITALS

Italic letters are a compressed form of the Roman Capital but they should not be made either too wide or too narrow. Keep letters at a consistent forward slope and make firm joins by starting the next stroke inside the stem it joins.

Too narrow, with the top sloping forward too soon – uplift before curving round.

Uneven in widths, caused by the second stroke going too wide.

Three strokes all the same thickness – steepen pen angle to make the uprights thinner.

Sloping backwards instead of forwards.

Diagonal too thin – need to flatten the pen to thicken this stroke.

Top heavy; better to be bottom-heavy for visual stability.

a b c d e f f g
h i j k l m n o
p q r s t u v w
x y y z ß ! ? &
è ü é æ å ø

COMMON MISTAKES – LOWER CASE

Branching arches are a key part of this alphabet. They should not begin too high up the letter. The letters should be kept at a consistent forward slope (not more than 12 degrees from upright) throughout a piece of work. Do not make letters too rounded as they should be kept narrow.

Arch is not branching; should start from the baseline and emerge half way.

Not at the correct angle, and crossbar should sit higher.

Loop should be smaller and not pulled down which causes letter to fall backwards.

Lacks essential upward branching arch – pen has come off at the bottom instead of going to the top.

Ascender is a little short, making it look squat.

Uneven in shape, with corners.

Flourished Italic hand

The Italic hand was developed during the Italian Renaissance and was more elegant and rhythmically written than the Gothic hand of northern Europe at that time. Flourished Italic is a slightly more modern and exuberant version of formal Italic and one that is more adaptable for today's calligraphy. It is lightweight and elegant in its execution and has an energy that comes from being written with speed. The letters have a forward slope and springing arches. The basic letter shapes are that of Formal Italic but with fewer pen lifts. The proportions are the same: five nib widths for the body height of the minuscule letter and seven nib widths for the capitals. The actual stroke that forms the letter tends to be straight. The only strokes that curve into a flourish are the first and last strokes.

The Flourished Italic capitals, which are based on compressed sloped Roman Capitals, are also called swash capitals. The ascenders and descenders are the easiest to flourish and extend. The greater the decoration, the more space is required.

When executing more exuberant writing, extra consideration is needed for layout and design space. Be careful not to over-flourish the letters, as less is definitely better. Too many flourishes will make the words difficult to read. You may find it helps to decide on where to flourish by using a pencil.

The basic flourished letters shown on these pages are fairly restrained so that it is easy to see how they are constructed. As you gain more confidence and greater control over the pen, flourishing can become more adventurous, and innovative and exciting effects can be produced.

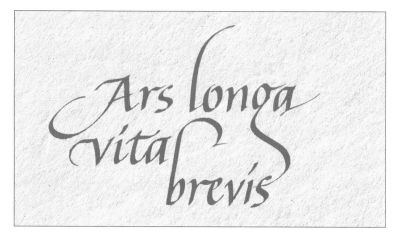

The basic rules

Attention needs to be given to the choice of paper. This should be easy to write on, with a surface that will not hinder the flow of the pen and ink. The pen nib should be smooth and easy to manipulate. For small writing the reservoir can be detached, giving the pen more flex. For the larger nib push the reservoir back from the edge allowing more of the nib to show. Load the pen before each flourish to ensure a good flow of ink. Ensure that the body height of the letter remains at five nib widths and continue to keep the Italic capitals at seven nib widths high or slightly less. The width of the letter forms are two-thirds body height to keep the proportions elegant. Modern Italic can sometimes be written in a more compressed and even pointed style to add interest to the writing.

LETTER HEIGHT
The x-height is five nib widths for the minuscules and seven nib widths for the capitals. The ascenders and descenders are normally three widths extra but can be more.

LETTER SLOPE
The letters are usually sloped between three and five degrees. They can slope 12 degrees or more but care will have to be taken over the angle of the pen nib to ensure that the letter weights are correct.

PEN ANGLES
The pen angles range between 30 and 45 degrees. There is some pen manipulation when flourishing to ensure easy movement on the paper. The average pen angle is about 40 degrees.

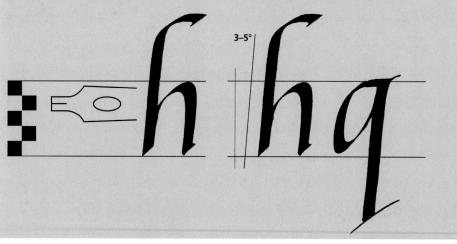

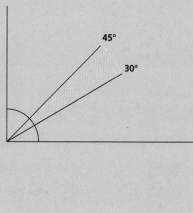

Practice exercise: **Flourished Italic hand**

Begin by writing in formal Italic. Lead into the chosen letters by extending the first serif before beginning the letter. Extend the exit stroke, for example with 'k' and 'z'. Try writing the ascenders taller and the descenders longer. Use a whole arm movement to create the letter, sweeping the pen off the paper at the end. Hold the pen lightly and write the shapes quite speedily. If you can do one or two letters well keep practising them to gain familiarity with the movements and confidence in what you are writing.

Group

Strokes (1st = red, 2nd = blue, 3rd = green)

Arched

The letter 'n' is the key letter in this alphabet. The asymmetrical arch that springs from about two-thirds up the stem is the shape of all of the arched letters in Italic. Practise this stroke until you are confident writing it.

This letter is written in two strokes starting from the serif at the top, going down and springing up, round and down, with a flourish.

The downward stroke sweeps round to the left. Spring the second stroke from two thirds up the stem and round at the bottom. Flourish.

Base-arched

With arched letters, a variety of flourishes can be produced. Use a pen angle of 40 degrees and employ the whole hand to create the flourish on the first stroke.

The 'u' follows the shape of the 'n' but in reverse. Start with the arch, then draw the stem, finishing with the flourish at the baseline.

Create the bowl of 'd' with a lid. Curve in from the top right to start the ascender, down to the baseline and flourish outwards.

Round

The round letters in this group begin with a downwards stroke. With 'e', the pen is moved downwards to create an oval shape with straight sides that curve when reaching the bottom.

Lead in with a long serif to do the top of the letter and create the bowl. Add the second stroke from the top right.

Create the descender. The crossbar of the 't' can be flourished a long way depending on the space available either side.

Diagonal

The nib may be flattened to 10 degrees in order to create the second diagonal in these letters. The flourishes can either be kept small or they can be extended to form quite elaborate designs.

The first stroke can be extended from the front serif, and the second can be drawn up into a sweeping flourished curve.

Pull down diagonally for the first stroke. Bring down the second stroke and flatten the pen angle. Add a third stroke to finish.

Flourished Italic hand

A B C D E F G

H I J K L M N

O P Q R S T

U V W X Y Z

1 2 3 4 5 6 7 8 9 0

COMMON MISTAKES – CAPITALS

Flourished Italic capital letters should use the same spacing as the Italic script. Large flourishes will demand a greater distance between lines. Do not allow the letters to become too cramped. It may be a good idea to pencil in the path of any extending ascenders and descenders.

This letter is too ornate.

Bowl too tight.

Shape is too narrow.

Flourish too tight and curly.

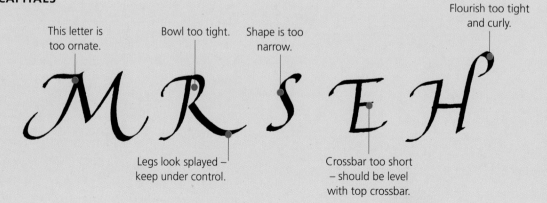

Legs look splayed – keep under control.

Crossbar too short – should be level with top crossbar.

a b c d e f g g

h i j k l m n v

p q r s t u v

w x y y z æ ! .

COMMON MISTAKES – LOWER CASE

The springing arches are the key to this alphabet. Do not start the arch too high on the stem because it will look like the round arch of Foundational hand. The arches in Flourished Italic spring from about two-thirds up the stem of the letter and are asymmetrical in shape.

The bowl is too round. Continue first stroke down, then lift stroke upwards to the top of the writing line.

The top part is too high.

The bottom stroke is too tightly curved, making it look contrived.

a h t y g r

The letter shape is too mannered or curved.

The tail is too narrow.

The second stroke is too short.

Rustic hand

The Rustic script, which was widely used in the Roman Empire, was originally thought to have been a development of Roman Square Capitals. The discovery of early documents, however, has proved that it in fact pre-dates this script.

'Rustic' is perhaps something of a misnomer as it brings with it the whiff of country air and all things rural and casual. The Romans did have a script that relates to today's idea of 'bad handwriting', which they would use to 'scribble' on a wax tablet or write a quick note to a friend. However, this has nothing in common with the Rustic hand, which requires considerable calligraphic skill in order to obtain the changes of pen angle that are required on the majority of letters.

Rustic letters are both elongated and refined, with particularly slim stems. They were probably written with a reed or brush – certainly very large brushes must have been used to write the graffiti that can still be seen on the walls of Pompeii and Herculaneum. The script's rhythm is lively due to its weighty diagonals and serif strokes.

Although second only to Roman Capitals in its position of importance within a document, the Rustic script seems to have been relatively unpopular with medieval scribes and most examples appear to be poorly written. In manuscripts, Rustic was often written in a continuous stream, without spaces. By the 15th century it had ceased to be used, and it was only during the 20th century that an interest in this singular script fuelled a mini Rustic revival.

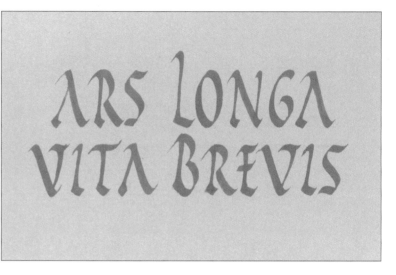

The basic rules

Rustic script is written at a relatively quick speed, and uses considerable variations in pen angle. In its original form the flexibility of the writing tool, probably a reed or a brush, would have allowed the change of pen angle and weight of stems to happen in one stroke. However, the modern metal nib is not as flexible and the effect is best achieved by using separate strokes. Many of the letterforms such as 'E' and 'T' are extremely narrow, and the difference in size between them and the wider letters such as 'M' and 'W' appears much greater than in classic Roman Capital letters. The interlinear space is minimal, probably no more than four nib widths.

LETTER HEIGHT
Seven nib widths for all letters except for 'B', 'F' and 'L'. These are written at eight nib widths.

LETTER SLOPE
This script should be written completely upright, without any slope.

PEN ANGLES
These vary from 80 degrees to 30 degrees. Right-handed calligraphers may find it easier to use a left-hand oblique nib.

Practice exercise: **Rustic hand**

It may take a little practice to retain the extremely steep pen angle used for this script. Before starting to write letters try making several hooked downstrokes to obtain the correct rhythm. The spacing between these strokes should be even and should reflect the normal letter spacing of this hand. Next, try holding the pen at 60 degrees and creating a series of oval shapes – drawing first the left side and then the right side. This will help to establish the hand movements needed for the rounded and oval parts of letters.

Group	Strokes (1st = red, 2nd = blue, 3rd = green)	

Diagonal

While at first glance these letters may not appear to have much in common, practice will underline their family characteristics. Note that the third stroke of 'A' appears in all of these letters.

Swing the first diagonal stroke's base right. From the first stroke pull left, then right to produce the foot. Add the final diagonal stroke.

The first stroke is similar to the last stroke of 'A'. The right-hand serif is formed slightly flat. The final stroke should leave a finishing lift visible.

Straight

The letter 'I' is the parent of this family. Note that the foot serif is elongated for the letters 'B', 'D', 'E' and 'L' and that the bowls of 'B', 'D', 'P' and 'R' continue the curve of the original serif in a downward movement.

Emphasize the hooked serif and make a well-defined swing to the right at the end of the stroke. The second stroke starts within the first.

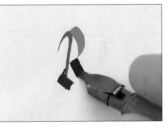

Construct a letter 'I', then with the pen within the curved serif, draw a bowl that meets the stem. Keep the angle to make the final stroke.

Oval

'O' is the parent of this family. Note how narrow it is. A pen angle of around 60 degrees is used to create these oval letters, and this angle needs to be maintained throughout the letter.

With a steep pen angle make the curved stroke. The second stroke reflects this shape and starts and finishes within the first stroke.

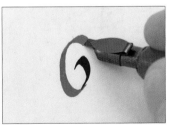

The first stroke is as for 'O'. The second starts just above the middle of the letter. For the top of the 'G' pull to the right, then lift slightly.

Ungrouped

Of these letters 'J' and 'U' have been designed to complement the rest of the alphabet as they did not exist in Roman times. Do ensure that the top and bottom strokes of 'S' are written with a concave curve, and that the letter appears upright.

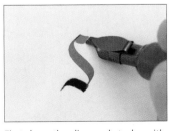

First draw the diagonal stroke with curved serifs to the right and left. The concave strokes at the head and tail should be kept short.

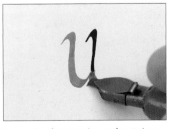

Begin the first stroke as for 'I' but finish with a curved bowl. The second and third strokes are the same as for a letter 'I'.

Rustic hand

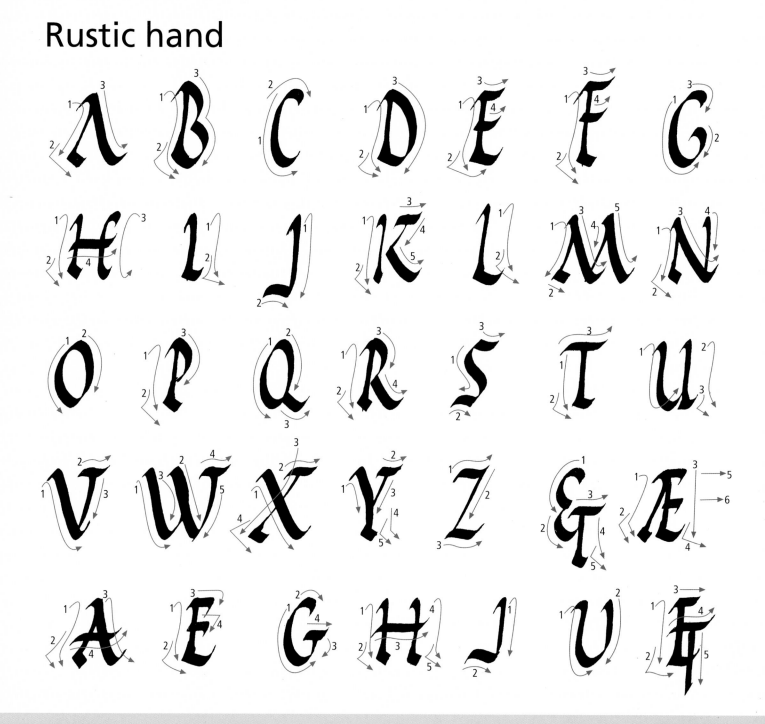

COMMON MISTAKES – CAPITALS

Some of the most common mistakes made with Rustic lettering occur when adding the serifs. Other mistakes include making the top and bottom strokes of 'S' concave. Keep the pen angle steep in order to produce thin vertical stems. Wide or round letters are always incorrect.

Lacking a hooked serif at the start.

Bowl of letter is too rounded.

Top and bottom strokes should not be concave curves.

Too conventional a shape. The hook serif on the second stroke is missing.

Letter should be one nib width higher.

This letter is too wide.

Incorrect foot serif – more akin to Gothic.

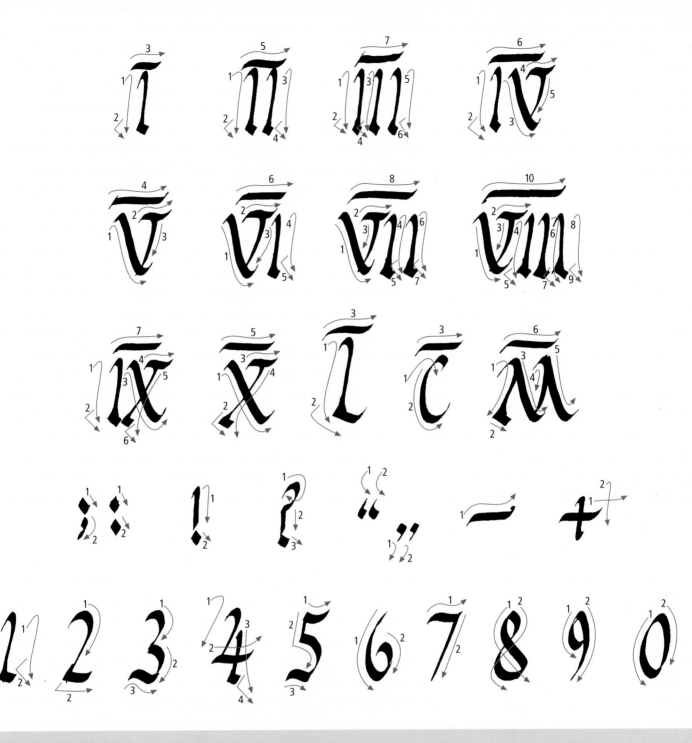

COMMON MISTAKES – NUMERALS AND SYMBOLS

Numbers and punctuation are just as important as letters in any finished piece of work and care should be taken so that unfamiliar shapes are not muddled giving a false impression. The overall effect should be one of harmony.

The 'L' should be one nib width higher to distinguish between the number 1 and 50.

The crossing of the strokes is too low. It should be at or a little above the optical middle.

The bowl is too large for this narrow script.

The overlarge hook serif makes it difficult to distinguish this number 1 from a number 2.

Too conventional a shape as the hooked serif on the first stroke has been omitted.

Top heavy. The bottom bowl should be the larger.

Carolingian hand

This beautiful hand is based on an extended 'o' shape, written at a constant angle of between 25 and 30 degrees. Carolingian evolved from Half-Uncial script in the court of King Charlemagne, who was king of the Franks from 768 to 814AD, Emperor of Rome and prime instigator of a widespread cultural revival. The script used here is based on the Moutier Grandval Bible written in St Martin's Abbey Scriptorium in Tours, France, in about 840AD.

Carolingian was used in the 9th and 10th centuries as a standard book hand. It has a gentle forward slope with tall, four nib width ascenders and descenders, and three nib widths for the main body of the letter. The cursive nature of the script makes it pleasant to execute and an elegant script to read. It also lends itself well to modern calligraphy. The space between the words is no more than the size of a lower-case 'o' but the space between lines is generous, at least three x-heights (or three body heights – equalling nine nib widths) to allow for tops and tails. The script should be written so that the upstrokes and overstrokes give the letters rhythm. Most letters are slightly wider than they are high. Avoid turning the pen to an

angle other than 25 or 30 degrees when creating curved strokes as this produces lines that are thick in the wrong places. Because the hand is so rounded it requires practice when forming words from letters. Particularly long letters may leave a large space that affects the rhythm of the piece.

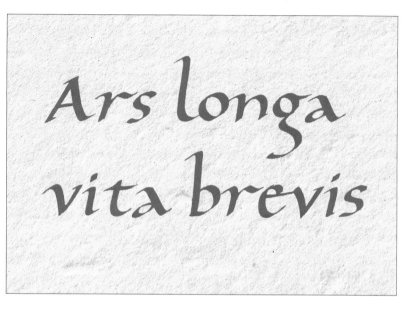

The basic rules

The alphabet is written with a shallow pen angle of between 25 and 30 degrees. The letters are very full and rounded. Both the round letters and the springing rounded arches of 'n', 'm', and 'h' are based on an extended 'o'

shape. The main body of the letter is three nib widths high with an ascender and descender height of four nib widths. The letters have a very elegant and flowing look when written in quantity. The capitals that accompany

this hand are based on Roman Capitals but are written at about five to six nib widths high. Edward Johnston chose the English Carolingian script used in the Ramsey Psalter as the model for his Foundational hand.

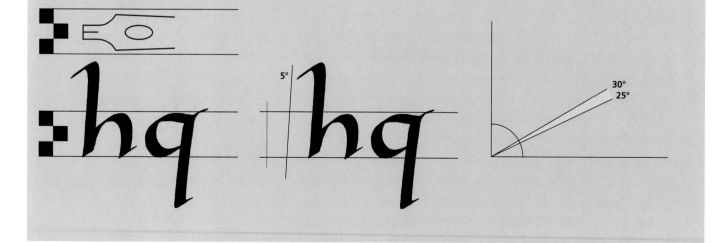

LETTER HEIGHT
The main body of the letter is three nib widths high with the ascenders and descenders at four nib widths.

LETTER SLOPE
This alphabet is written at moderate speed and the letters slope forward at about five degrees from the vertical.

PEN ANGLES
The pen angle is about 25 to 30 degrees and is constant throughout the letters, giving a uniform rhythm to the script.

Practice exercise: **Carolingian hand**

The very rounded 'o' shape used in this script is slightly wider than a circle, with few lifts within the letters. Some letters do not have serifs on some of the strokes, most notably at the bottom of the first stroke of 'h', 'k', 'n', 'm' and 'r'. On historical models the finishing stroke on these letters often are pulled in to the left instead of displaying the usual serif ending. The written words have verve and a cursive quality about them which adds to the rhythm.

Group	Stroke (1st = red, 2nd = blue, 3rd = green)

Round or circular

The letters in this group are wider than they are high giving a fat, rounded appearance. Two overlapping strokes can be used to create the curved shape of the 'e' and 'o', beginning with a left-hand stroke.

With the nib at 30 degrees write the left-hand curve first. Add the curved top and then add the crossbar with a flattened angle.

The first stroke keeps a nib angle of 30 degrees. Overlap the first stroke to make the second stroke, overlapping again at the bottom.

Arched

These letters contain the branching and springing round arches so typical of this hand. Attention should be given as to whether serifs are drawn at the top or bottom of the stroke.

The first stroke has a small serif only at the top. Add the springing arch from about two thirds of the way up the stem.

The first stroke has a serif only at the top. Spring the second stroke in an arch to go to the baseline finishing with a small serif.

Combination

Both straight and rounded features combine to create the shapes of the letters in this group. Take care to keep the distinction between the different elements.

Keep the first stroke rounded. The second falls below the line until the pen line thins. Come back on to the existing line with a flat stroke.

Make the first stroke and take it to the top of the letter space. Add the second stroke over the top of the first to go to the baseline.

Diagonal

Keep a constant angle of 30 degrees for these letters. You may wish to very slightly steepen the angle on the first stroke of 'v', 'w', 'x' and 'y', although this is not absolutely necessary.

Start with a serif then write the first three stokes as one. Add the last stroke separately.

Write the first stroke with a serif. Flatten the angle to 25 degrees for the second stroke.

Carolingian hand

A B C D E F G

H I J K L M N

O P Q R S T U

V W X Y & Z

1 2 3 4 5 6 7 8 9 0

COMMON MISTAKES – CAPITALS

Carolingian hand's capital letters bear a strong resemblance to those of Foundational, but take on a slight lean. By keeping the pen at a 25 to 30-degree angle the letters can be kept generous; they should not, however, be splayed. Be careful not to produce letters that are too heavy.

Letter is too narrow.

Centre diagonal is too curved.

Second stroke is too curved where it should be straight.

Letter is too narrow and not rounded enough.

The foot is too curly.

a b c d e f g h i
j k l m n o p
q r s t u v w x
y z & ß ě ŭ é !?

COMMON MISTAKES – LOWER CASE

Ensure that widths, arches, nib widths and ascender heights are correct to avoid producing letters that resemble a poor version of Foundational or Italic hand. Do not make the bowls of letters to tight, or descenders too curly.

Stroke is not sloped enough.

Bowl is too large and descender too narrow.

Letter is too narrow. Strokes are too curly and should have flatter arches.

Crossbar is too steep – letter tips backwards.

Arch springs from too high up.

Top is too high and should have no top serif.

Copperplate hand

Developed in the 16th century from the Italic script, Copperplate is a flowing cursive hand that is the closest relation to modern handwriting of all the calligraphic scripts.

This hand was named Copperplate because it was based upon the writing used by engravers. In the late 16th century a new printing method developed whereby letters and designs were engraved in reverse on sheets or plates of copper using a pointed metal burin (engraving tool). The sharp point of the burin created a delicate line quite unlike that made by a square-edged pen. This spidery line soon became the vogue in Europe. The flexible pointed nib used for Copperplate writing on paper is designed to copy the effect of the burin. The nib produces a thick stroke when pressure is applied, which contrasts with the thin, wispy upward strokes of the hand. Many of the nibs used for Copperplate writing today were in production in the 19th century or before.

By the 19th century Copperplate had become the established hand of clerks and was taught in elementary schools to enhance the future prospects of pupils interested in advancing their career, since handwriting played an important role in many businesses. As well as being the main business hand, Copperplate was also the vernacular writing style of the period. It was taught by means of printed copybooks, such as George Bickham's *Universal Penman*, printed in 1741, and people developed their own variation of the hand using these exemplars.

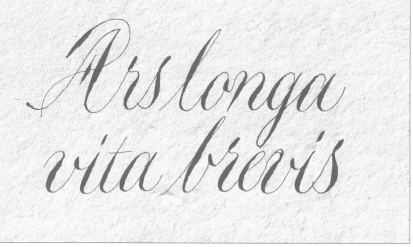

The basic rules

The characteristics of this hand are created by the basic form of an oval 'o' and a slope of 54 degrees. Unlike the edged pen, the pointed nib that is used for Copperplate writing can be used to write letters of any size and weight and so the x-height of the letters and the pen angle are not relevant. The pressure used to write Copperplate script is, however, very important in order to obtain the contrast of thick and thin strokes. Light pressure will reduce the flow of ink through the nib producing a delicate, thin stroke, whereas heavier pressure will open the nib slightly to let more ink through, thus producing a thicker line. Only apply pressure on the downstrokes.

LETTER HEIGHT
Letters written with a pointed nib cannot be measured in the same way as those written with a broad-edged nib. A variety of letter sizes and weights can be achieved by adjusting the body height (x-height) of the letters.

LETTER SLOPE
The slope of this hand is 54 degrees. Some faint guidelines will help to maintain this angle of writing.

PEN ANGLES
There is no pen angle for Copperplate but the nib is pointed in the direction of the letter slope.

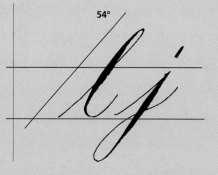

Practice exercise: **Copperplate hand**

Practise making the contrasting thick and thin strokes by increasing pressure on the nib on the downstrokes and applying only the lightest pressure on the upstrokes and ligatures. It helps to lay the paper flat and at an angle (anticlockwise) so that the slant of the letter slope is vertical to the body when writing. Try to leave even spaces between the thick strokes. Watch that the ascenders and descenders to not touch each other.

Group	Strokes (1st = red, 2nd = blue, 3rd = green)

Oval

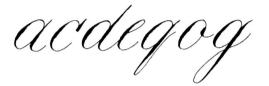

This group of letters follows the form of the elliptical or oval 'o'. Each letter is begun by drawing the elliptical shape in an anti-clockwise direction using increased pressure on the downward curve on the left side. The additional elements are then added.

The elliptical bowl is drawn using more pressure on the left curve. The letter is finished with a small loop, which is flooded in with ink.

The bowl is drawn as for the 'o'. Next, a downward stroke is made with increased pressure in the middle, finishing in an upward loop.

Looped and straight

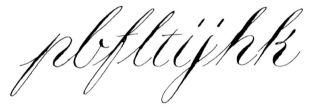

A light, curved, upward stroke is made as a ligature or lead-in stroke for letters in this group. Loops are made with light pressure on the pen, and this pressure is increased towards the centre of the downstroke to create a thicker line.

A curved upward stroke is drawn which makes a loop then the stem. The nib then continues up the stem and round to make an arch.

The first stroke is as for 'h'. Then, in a continuous movement, the nib is drawn down and round to form the bowl and leg of the letter.

Curved arches

Some arches are preceded by a straight downward stroke made with increased pressure. The arch springs from the base of the downstroke using a light upward movement leading into the curved arch and pressure is applied on the downward stroke.

A small lead-in ligature begins the upward movement and increased pen pressure is applied to the downward stroke.

A thin arched stroke is made and pressure is applied to the down-ward curve. The stroke is finished with a small loop flooded with ink.

Ungrouped

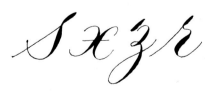

Although these letters do not fit into the other groups, the same basic rules are applied when writing them. Upwards strokes are made with light pressure and increased pressure is applied on the downstrokes. Aim to keep the letters looking balanced.

A ligature is made and a small elliptical shape is drawn and then flooded in with ink. The stroke continues with a small arch.

Pressure is applied to the centre of each curve and a thin crossbar is drawn through the centre using very light pressure.

Copperplate hand

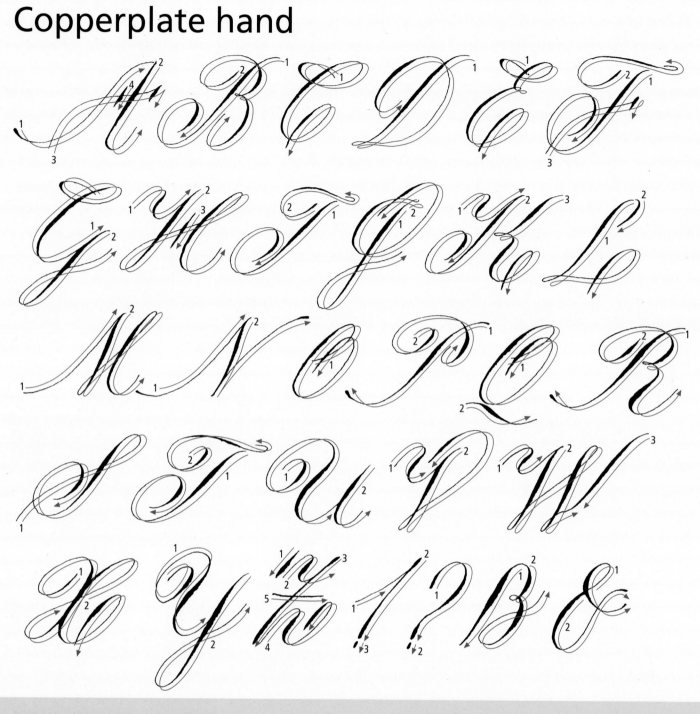

COMMON MISTAKES – CAPITALS

There is a tendency to make the downstroke too straight whereas this elegant line should begin with a curve and end with a curve. Letters are often written too wide with insufficient width of flourishing to the left of the downstroke.

Should be elliptical and the letter should not be drawn too wide.

The bowl should be kept slim.

The bowl should reach to just above midway before the loop of the downstroke.

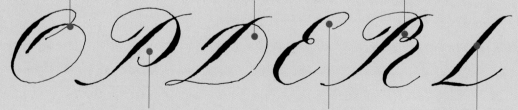

The bowl should not be too large and too long.

The top curve is smaller and shorter than the lower curve.

The downstroke should not be too straight.

a b c d e f g h i j

k l m n o p q r r

s t u v w x y z

1 2 3 4 5 6 7 8 9 0

COMMON MISTAKES – LOWER CASE

Letters are often constructed either too narrow or too wide. Aim for a visually even balance between letter-strokes and ligatures. If the change between thick and thin strokes is too sudden, the characteristic contrasts of the script are lost.

The two arches should be of equal width.

Do not apply pressure until after finishing the loop.

The small loop should be made above the line rather than extended too horizontally.

The thin upward ligature should be quite close to the downstroke and the bowl of the letter should not be too wide.

The bowl of the letter should be rounded and not too wide.

The base of the bowl should not be too wide but should follow the elliptical shape.

Batarde hand

The script known as Batarde is a cursive Gothic hand which is particularly decorative when well executed. Unlike its Gothic predecessors, Batarde is relatively informal and has a flowing style. When it is compared to Textura, the most widely recognized of the Gothic scripts, the real differences in rhythm and flow become very apparent. Although Batarde uses the pointed arches characteristic of Gothic scripts, its diagonal letters have a vigorous swing, which gives it much more movement than the very upright Textura. This hand appeared in French manuscripts between the 13th and 16th centuries.

Batarde is characterized by its short, bold body height and very long ascenders and descenders. This script has a characteristic 's' and 'f', which are made by twisting and drawing the nib to a greater angle for the long downstroke. A quill is the most suitable tool for this writing as the flexibility of the nib is ideal for such manipulation.

The elegant letters of Batarde hand were often illuminated, and many medieval manuscripts were complemented by lavish illustrations. This is particularly evident in the Books of Hours that were popular at the time. The upper case of the Batarde hand is very decorative with flamboyant hairlines and flourishes. Although they are certainly impressive, these letters are not always easily legible. They are therefore usually limited to the beginning of a paragraph or line, and are considered unsuitable for a long run of words.

The basic rules

The key features of the lower case of Batarde are the pointed oval 'o' form and the sharp, pointed arches. The letters have a short body height with long ascenders and descenders. The slope of the letters is usually between 0 and 3 degrees although the long 's' and 'f' have a more exaggerated slant of around 10 degrees. The pen angle is usually between 35 and 45 degrees, but because some pen manipulation is involved in writing this script, a constant pen angle is not kept throughout. The flourishes and exaggerated ascenders and descenders use a number of up-and-over strokes, which you may need to practise before you can execute them in a controlled manner. It is also important to use a pen which will move smoothly over the paper for these upward strokes.

LETTER HEIGHT
The lower case of this hand is written with an x-height of three nib widths, with ascenders and descenders written at three nib widths. The upper case letters are written with an x-height of six nib widths.

LETTER SLOPE
The slope of writing is usually between 0 and 3 degrees with the exception of letters 's' and 'f', which have an exaggerated slope of 10 degrees.

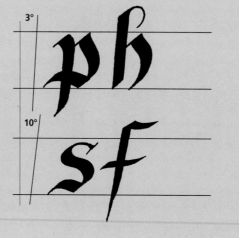

PEN ANGLES
The pen angle of this script is approximately 45 degrees although this does vary in some manuscripts between 35 and 45 degrees.

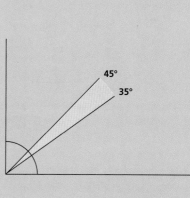

Practice exercise: **Batarde hand**

The strokes used in this hand are a little more difficult to create with a metal nib as it is not as flexible as a quill pen. This can be overcome as thin strokes may be created by dragging the ink along the corner of the nib for hairline strokes. Pressure is applied to the nib to create the fullness of the down stroke of 'f' and 's' and the nib is then twisted to form the long tapered point. Alternatively, the long stroke can be made with two pen strokes to create the width.

Group

Strokes (1st = red, 2nd = blue, 3rd = green, 4th = mauve)

Pointed oval

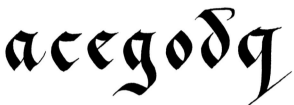

The letters in this group all begin in the same way, following the pointed elliptical curve of the 'o' form. The left-hand stroke is always drawn first.

Begin the letter 'o' with an anti-clockwise curve. Complete the letter with a clockwise curve, which links at the base.

Begin the first stroke as an 'o'. The ascender projects beyond this stroke to the left. A hairline serif extends at the top of this.

Straight

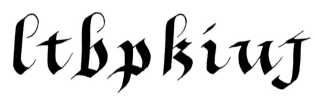

These letters all begin with a straight stroke although the lead-in serif can vary from letter to letter. When this serif is delicate and looped, it should be made using the corner of the nib.

A hairline serif is looped at the top of the first stroke with the nib corner. Three strokes make up the rest of the letter.

The 'i' is made by pulling diagonally from left to right then straight downwards and ending with a diagonal pull to the right and a dot.

Arched

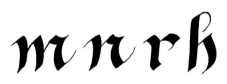

The letters in this group all have asymmetric, pointed arches, which relate to the shape of the 'o'. The arch is started within the stem, and is formed by a thin upstroke drawn using the edge of the nib, followed by a thick downstroke.

The first stroke of the letter 'r' is the same as for an 'i'. An upwards movement of the pen followed by a small curve forms the arch.

The first stroke is straight with a hairline serif. For the arch, the pen is drawn upwards, then continued downwards in one movement.

Ungrouped

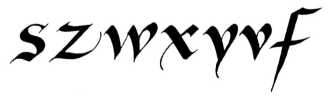

Make any hairline strokes using the edge of the pen. The letters 'x', 'w' and 'y' are looped on the right-hand side. This loop is formed using a single up-and-over stroke that begins halfway down the left-hand stroke and joins at its base.

Firm pressure creates the thick downstroke. The nib is then twisted to a steep angle for the thin tail. The crossbar is added last.

The first stroke is made with a diagonal movement. The second stroke is drawn up, over and down to the base of the first stroke.

Batarde hand

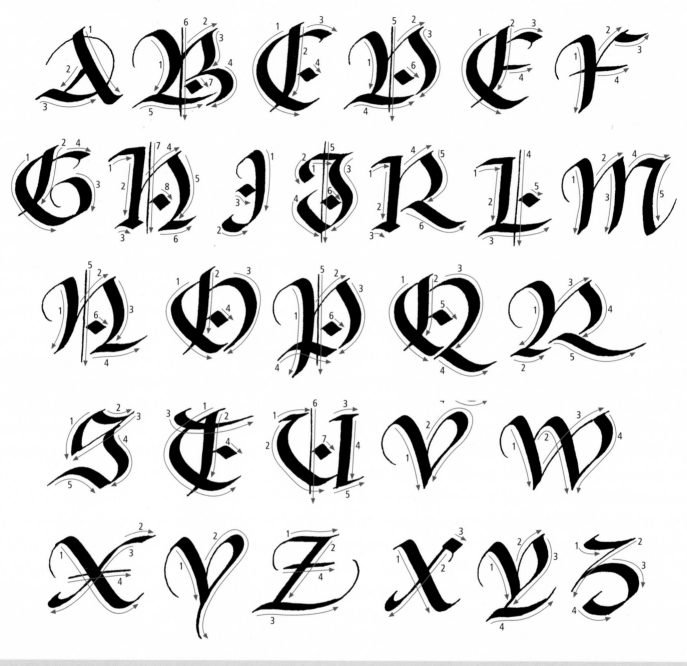

The capitals are bold and extravagant in width compared with the lower-case letters. One common mistake that is often made is that the letters are constructed too narrow – they should be very wide. Take care with ascenders, keep thick strokes wide and full, and check that the bowls are well rounded.

Clockwise curve should be wider to make a fuller stroke.

The diagonal stroke should cross just above midway.

Too close to first stroke with not enough thin lead-in stroke.

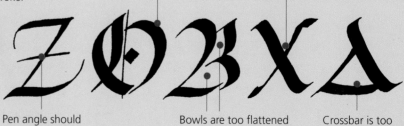

Pen angle should be horizontal.

Bowls are too flattened and too narrow.

Crossbar is too flattened creating a heavy appearance.

a b c d e f g h i

j k l m n o p q

r s t u v w x y

z ʒ ſ ʃ ß ? ?

1 2 3 4 5 6 7 8 9 0

COMMON MISTAKES – LOWER CASE

There are many pen lifts with changes of nib angle, and much use of manipulation in this script which often interrupts the flow and rhythm. Keep the hand flowing without making the ascenders droopy or over-emphasizing the end strokes.

The curve is too accentuated and needs to be flatter.

The back of the ascender is longer and straighter before it curves.

Legs are unevenly spaced and the last stroke too close.

Legs are unevenly balanced and should be less cramped.

Stroke of the curve is too high and should be flattened to open up the bowl.

The shape is slightly too wide and the sharpened points not accentuated sufficiently.

Neuland hand

Most modern scripts used by calligraphers today are influenced by the writing of people who lived many centuries ago. This, however, is not true for Neuland, or 'New World' as it actually translates into English. Designed in 1923 by Rudolph Koch (1874–1934) as a typeface, the originality of its form, a sans serif with attitude, inspired its early use as a decorative script. Rudolph Koch cut the original punches freehand, which accounts for the irregularity in some of the sizing and gives Neuland its special feel. At first the written version was true to the typeface with very round counters. It takes a minimum of four strokes to write an original Neuland 'O'. However, during the course of time, tastes change, and even a script whose history is as well documented as that of Neuland is not immune to this. The 'O' and its associated letters are often, nowadays, written more simply, with counters that are pointed rather than round. This gives quite a different feel to the script, and makes it considerably quicker to write – a modern Neuland 'O' can be written in two strokes rather than four. The preferred style is a matter of choice but, for the sake of harmony, only one style should be used in any single piece of work.

Rudolph Koch often wrote this hand with a rule drawn between the lines and colour added to selected spaces producing a really fresh and striking visual effect. The eye-catching nature of Neuland has not diminished over the years, and it has been used by countless designers and advertisers from the 1920s up to the present day.

The basic rules

Because this script is based on a typeface, it does not have the inherent rhythm that a script that has developed over time from its writing instrument and usage has. The pen angle changes from stroke to stroke, and even within a stroke, but a guideline is to make vertical and diagonal strokes with a flat pen angle of 0 degrees, and horizontal strokes with the pen held at 90 degrees. The aim is always to achieve the maximum weight of line whatever the direction of the stroke. This gives the hand its characteristic boldness.

The original Neuland, with its round internal counters, has been joined by a variation with pointed internal counters. Both versions are fully illustrated here, but should not be intermixed. Take care to make joins of strokes clean and sharp, particularly in 'B' and 'R'.

LETTER HEIGHT
This should be no higher than four and a half nib widths and no lower than four nib widths. A height of four nib widths gives a heavier letter.

LETTER SLOPE
This script should be written without a slope.

PEN ANGLES
The majority of strokes are made with a pen angle of 0 degrees or 90 degrees. When writing round letters the angle varies to ensure that the width of the line remains constant.

Practice exercise: **Neuland hand**

Without forming letters, practise both vertical and horizontal strokes, making sure that the hand is turned to the correct position. Also practise drawing diagonal and curved lines, aiming to always hold the pen at an angle that gives the widest line possible. This is a constructed hand and therefore it lacks the fluency of a drawn script. Two types of Neuland are shown on the following pages – modern and traditional. The practice exercise follows the modern hand.

Group

Strokes (1st = red, 2nd = blue, 3rd = green)

Round or circular

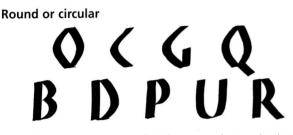

It may be necessary to manipulate the pen angle to maintain the even thickness of the curved strokes. The curve ends with the line still at the same width. Note that the second stroke of 'O' and 'Q' begins and ends within the first stroke.

Both strokes are drawn with a flat pen angle of 0 degrees. The curve should not be angular nor should it be too pronounced.

Both the first and second strokes are written with a flat pen angle of 0 degrees. The third stroke maintains a flat pen angle.

Straight

Probably the easiest group of letters. The pen angle should be 0 degrees for vertical strokes and 90 degrees for horizontal strokes. Where the strokes join, the second should start within the first. Note that the letter 'J' is the second stroke of the letter 'U'.

The second and third strokes start within the first. Keep the third stroke shorter than the second so that the letter is well balanced.

The first stroke is written with a flat pen angle of 0 degrees. The second stroke is written with a pen angle of 90 degrees.

Diagonal

A flat pen angle of 0 degrees must be maintained for all the diagonal strokes. Always start at the top of the letter and draw the pen downwards. The horizontal strokes are written with a pen angle of 90 degrees.

Make the diagonals using a flat pen angle. The third stroke starts within the first stroke and finishes well inside the second.

The second stroke starts at the top line a little bit in from where the bottom of the first stroke finishes. They cross at the optical middle.

Ungrouped

The 'S' does not fit in to any of the other groups. It is probably the most difficult of all the letters as it requires changes of direction and pen manipulation within the single stroke that forms the letter. Practice makes perfect!

Start at the top of the letter and smoothly draw the pen downwards, manipulating the angle to keep an even thickness of line.

Tip: Neuland makes a big impact when used for posters and other similar projects. When written in black it really stands out and also photocopies well. Black gouache is often a better writing medium than black ink as it is easier to wash off nibs.

Neuland hand

MODERN

A B C D E F G

H I J K L M N

O P Q R S T U

V W X Y Z & Æ

1 2 3 4 5 6 7 8 9 0

COMMON MISTAKES – MODERN

The characteristic of Neuland, whether the modern or the original version, is its extreme weight. While its letters are sans serif they have attitude and no weaknesses should be allowed to creep in.

Without the overlap of the first two strokes the letter appears weak.

An incorrect pen angle has been used.

The curves are too exaggerated and the second stroke has not begun and finished within the first stroke.

An incorrect pen angle has been used.

Letter is too wide and crosses too low.

The 'V' shape of the 'Y' is too short.

TRADITIONAL

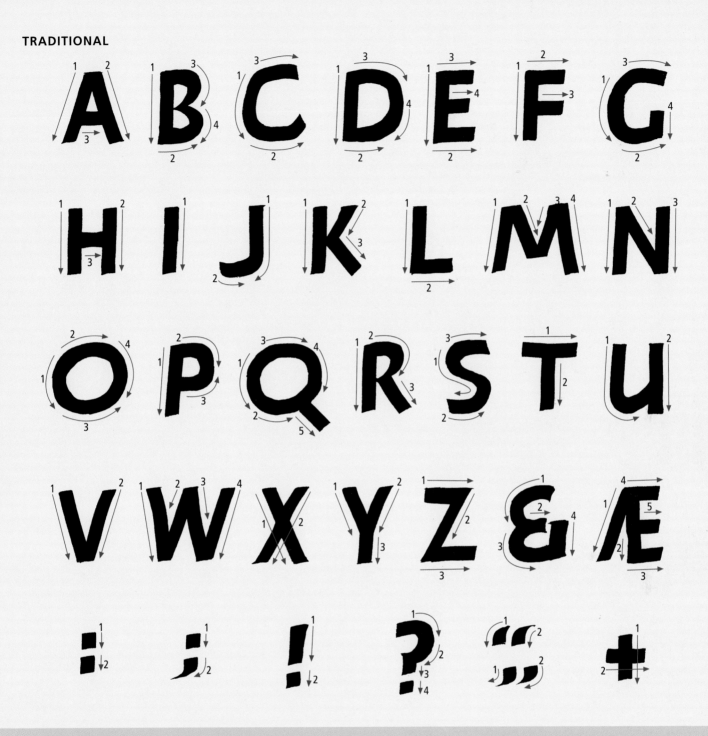

Take care to keep the letters even and balanced in appearance. Crossbars should be centrally positioned – neither too high nor too low. It is important to use the correct number of strokes to draw the circular shapes, otherwise the counters will look pointed.

Crossbar too high.

Letter too narrow.

Incorrect pen angle.

Pen angle not maintained on the curved stroke.

Crossbar too low.

Downstroke not in the middle of the crossbar.

Downstroke too high.

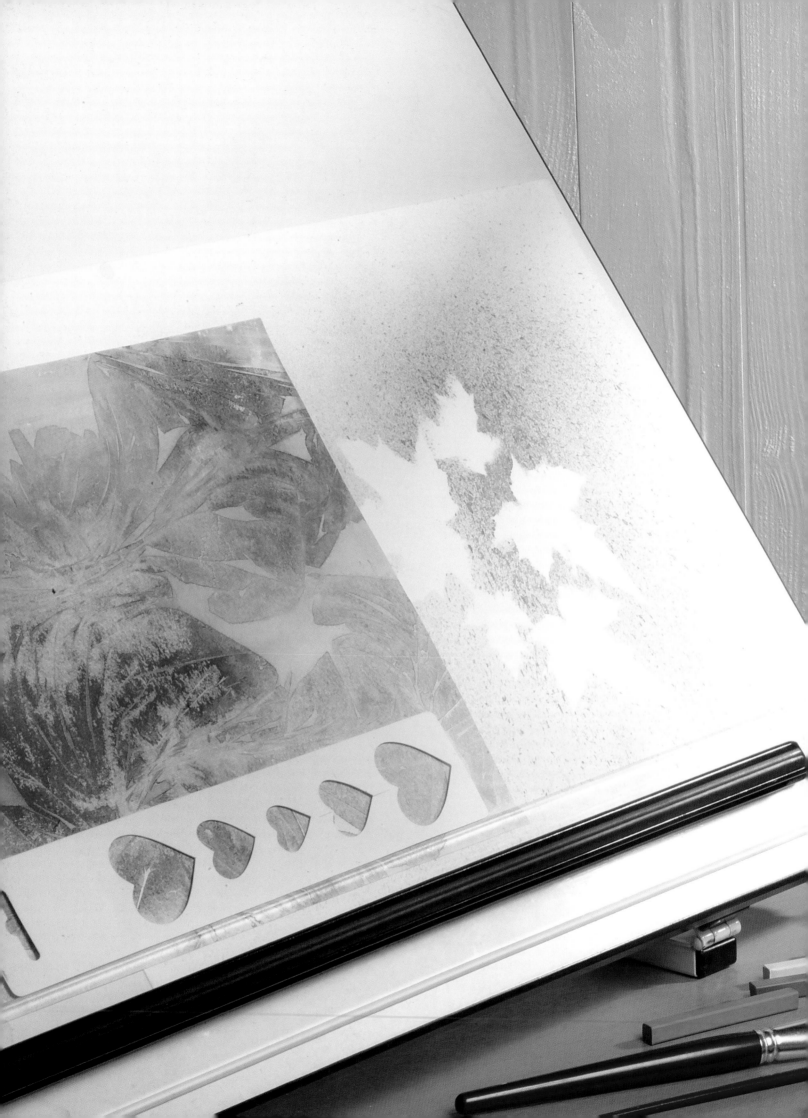

Calligraphic Techniques

There are numerous techniques, both traditional and modern, that can be combined with calligraphic lettering to create wonderful visual effects. This part of the book guides you through a number of these methods of decoration and embellishment, from the elegant simplicity of embossing to the more complicated but richly satisfying technique of gilding, and shows how they can be put into practice. At the end of this section an introduction to digital calligraphy demonstrates the exciting possibilities presented by this new art form, and outlines all you need to create calligraphic art on your home computer.

Flourished Italic and Italic swash capitals

Flourishes are extensions applied to the beginning and ending of letters. The variations produced by flourishing Italic letters are fun to do and the possibilities are endless. Practising will give you confidence in handling the pen. Some letters are easier to flourish than others, and there are some letters that cannot be flourished. Swash or flourished Italic capitals have simple extensions to the letter. A swash should be a simple flourish that is not too ornate, so as not to alter the character of the whole piece.

Practising letters

The letters are written and spaced as for formal Italic hand with the same x-height of 5 nib widths. The interlinear space will need to be greater to accommodate the flowing upward and downward flourishes. Care should be taken to keep a good basic Italic letterform throughout. The flowing movement of the letter extensions should not appear to be too constricted or too tight as flourished letters do not look good if they are too cramped. When deciding on the route of the extensions on the ascenders and descenders, a finely drawn pencil line is often helpful. Use a dip pen and keep it well loaded with ink as this helps the flow. Try writing the letters using some different sized nibs and a range of nib widths. Experiment with different letters of the alphabet to discover which flourishes work best.

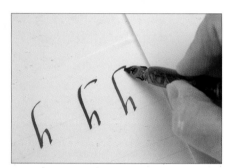

1 Rule writing lines as for formal Italic but make the interlinear space much larger to allow more space for the flourished ascenders and descenders. Begin flourishing by making the ascenders a little taller than usual. Try a simple lead-in stroke from the right of the letter 'h', completing it as normal. Go back to the top of the ascender and add the second stroke.

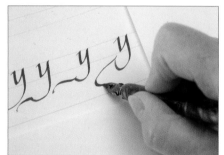

2 Try flourishing the letter 'y'. Remember to keep the underlying letterform. If the flourishes seem awkward to do then it is best not to pursue them. Practise the shapes that flow easily from the pen.

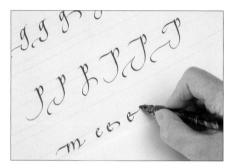

3 Try some different flourishes – be adventurous. Sometimes it is useful to extend the letter along the line (as in the case of 'm' and 'n'). Try elongating the central bar of 'e'. By trial and error you will discover which flourishes are the most successful.

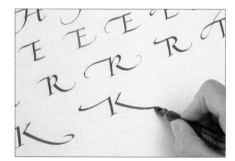

4 Flourished Italic capitals or swash capitals are also exciting to do and look very smart as a single letter to introduce a line of lower-case Italic writing. Practise adding some simple extensions first.

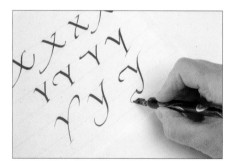

5 Try to relax when writing these shapes. The pen angle can change as you are working: moving from 40 degrees through to 5 degrees to enable you to manoeuvre the pen in a fluid way. Here the pen has been turned on its tip. It can be tilted on its side to add fine detail. This pen manipulation is quite acceptable.

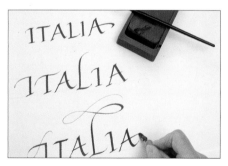

6 Practise three variations of Italic capitals with flourishes added. Note that not every letter is flourished. Less is better and has more impact.

Planning flourished letters

When flourishing letters, the action of the hand holding the pen should come from an arm movement rather than just the fingers or the hand. To practise these arm movements take a large sheet of practice paper and make some expansive, gestural movements with a loaded pen. This exercise will help you to create sweeping flourishes.

In a line of writing it is best to plan the letters that can be flourished. Resist the temptation to flourish every ascender and descender as this will look crowded and over ornate, making the writing unpleasant to read. On a short line of text, you should only flourish the first and last letter. Flourished capitals allow room for lots of creativity and can look very striking, but do not be tempted to use them for whole pieces of text – too many will not work well together as they make the text appear overly busy. Flourishes should always have a specific purpose – as decoration, to balance a design, or to emphasize the flow of the line. They should be lively but applied cautiously.

Practice exercise: **Name tags and place labels**

Show off flourished Italics and swash capitals by writing the names of friends and family for an event or party.

Materials
- *Layout or practice paper*
- *Black ink or gouache*
- *Good quality paper or thin card (stock), in a variety of colours*
- *Gouache paint in white*
- *Dip pens*
- *Scissors or craft (utility) knife*
- *Hole punch*
- *Ribbon*

> **Tip:** Have fun writing in colour or adorn your place cards with flourished pen patterns.

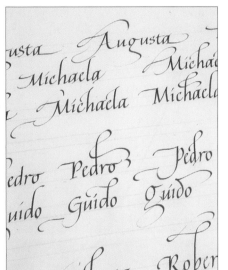

1 Name tags are a wonderful way to enjoy flourished Italic. Practise writing the names of people that you wish to invite on layout paper. Do a swash capital first followed by flourished Italic minuscules.

2 Make the gift tags by writing the names on coloured paper or thin card, then cut to size. Embellish decoratively and punch a hole to thread a ribbon, if required.

Practice exercise: **Quotation or poem**

Try writing a favourite quotation or poem and plan where the flourishes and swash letters should fall.

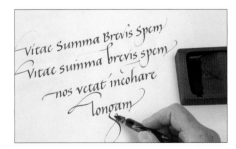

1 Practise writing the small quotation or poem and carefully plan the route of the flourishes to enhance and complement the layout of the design.

Materials
- *Layout or practice paper*
- *Black ink*
- *Dip pen*
- *Good quality paper*
- *Gouache paint in various colours*

2 Transfer to good quality paper. Decorate the project with colour, such as red and gold.

Pen patterns

Trying out different pen patterns is an excellent way to establish what your pen can do. These patterns help develop the skills that are required for calligraphy, as well as being an end in themselves. There are many decorative devices that can be copied and then developed as you build up a repertoire. The repetitive nature of pen patterns is also important because it enables you to build up a rhythm in writing.

Felt-tipped pens are ideal to use for pen patterns as they move freely across the paper without resistance. Choose two sizes of pen, in two colours, or the kind with a nib at each end in two sizes. This gives much more opportunity for variety in pattern-making at little cost. Once you are confident in using the felt-tipped pens, try creating the patterns using different sizes of broad-edged brushes.

Practising strokes

Many of the strokes that can be practised are parts of letterform strokes. Pen angles have to be consistent, or the pattern will be uneven, and this is a good discipline to learn. Notice any change in angle, and train your hand-eye coordination to maintain that angle. Measuring and ruling lines to accommodate the pattern is good practice for preparing lines for writing.

> **Tip:** When using patterns try to achieve complete harmony throughout your work. Pattens should be planned before a piece of calligraphy is begun and not simply added in on a whim. By using a square grid at 45 degrees to the horizontal, you can create the diamond which forms the basis of the zig-zag pattern.

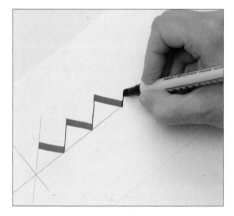

1 Practise holding the pen at a constant 45-degree angle. Control the pen by making equal-sized zig-zags. Practise making very thick and very thin lines in the zig-zags.

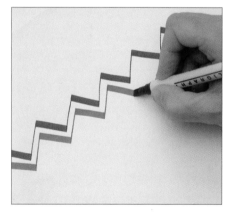

2 Put another row next to the first in a different colour to make parallel zig-zag marks. This will help develop coordination.

3 Make smaller, more concise marks just by making squares; make their edges touch – this takes more care.

4 Do another zig-zag, then add squares using the other colour.

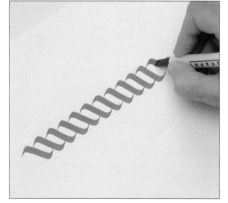

5 Curves are next; but do not be deceived, this is a small curve at each end of a straight stroke, which is repeated to build up the design.

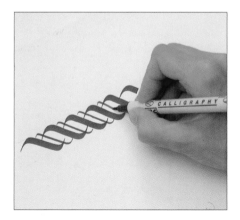

6 The appearance of the 'rope' created can be varied by opening up the white spaces between the curves and adding a narrower side stroke.

Practice exercise: **Building up pen patterns**

Continue to practise with more complex pen patterns created by using two colours of felt-tipped pen, each in large and small sizes, such as 5mm (1/4in) and 2mm (5/64in). Alternatively, use two sizes of broad-edged pen and two colours of ink. When you have perfected drawing the patterns in pen, try using brushes. Alter the pressure on the brush to change the thickness of the line.

Materials
• *Plain white paper*
• *Pens in two sizes*
• *Inks in two colours*

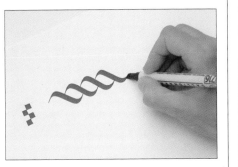

1 In one colour, make wide curves, paying attention to keeping the white spaces inside an even distance apart. Use a constant 45-degree pen angle.

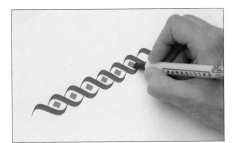

2 In another colour, add squares inside the curves, maintaining the 45-degree pen angle.

3 In one of the two colours already used, build up the pattern with a thinner pen on the outside.

4 Complete the decoration with small squares using the narrower pen in the other colour.

5 The finished design: repeated strokes develop a rhythm that makes a lively pattern. The two sizes add visual interest.

6 This would make an attractive border to a piece of work, or it could be given a frame and mounted by itself.

Other patterns

These decorative patterns will help you to practise different pen strokes.

Curves ▲
It can be helpful to turn the page the other way up for the second row so that the marks are being repeated in the same way.

Circles and diamonds ▲
If all the circles are made first, judging the gap for the diamonds will be difficult, so make the diamonds as you progress.

Build up 'L' shapes ▲
Make all the 'L's, then go back and make inverted 'L's in another colour. Add the diamonds last.

Squares and circles ▲
Alternate colours create added visual interest in this pattern.

Ruling pen

The ruling pen is a tool made up of a pen holder with two stainless-steel blades attached at the writing end. One of the pen's blades is straight and flat and the other bows slightly outwards. The tips of the pen almost meet and the space between them forms the reservoir for the ink or paint. The pen is loaded with ink or paint using a brush or the dipper that is supplied with bottles of ink. The thumbscrew on its bowed blade alters the distance between the tips and finely adjusts the amount of ink that flows, thereby changing the width of the line. The further apart the tips, the thicker the line made by the pen.

The original purpose of the ruling pen was for ruling accurate lines of uniform thickness. Technical drawing has now been overtaken by the use of technical pens, and in more recent years, by computer technology, which is able to produce ruled lines much more quickly. However, calligraphers have adopted the ruling pen as an artistic tool, and have found new ways to make marks, both conventional and more experimental. The attraction of this pen in calligraphy is its freedom of movement in any direction, unimpeded by a broad edge, which means it flows freely across the paper. Although the ruling pen is still frequently used for creating straight lines, it also presents possibilities for making calligraphy exciting for those who prefer expressive, gestural writing.

Practising ruling lines and making marks

Drawing neat straight lines is one way of using the ruling pen, but there is so much more that it can be used for. It is also an ideal tool for creating free, fine strokes for either writing or drawing, and if it is held in a less conventional way, flattened over the paper, with its open side pressed towards the paper, more ink will escape, making a thicker mark. When used in this way the ruling pen produces a heavy line rather like a brush. Once this technique has been mastered, the pen can be manipulated and bold marks of various thicknesses can be developed.

1 To rule lines conventionally, place the rule with its bevelled edge up, to prevent ink seepage. Dip the pen in ink and rule a straight line. Adjust the thickness with the screw thread.

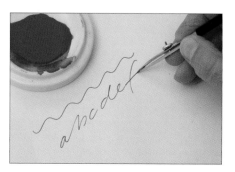

2 Without the ruler, use the ruling pen as an adaptable tool for sketching, scribbling, or writing a quick, flowing line.

3 Held on its side, well charged with ink and with the open edge against the paper, the ruling pen will discharge its ink very dramatically.

4 Make a more controlled mark from thick to thin, by changing the hold on the pen as you go down, moving from side to point.

5 Dramatic upward strokes are also fun to try for lively ascenders.

Tip: A ruling pen attachment is often included in a compass set. The attachment can be inserted into the compass instead of a pencil, and can be used to draw circular lines, either as guidelines for writing or as decoration.

6 Combining a thick stroke with a thin one takes a little more practice. Use a flick of the wrist as you change from holding the pen flat to riding back up to its point; thick stroke down, thin stroke up.

Practice exercise: **Core letters (a, b, c)**

Practise the first letters of the alphabet using contrasting thick and thin strokes.

Materials
- *Technical ruling pen*
- *Plain white paper*
- *Free-flowing ink or paint*

1 Write the core letter shapes in monoline first, holding the pen like a pencil and moving down, up, down to create this Italic form of 'a'.

> **Tip:** Do not unscrew the ruling pen very much. Start with the points just touching, then loosen a hair's breadth – if the gap is too wide it will not allow for surface tension to hold the ink in place and it will not flow properly.

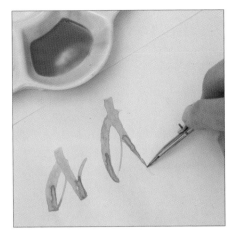

2 Repeat the structure of the letter, but this time manipulate the pen to create a thick downwards stroke and a thin upwards stroke.

3 Follow the 'thick down, thin up' process for 'a, b, c' and keep writing these three letters until a successful set has been created.

4 Make a thin-lined flourish to complete the design – it may help to complete this flourish by turning the work upside down.

Practice exercise: **Core letters (x, y, z)**

Just three letters create an attractive design in their own right. Placing any three letters together needs practice to avoid forming unsightly holes.

Materials
- *Technical ruling pen*
- *Plain white paper*
- *Free-flowing ink or paint*

> **Tip:** Always make sure both tips of the ruling pen are on the paper, otherwise the ink will not flow.

1 Write 'X, Y, Z' using all diagonals. Hold the pen flat to create the thick lines usually made by an edged pen.

2 Try another version of the same letters, combining diagonals with curves and a bold flourish.

Brush lettering

The broad-edged brush is an underused calligraphic tool. The benefit of using a brush is that it allows writing to be carried out on surfaces that would be difficult for a pen. Brushes are also particularly useful for large-scale writing as they come in much larger sizes than pens. Beginners sometimes find the most difficult part of using the brush is controlling the hairs, as there is no definite pressure to be felt as when putting pen to paper. The secret is not to hold the brush in the same way as a pen. Instead, hold it perpendicular to the paper – this will feel unnatural at first. Position your fingers with the thumb one side and the first two fingers on the other; test if you can twist the brush with those fingers. Use the rest of your hand to steady the brush by resting on the paper. Slide your hand around to make the letterform – do not try to do it all using the fingers.

5 Check your fingers are either side of the handle and that you can twist the brush by moving your thumb, not your wrist. Try twisting a quarter turn.

> **Tip:** Even if you make a mistake, do not stop work on a piece as it is good practice and helps you get used to the brush. With time, it will become easier to know the best brush to use in order to achieve the required effect.

Practising with the brush

The brush techniques shown here will help control lettering with the paint.

1 Practise preserving the chisel edge of the brush, by filling it with paint then wiping most of it off against the flat edge.

3 Keeping the brush overcharged with paint will result in an unattractive blobby mark.

6 Twisting gives subtlety to strokes. Here the brush starts with its edge at 45 degrees to the writing line, then is smoothly twisted to 90 degrees.

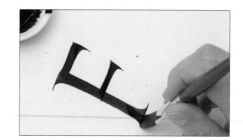

2 Get into the habit of checking closely that sufficient paint has been wiped off the brush to create a sharp chisel edge.

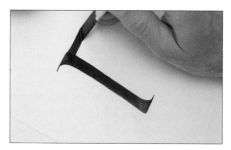

4 For best results, hold the brush perpendicular to the paper, not like a normal pen; this way you will be able to make fine lines as well as broad ones.

7 Blend adjoining strokes by starting the second stroke within the first. This is important with large letters, as thin joins weaken the structure.

8 The final serif on this 'F' starts entirely within the upright stroke and twists clockwise as it emerges.

Practical exercise: **Making an Uncial 'E'**

This exercise uses the brush and two colours of paint to make an Uncial 'E'. Uncials are upper case letters and very rounded. Keep the brush at a flat angle or the letters will become too narrow.

Materials
- *Gouache paints e.g. ultramarine and magenta*
- *Paper with slightly rough surface*
- *Paint palette or saucers*
- *Water pot*
- *Broad-edged brush*
- *Handmade and Ingres papers*
- *Kitchen paper*

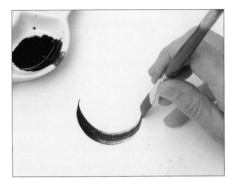

1 In the blue gouache, make a smooth half-moon curve by holding the brush perpendicular to the paper and moving your arm round in a sweeping movement.

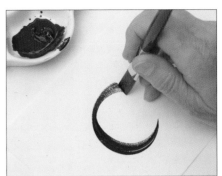

2 Without cleaning the brush, replenish with magenta paint at the same consistency; check you have wiped to a chisel edge. Start this stroke inside the first, and manipulate the serif by twisting.

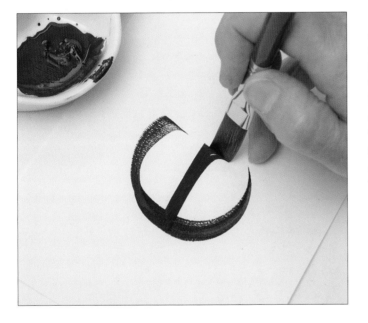

3 Replenish with more magenta (remember to wipe it sharp), hold the brush at 45 degrees to the writing line, pull a straight stroke and finish with a twist for the serif.

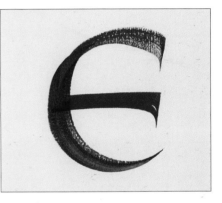

4 Using a large brush on paper with a 'tooth' can give a pleasing granular effect in places, adding texture. Here the colour changes highlight the structure of the letter, making it an object of visual interest.

Special surfaces

One big advantage of the brush is its ability to write on special surfaces such as quite rough-surfaced paper, which would be unsuitable for writing on with a metal pen. Experiment with any forms you can find.

Tip: Brush lettering is suitable for a huge range of designs and can be particularly effective when used as a headline. By placing a piece of paper underneath your working hand, you can help ensure the paper remains clean.

Handmade Indian petal paper ▲
This rough-textured paper has fibres and petals embedded in it which give the paint a slightly granular effect.

Ingres pastel paper ▲
This paper is lightly textured which creates plenty of 'drag', enabling controlled brush work.

Cutting balsa, reed and quill pens

Early writers used natural materials such as reeds and feathers for nibs. These materials have been used successfully for thousands of years as alphabets developed requiring a fine balance of thick and thin strokes. The modern calligrapher has access to an enormous range of modern equipment. However, elaborate effects may call for the use of more adventurous tools on traditional papers and surfaces such as vellum. It is well worth trying to create tools using traditional materials, and they are inexpensive to make and easy to replace.

Making a balsa pen

Balsa wood pens are enjoyable to use. They are quick and easy to make and many can be made from one sheet of balsa wood. Try a variety of sizes by varying the width of the pen. Balsa wood is a very lightweight wood and is often used in model-making because it is easy to cut and shape. There is a grain to the wood and it is best to follow the grain when cutting the length of the pen.

Materials
- *Sheet of balsa wood*
- *Self-healing cutting mat*
- *Scalpel and craft (utility) knife*

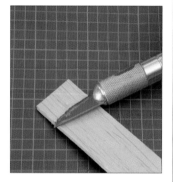

1 Cut the wood into a rectangle approximately 10–12cm (4¹⁄₂in) in length. The width can be varied to suit your needs, but about 2.5cm (1in) is a good guide.

2 Starting 1cm (¹⁄₂in) away from one of the narrow ends, use a sharp craft knife to shave a bevelled cut. A left-hander should make a left-oblique cut.

3 Make a cut straight down at 90 degrees, using the scalpel. The edge will need to be sharp to do this.

Making a reed pen

Reed pens date back even further in history than the quill. They were used by Middle Eastern scribes because reeds were in plentiful supply. They were sturdy and hollow-centred which made them very suitable to cut as a writing tool. Reed pens are still used by calligraphers today. Bamboo cane is often used as a substitute and is readily available. It is possible to cut reed pens with a thicker nib and they are used for larger writing.

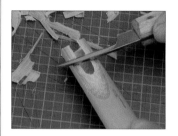

Materials
- *Sharp knife*
- *Length of reed or bamboo*
- *Self-healing cutting mat*
- *Drinks can*

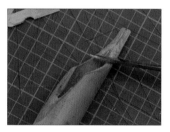

1 Using a sharp knife, cut the reed to about 20cm (8in). Cut a downward stroke, beginning 2.5cm (1in) from the end of the reed curving sharply to mid-way, and then bring the curve parallel with the reed shaft. Scrape away the soft pith.

2 Cut the side sections to form the shoulders of the nib.

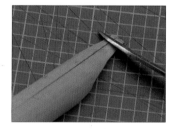

3 Make a vertical slit up the centre. Do not make this too long or the nib will separate when writing.

4 Cut across the top at an oblique angle of 30 degrees to shape the nib.

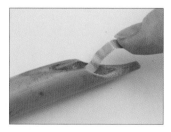

5 Cut the tip cleanly across to form a sharp writing edge at 90 degrees.

6 To make a reservoir, cut a strip of metal from a drinks can, bend it and insert it in the barrel. The ink sits behind the reservoir.

Curing and cutting a quill

Quills have been used for hundreds of years. Most calligraphers frequently use metals pens, but quills are still the preferred choice for writing on vellum because of their sensitivity and flexibility. Calligraphers mainly use goose, turkey and swan feathers, and crow for very fine writing. The best feathers for use with the right hand come from the first five flights of the left wing of the bird, and for a left-handed scribe, from the right wing of the bird. This is because the natural curve of the feather gives the correct balance in the hand.

Once prepared, the quill pen does not quite live up to its image of the beautiful plume – the quill is cut to a manageable length of about 20cm (8in) and stripped of its barbs, which makes it easier to handle.

Materials
- *Silver sand*
- *Cooker and pan*
- *Feather*
- *Sharp knife*
- *Self-healing cutting mat*

Tip: The drying process eliminates oils. Ideally, this should be carried out naturally, but this could take many months of drying. Instead an artificial heat source is used with a pan, but this needs to be kept gentle and very brief or the barrel becomes too brittle. The heating alters the quill from being soft textured and opaque to becoming harder.

1 The quill needs to be cured so that the barrel is hardened. Before this is done, cut the sealed end of the barrel, then soak in water overnight. The next day heat the silver sand in a pan for about 15 minutes until really hot. Temper the quill by pouring hot sand down the upturned barrel. Insert the quill into the hot sand and leave for about 10–15 seconds (this is trial and error). If it is left too long, the nib will not crack cleanly and if under-cured, will be too rubbery. Cool the quill quickly by dipping it into cold water then shake it dry. The outer membrane is then scraped away using the back of a sharp knife.

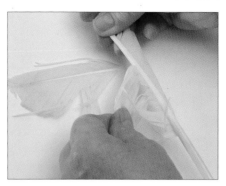

2 Use a sharp knife to cut the quill. Cut the feathers to about 20cm (8in) in length and strip away the barbs.

3 Make a long scoop on the underside of the barrel.

4 Scoop out the shoulders, matching both sides equally.

5 Place the top of the quill on a cutting mat. Place the knife blade in the centre of the nib and make a slit of one and a half times the nib width.

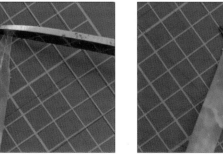

6 Trim the end of the quill with a small cut off the tip.

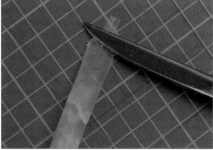

7 Scoop a thin sliver off the top of the nib.

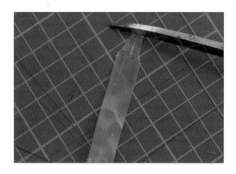

8 To square the nib, make a 90-degree clean cut.

Cut-paper lettering

Paper cutting has been a folk art ever since paper was invented in AD105 by Ts'ai Lun, an official in the court of Ho Ti, Emperor of Cathay in China. However, it has not been widely recognized as an art form, although artists and historians are becoming increasingly aware of its valuable folk heritage. Traditional techniques using cut paper include German *scherenschnitte*, Chinese *chien-chih*, Japanese *kirigami* or *mon-kiri,* Polish *wycinanki* and French *silhouettes.*

The craft of paper cutting is easily adapted to cut letters and may be used in conjunction with a piece of calligraphy or as a stand-alone design. The basic technique of cutting letters out of paper may be separated into two distinct categories – stencil and silhouette images. While similar, they each have their own 'rules'. These refer to whether it is the letter or the background that is cut out. For stencils, the letter is cut away, while for silhouettes it is the background that is lost.

Silhouette and stencil letters

On the left of this card is a silhouette, or positive letter, which is best thought of as a letter within a frame, ideally touching in at least three places. The letter stays while the background is cut away. On the right is a stencil or negative letter, which is removed from the paper leaving the letter-shaped hole, with the background firmly in place.

With practice it is possible to develop skills that allow elaborate lettering and designs to be cut out. It is important to remember when cutting around the curves of a shape or letter only to cut in small arcs, before stopping and moving the paper. Do not lift the knife, but keep it in the same position and continue cutting when the paper has been repositioned. This may seem a slow technique, but it will ensure a smoother shape to your cuts. Keep the blade upright – without slanting it to one side or the other – and make sure that the sharp edge is facing towards you. A sharp blade makes a great deal of difference to the quality of the cuts as well as the amount of effort that is needed to make them. A blade that is not sharp will produce uneven edges and poor curves so change the blade frequently. Choose the paper carefully because the thickness of the paper and the amount of detail in the letters also play a role in how successfully the letters are cut.

> **Tip:** For crisp cutting, work in two directions – downwards and to the right. Turn the work to accommodate these directions. Left-handers should reverse the latter directions to work to the left and anticlockwise. At all times keep your free hand away from the cutting direction.

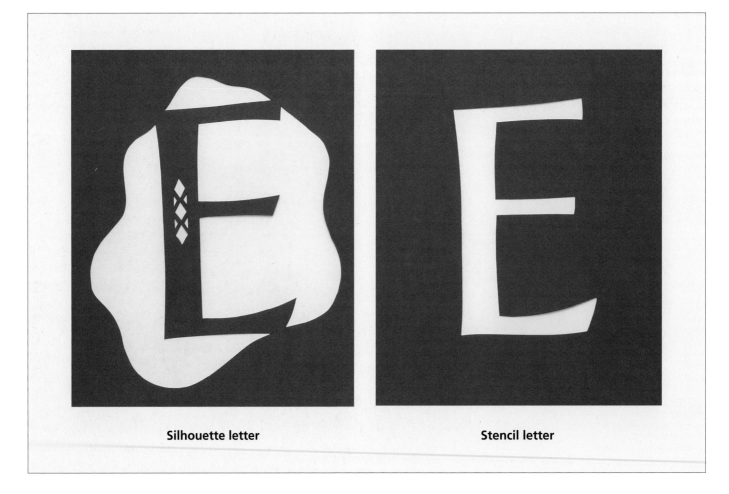

Silhouette letter **Stencil letter**

Making stencil letters

When cutting these stencils careful thought needs to be given to letters with enclosed areas that could simply fall out. If the stencil letter has a 'counter' or enclosed space, there needs to be a way to keep this 'island' in place as the letter is cut away. The letters with counters are: 'A', 'B', 'D', 'O', 'P', 'Q' and 'R' and 'a', 'b', 'd', 'e', 'g', 'o', 'p' and 'q'.

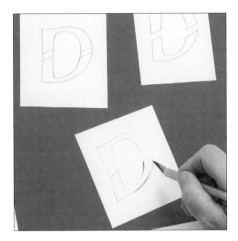

Cutting the counter ▲
Draw in pencil before you cut, to show where the letter will be cut. The addition of a 'pathway' such as a chevron can hold the middle of a letter, such as a 'D'.

Using designs to create pathways ▲
Make use of designs to create 'pathways' of safety. Including shapes such as hearts or diamonds midway across the letter can create a pathway. Rub out any overlap points to avoid cutting and making mistakes.

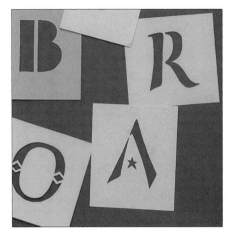

The finished letters ▲
These are some of the ways of making safe pathways on letters. When combining stencil letters within words, it is also important not to let them touch each other as the design will become physically unstable.

Practice exercise: **Making a stencil and silhouette letter**

When cutting silhouette letters, counter shapes and backgrounds are removed, but it is important that letters physically touch each other and their frame at overlap points, so that the design will be stable and hold together.

Materials
- *2H pencil*
- *Lightweight watercolour paper*
- *Craft (utility) knife or scalpel with a long, pointed blade*

1 Draw the letter 'A' on to watercolour paper. Be very clear about where the cut is to be made, marking the spaces where the card can be cut away with an 'x'. To add a border around a silhouette letter, draw three lines in tandem, ensuring the letter protrudes beyond the outer line in at least three places and rubbing out the overlap areas.

2 Cut a channel between the outer and middle lines and all other marked areas. Leave the border intact, because it keeps a pathway of safety.

Tip: Mark the areas to be cut and rub out overlap points. Do not just cut out the letter profile, or it will fall out.

3 It is possible to combine both silhouette and stencil techniques, by further cutting into a silhouette letter. When doing so it must be remembered that stencil rules now apply, and care must again be taken to save the middles of letters.

Embossing

This is a technique that is sometimes described as 'white on white'. Unlike usual calligraphy it does not use colour against a contrasting surface to make itself legible. Instead it uses shadows. The effect is achieved by stretching the paper through a stencil using a specialized embossing tool or a substitute such as a pointed bone folder. With practise, it is possible to cut very elaborate stencils for this purpose but it is best to start with a simple design, which should be relatively heavy as, when embossed, the shapes will appear narrower.

Always use a sharp blade when cutting your stencil. If the stencil is very complicated, the blade may need to be replaced several times. When cutting, keep your fingers well away from the blade. If you have an assortment of different sized embossing tools always start with the largest and progress to the smallest. This way the paper will gradually be stretched and will not be pierced. Do not emboss all the way around the stencil in the same direction as this will tear the paper. Start at the middle of one side and work part way around then go back to the beginning and work in the opposite direction. Take care of your stencils as they can be used many times. The cardboard of cereal boxes is an ideal material for making stencils. Remember to always stencil from the reversed side. You need a light box or light source for embossing, which should be secured with tape.

Making a stencil and embossing

The technique involves making two embossed letters in Foundational script, 'a' and 'n'. To form the letters use a double pencil (two pencils taped together). The letters are traced and the counter of the 'a' is glued in the correct position. Work on a light box or against a window to give you the best light. Go over the outline of the shapes with the embossing tool.

1 With double pencils and on layout paper, write two letters, one of which should have an internal counter.

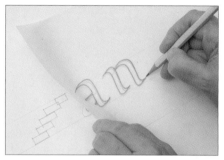

2 With tracing paper and a B pencil, trace the outline of these letters. Reverse the tracing paper and fix to a piece of lightweight card with masking tape.

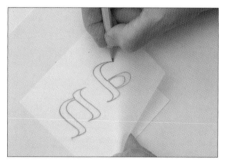

3 To transfer the design, carefully trace over the reversed letters with an H pencil onto the piece of lightweight card.

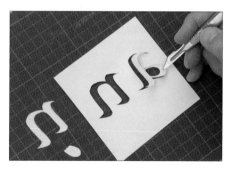

4 Remove the tracing paper and, with a scalpel on a self-healing cutting mat, carefully cut around the shapes. The counter space will come loose.

5 Erase any pencil marks and glue the stencil, with the correct letterforms face down, on tracing paper. Lay this over the original tracing and glue the loose counter space in position.

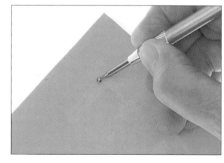

6 Place the stencil on a light box. Lay the good paper over this and tape the top edge to the light source. Using the embossing tool, carefully go around the outline of the shapes.

7 Remove your paper and turn over to appreciate the embossing.

Practice exercise: **Making an embossed bookmark**

This simple but effective bookmark uses a technique of overlapping using a series of hearts to portray a love of books, or it can be made as a special present for a friend.

Materials
- Pencil
- Tracing paper
- Lightweight card (stock)
- Scalpel or craft (utility) knife
- Self-healing cutting mat
- Lightweight watercolour or pastel paper
- Light box
- Masking tape
- Embossing tool
- Scrap paper
- Glue stick

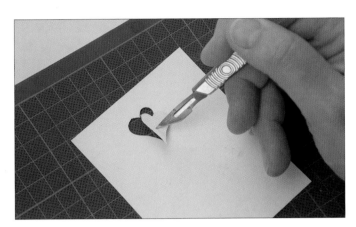

1 Draw a simple heart. Trace and transfer this to a piece of card. On a cutting mat, cut the stencil by taking out the heart using a scalpel or craft knife.

2 Cut a piece of lightweight paper to the dimensions of a bookmark. Lightly pencil a flowing line along the length.

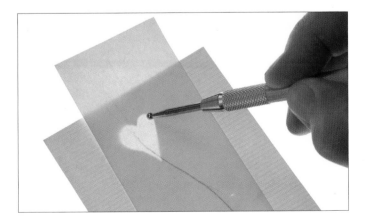

3 Secure the stencil to a light source using masking tape and, using the line as a guide, emboss hearts all the way along, making sure they overlap. Do not erase the pencil line as this will flatten the embossing.

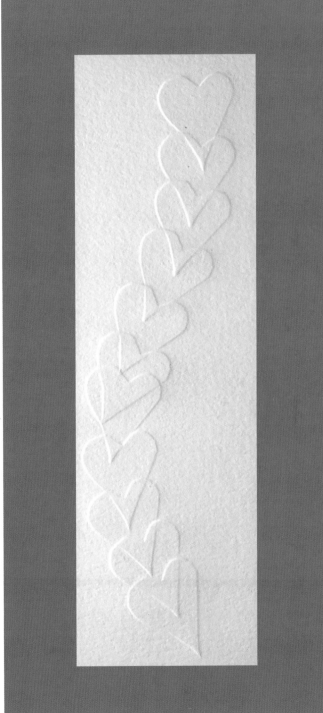

4 Remove from the light source and place on a piece of shiny scrap paper for protection. Glue around the edges before turning the embossed paper over and fixing it to a contrasting piece of card.

Washes and backgrounds

There are many different effects that you can create with background washes. There is a wealth of possibilities if you consider using different media and tools. Dry brush techniques, clear film, spattering, spraying, rollers, sponge and textured cloth all produce different marks when used with paint or acrylic inks. With experimentation and practise, texture and visual excitement, mood and atmosphere can be achieved in the backgrounds to calligraphic work. There are lots of creative possibilities to be explored using washes, single or variegated, with dropped-in colour on the paper.

Before making washes and backgrounds it is wise to stretch the paper if it is under 300gsm (140lb) in weight. This means saturating the paper with water and then securing it on to a wooden board with brown paper tape. Overlap the tape at the corners, keep the board flat for drying and leave the paper attached until all the colour work is finished. When dry, the paper becomes taut and accepts any amount of watercolour without buckling or becoming wrinkled.

> **Tip:** For best results use hot-pressed or cold-pressed papers for colour washes. Mix up enough paint to ensure you do not run short during an application. Thinly diluted watercolour paint will produce a more subtle wash effect, and applying the wash quickly will help avoid streaks and runs from forming.

Different effects

Try these washes and paint effects to create different backgrounds and patterns on paper.

A single wash ▲
Raise the board at one end to apply the wash to the paper. Mix the watercolour paint or acrylic ink to a watery consistency. Dip a large brush in the paint draw it across the paper to create a smooth wash.

A variegated wash ▲
Mix up three separate colours. Dip the brush into the first colour and apply to the paper randomly. Rinse the brush and load with the second colour, adding it to the paper and blending into the spaces. Rinse the brush and add the final colour.

Using clear film or plastic wrap ▲
Paint a variegated wash on the paper, dropping in extra colour while it is still very wet. Drape a large piece of clear film on to the wet wash and drag it into different patterns. Leave to dry thoroughly before removing the film. This will create patterns in the colours.

Spatter colour ▲
Use an old toothbrush loaded with paint. To spatter the paint drag a piece of card (stock) or a metal rule over the bristles towards yourself. Use a second brush for another colour. Alternatively, a spray bottle filled with paint can be used to create a similar effect.

Using a roller ▲
A printmaking roller or commercial paint roller can be used. Each will create a different effect. Squeeze two different colours into a flat wide container and add water. Roller the colours together slightly before applying them in broad bands.

String around the roller ▲
The string creates interesting random patterns when it is used to roll ink or paint on to the paper. Thin string on a print roller has been used to create the effect shown here. For a different effect try strands of cotton around the roller.

Practice exercise: **A decorative card**

Practise background colours by blending washes and creating different effects on paper. Use a limited range of paint or ink colours to help you to remember the paint mixes. By using acrylic inks or casein paint in the background, your paper will have the added advantages of it being waterproof when dry, giving a soft pleasant surface on which to work and allowing easy removal of writing mistakes. If the paper is 300gsm (140lb) and small in size then it is not necessary to stretch it. The larger the piece of paper, the more water it will hold and the more buckled it will become if it is not taped to a board.

Materials
- *A selection of practice sheets*
- *Coloured card (stock)*
- *Decorative paper*
- *Craft glue*
- *White photocopy paper*
- *Ribbon*
- *A sequin or decorative motif or beads (optional)*

Tip: When using washes, varying the length of time that each colour is allowed to dry before adding another can create a more complex design with greater depth. Always wait until all the paint is completely dry before you start to write on the paper.

1 Create a variety of different textured and coloured paper, including different washes, patterns made with clear film (plastic wrap), spatter and coloured paper.

2 Cut a small sheet of coloured card in half, then fold each piece in half to create two separate cards. Cut some of the decorative pieces of paper into small rectangle or square shapes. Choose colour patterns that work harmoniously together and stick them to the cards with craft glue, piling different shapes on top of one another.

3 Finish the cards by adding a paper insert. For each card fold a small sheet of white photocopy paper in half and trim around the edges. Write your own message inside the folded paper and stick each one carefully into a card. Add a ribbon around the back spine making a neat bow on the outside. A sequin or decorative motif or beads can be added as a final decoration on the front of the cards.

Resists

Methods that are used to protect areas of work are called resists. This allows work to eventually appear through any processes that have covered them. The definition of 'resist' is 'to stop from reaching'. White gouache, a white candle and masking fluid can all be used to create a resist, and each will produce a different result. When using resist techniques, ensure each step has dried completely before going on to the next. If speed is important, work may be gently dried using a hairdryer. Make sure that your paper can withstand the resist soaking and sponging before you start your main work.

Experimenting with gouache

This resist is made by using dilute gouache on water-colour paper, covering it with colour and dissolving the gouache in hot water.

Materials
- *Bleed proof/permanent white gouache*
- *Watercolour paper*
- *Automatic pens*
- *Large brush or hake*
- *Waterproof ink or acrylic colour*
- *Bath of water*
- *Natural sponge*
- *Drawing board*
- *Brown paper gum strip*

1 Using dilute white gouache (but not too dilute) on a piece of watercolour paper, write a large capital letter with the automatic pen. Allow to dry.

2 Fill a large wide brush with waterproof ink or acrylic colour and, with even strokes, cover the paper. Do not go back over a stroke as the gouache could dissolve. Allow to dry.

3 Soak the paper in water, either in a bath or under a tap. Gently rub the surface with a natural sponge. The gouache will dissolve and lift away taking the waterproof covering with it.

4 Place on a drawing board or similar and stretch with gum strip. Allow to dry before removing.

Experimenting with white candle wax

This method of resist uses the wax of a candle to form a resist against paint that is rolled over it.

Materials
- *Watercolour paper*
- *Waterproof ink*
- *Gouache paint in two colours diluted with water and washing-up liquid (liquid soap)*
- *Low-tack masking tape*
- *White candle*
- *Foam paint roller or equivalent*

1 On a piece of watercolour paper draw the outline of a letter in waterproof ink. Fill in the shape with the darker of the gouache mixtures and leave to dry.

2 Outline the area of the design with low-tack masking tape, press down well to prevent seepage and vigorously rub the entire surface with the candle making sure that everything is well covered.

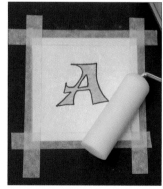

3 Using the foam paint roller, cover the surface with the paler gouache mixture; this should be very diluted. Leave to dry before carefully removing the masking tape.

Experimenting with masking fluid

This method of resist uses masking fluid to form a resist against watercolour that is brushed over it. This technique can be used to create quite intricate or delicate designs.

Materials
- *Watercolour paper*
- *Pencil*
- *Masking fluid*
- *Small and large paint brush*
- *Watercolour paint*

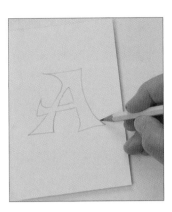

1 On a piece of watercolour paper draw an outline of the letter 'A'.

2 Paint over the outline of the letter with masking fluid. Allow to dry.

3 Using a large brush wash colour over the surface of the paper. Leave to dry.

4 Gently remove the masking fluid by rubbing it with your finger.

Practice exercise: **AZ**

This exercise uses gouache to create an interesting layered resist. Two colours of paint are used, which mix to form a third, apart from in the places where the gouache resist has been applied. It is possible to use many different layers of colour.

Materials
- *White gouache*
- *Watercolour paper*
- *Small brush*
- *Large brush or hake*
- *Waterproof or acrylic paint (two colours – one darker than the other)*
- *Natural sponge*

Tip: If you do not want any white to appear on the page, paint a coloured wash on to the paper before adding the first resist. Leave this wash to dry thoroughly before adding the resist. The 'blank' area will then be the colour of the first wash.

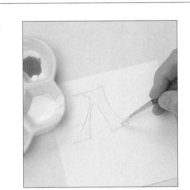

1 Using white gouache write a capital letter 'A' on to watercolour paper. Allow this to dry.

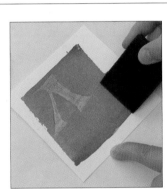

2 With a hake or similar wide brush, cover the surface of the paper with a wash of light coloured paint. Leave to dry.

3 Using white gouache, write a capital letter 'Z' over the obliterated 'A' and once again leave to dry.

4 Cover the surface with a darker wash of waterproof or acrylic colour. Take more time over this than before, because the two colours need to dry.

5 Allow the paint to dry before washing it off the area of resist and stretching.

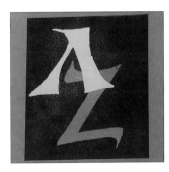

6 The finished resist before being removed from the board.

Gilding

Gold imparts a sense of richness and splendour to the page. It is a unique commodity and its specific qualities have been recognized by artists and artisans for thousands of years. It is pure, non-tarnishable and is one of the most malleable metals – which means it can be beaten into leaf by virtually the same methods as used in antiquity.

There are three methods of gilding: using powdered gold, applying gold leaf on to a gum base and burnishing gold leaf on a raised gesso base. Both flat and raised gold can be produced. Some techniques are easy and some are a little more technically demanding but most people will find a method which suits them and the piece they are working on.

Powdered gold

This type of gold is mixed with distilled water and gum arabic before being applied to the paper or other surface. It is often referred to as 'shell' gold (so called because the gold was originally sold in mussel shells), and is painted with a fine brush, or loaded into a pen. It dries flat and can be burnished, and patterns of lines and dots may be impressed into its surface with a pointed burnisher. The gold needs to be stirred from time to time to keep the particles well mixed. Powdered gold does not have the high brilliance of gold leaf, but using the two types of gold together can make a stunning contrast.

Gilding with gold leaf

This is quite a simple technique whereby wafer-thin sheets of gold are applied to a layer of gum. Traditionally only natural gums were used such as gum ammoniac, glair, parchment or vellum size. There are now synthetic adhesives which are equally suitable for gilding such as PVA (white) glue, acrylic gloss medium and gold water size. Gum ammoniac is easy to use. It can either be bought ready prepared or it can be made up and mixed with a little water and colour. Gesso, which is made mainly from plaster, can be made up or bought in cakes, and is the ideal base for gilding with loose leaf gold.

Practice exercise: **Using gum ammoniac to apply loose leaf gold**

This technique uses gum ammoniac, made from resin, as the base for laying loose leaf gold.

Materials
- *Gum ammoniac resin*
- *Plastic bag*
- *Rolling pin or hammer*
- *Small jars*
- *Distilled water*
- *Dish*
- *Muslin (cheesecloth)*
- *Liquid watercolour*
- *Brush*
- *Rolled paper*
- *Loose leaf gold*
- *Glassine paper*
- *Burnisher*
- *Clean cotton rag*
- *Paint and brush*

1 Put the gum ammoniac on a hard surface and crush the gum into fine pieces with a rolling pin or hammer.

2 Transfer the pieces of crushed gum ammoniac to a small jar. Fill the jar with just enough distilled water to cover the gum, stir and leave overnight to dissolve.

3 Strain the milky liquid through some muslin into another jar. Transfer to a dish. (Instead of using muslin you can use a piece of fabric cut from some old tights.)

4 Add a couple of drops of liquid watercolour to the gum ammoniac and it is ready to use. Apply the gum to the surface using a paintbrush. Wash this brush.

5 Using a piece of rolled-up paper, breathe on the letter to create a tacky surface.

6 Apply a sheet of loose leaf gold and press down. Apply more gold on top if necessary.

7 Brush away the excess gold and use the burnisher. Polish the gold with a clean cotton rag.

8 Complete the decoration. The gum ammoniac produces a flat layer of gold.

Practice exercise: **Using gesso to apply loose leaf gold**

This technique uses gesso to lay loose leaf gold. Gesso needs to be reconstituted before use, adding water to break up the pieces of gesso.

Materials
- *Distilled water*
- *Gesso*
- *Paintbrush*
- *Craft (utility) knife*
- *Burnisher*
- *Glassine paper*
- *Rolled paper*
- *Loose leaf gold*
- *Paint and brush*
- *Soft brush*
- *Clean cotton rag*

1 Add drops of distilled water to the gesso until it is the consistency of thin cream. Stir very gently to avoid air bubbles. If bubbles appear, blot them with a tissue.

2 Load a paintbrush with this mixture and 'tease' the gesso into the shape. Leave to dry overnight. If it does not have an even surface, gently scrape it with a craft knife.

3 Burnish the gesso with a burnisher through glassine paper until the surface is completely smooth. This will encourage the gold leaf to adhere to the gesso.

4 Breathe on to the gesso to create moisture, then quickly lay a sheet of loose leaf gold on it and apply pressure. If there are areas without gold, repeat this process.

5 Leave for an hour or so before burnishing first with the burnisher through a piece of glassine paper and then directly with a finger through the glassine paper.

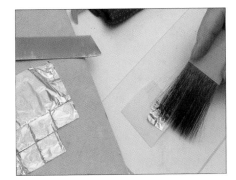

6 Applying additional layers of loose leaf gold will add even more brilliance. Brush away the excess gold with the soft brush, using short, light strokes to flick the gold away.

7 Burnish directly on to the gold, making sure that the gold has stuck at the edges.

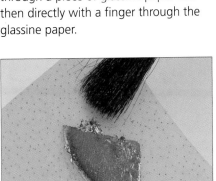

8 Brush away the loose gold at the edges. Continue brushing until all the surrounding gold leaf is removed. Burnish until smooth and polish with a clean cotton rag.

9 Complete the decoration. The gesso produces a raised gold finish to the piece.

Digital Calligraphy

Digital calligraphy is a very new art form that is now becoming increasingly common. Calligraphy is usually considered to be a creative hand-rendered skill. Unlike the use of so-called 'new technology' in many other art forms, digital calligraphy has been slow to catch on, in part because lettering traditions are firmly steeped in the past. This is also because there is a concern that traditional skills may be subsumed by mechanical and technological methods. These fears are entirely unfounded.

The definition of digital calligraphy

What do we mean by 'digital calligraphy'? This question is best answered by defining what digital calligraphy is not. Digital calligraphy is not typography. Type designers have been using computers for many years to design and manipulate fonts, many of which are calligraphic in character. However, using script typefaces such as Lucida Calligraphy or Vivaldi as a substitute for handwritten script is not calligraphy.

Digital calligraphy is calligraphy only when the artist, creator or scribe has contributed some original creative element to the lettering and its application. This could be by applying digital effects to lettering that has been scanned. Perhaps calligraphic forms could be used to build up a creative piece of work using digital techniques. In more advanced cases the calligraphic forms themselves are generated as 'virtual' calligraphy on screen without the need for any of the traditional writing instruments or materials such a pen and paper.

Equipment

Although the majority of designers use Macintosh computers, the more widely owned PC is equally adequate for digital calligraphy. The software used is available on both types of computer and is very similar. Almost any new computer available today will run the necessary software at an adequate speed and will usually have been supplied with a mouse. An alternative to the mouse for writing calligraphy directly on to the screen is the digital pen and tablet. With practice, this will feel more 'natural', and effects that are impossible with a mouse, such as line thickness changing with pen pressure, can be achieved. A scanner is useful for converting traditional calligraphy into a digital file. If you want to keep hard copy prints of your work a colour printer is essential.

◄ Printer

This does not have to be an ultra-high resolution photo printer. Printers that print larger than a standard paper size are very expensive, which may restrict the output to small-scale work.

Scanner ▶
A scanner will enable hand-rendered calligraphy to be transferred to the computer.

◄ The computer
For graphics work such as digital calligraphy the computer needs a high capacity hard disk, preferably with a minimum of 40 gigabytes (GB).

◄ Digital pen and tablet

The pressure sensitive nature of this tool makes it ideal for digital calligraphy.

Software

Professional level software is expensive. An ideal list would include Illustrator™ and Photoshop™, both available from Adobe as the Creative Suite® (CS), or CorelDRAW® that includes CorelDRAW itself and Corel PHOTO-PAINT®. Another version of Photoshop is available as Photoshop Elements®, a more compact version of the full Photoshop package. Other professional packages that can be used for digital calligraphy include Jasc's Paint Shop Pro®. Remember that software is being updated and refined all the time so it is worth keeping up to date with what is available.

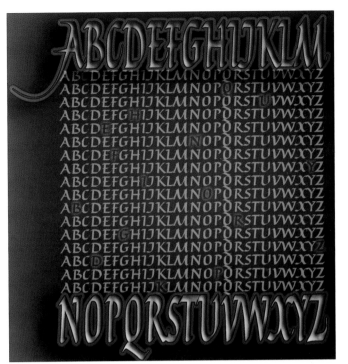

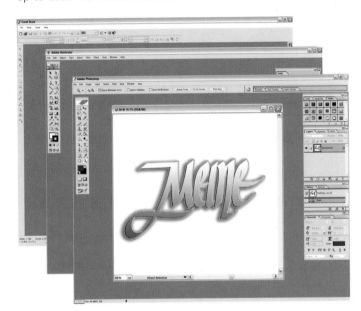

Digitally modified script ▲
An example of what can be achieved using digital calligraphy. The script produced on the computer is then modified using software filters and effects.

Tip: Some software packages are available to buy in 'cut-down' versions, which are less expensive. These versions have fewer features, but may be perfectly adequate for the needs of many digital calligraphers.

Software packages ▲
These are some of the software packages available for digital calligraphy. The menus of some professional software are wide ranging but even a limited number of options can produce sophisticated calligraphic effects.

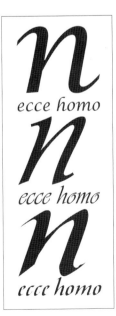

◀ **Calligraphic typefaces and type**
The top two illustrations (Lucida Calligraphy and Vivaldi) are calligraphic but are not calligraphy. The bottom example shows how calligraphy reflects the free movement of the broad-edged pen and produces a 'sharpness' absent in the typefaces.

'Virtual calligraphy' ▲
This complex image using calligraphy is designed to be viewed on a computer screen rather than in print.

Scanned hand-rendered calligraphy

One of the simplest ways to get started in digital calligraphy is to write text in the traditional way with pen on paper and transfer the calligraphy to the computer for further development. This provides the opportunity to retouch any minor faults in the original work. In addition, you will be able to use your own work as a basis for a wide range of exciting imagery. The process of scanning flat copy and saving it to file is a very simple matter although it varies a little from one computer system to another.

When a piece of traditional calligraphy is planned, its dimensions need to be considered. The same applies to digital calligraphy. However, there are some important differences. The image can be viewed on screen at any size by zooming in and out and it can be printed out to any size, dependent only upon the restrictions of the printer. If an image is enlarged too far beyond the original size it may break up into little squares or pixels. To avoid this, it is best to work at the final size and set the resolution fairly high (about 300 dpi). Of course, you may wish to retain the pixellation effect.

Changing scale and proportion

The simplest transformation of your scanned calligraphy is to change the scale or proportion. Most software lets you do this in two different ways – either by dragging handles around the image or by typing in new sizes in one of the drop-down menus.

1 To change the scale or proportion by dragging, simply select the image and drag the corner or side 'handles' with the mouse.

2 To change the proportion only, drag one of the side handles.

Tip: The interactive method of resizing is often best, because changes can be instantly assessed.

3 To change the scale of the image and retain its correct proportions (aspect ratio), hold 'shift' or 'control' (depending on the software) while dragging one of the corner handles.

4 To change the scale and/or proportion of the image using menus, select the appropriate drop-down menu or submenu and type in the new size.

5 It is also possible to change the slope of the lettering. This may be done by dragging the corner handles (depending upon the software).

6 Alternatively, you could key in the slope (skew) of the letters, either forward (positive) or backwards (negative).

Creating a design from a piece of scanned calligraphy

Another effective procedure is to use several copies of the same or different lettering, at the same or different scales, to create a design. To do this with some software such as Photoshop or Corel PHOTO-PAINT is a very simple task, although it may be necessary to find your way around other programs to perform these steps.

1 Irrespective of the software that is being used, write some calligraphy in black ink on white paper. Make the writing as black and solid as possible, as this will make it easier to work with in the later stages. Scan the lettering at a fairly high resolution (at least 300 dpi) and transfer the image to the graphics software. This example uses a Latin quotation: *Nunc est bibendum* ('now is the time for drinking').

2 When using Photoshop, the simplest way to work is by using layers. Each layer holds a copy of the calligraphy that can be worked on separately. Make at least five copies of the lettering by applying the command Layout>Duplicate layer from the drop-down menu.

3 With Corel PHOTO-PAINT and some other programs the Magic Wand tool is used to select the lettering. Copy and paste it five times as new objects. It will then be possible to work with each copy (object), in the same way as with layers.

4 Separate out each copy and position it. Apply scale, fills and effects to each separate copy as well as different levels of transparency, so that some of the lettering shows through from below.

5 A composite calligraphic image can be created, using overlays, transformations of scale, colour and other effects.

Tip: Prepare the original handwritten lettering in black on white and scan it at high resolution (set the scanner to at least 300 dpi). When the lettering has been transferred to the graphics software, convert the format to RGB so that you can work in colour.

Creating digital calligraphy on screen

The 26 letter symbols that make up the alphabet have basic shapes that must be retained so everyone can understand them. Good calligraphic letterform goes beyond that and demands an aesthetic element that makes the script pleasing to the eye and adds individuality or feeling to the text. Much of this comes from the writing instrument used, principally the broad-edged pen that makes thin and thick strokes and creates a satisfying visual rhythm as well as that calligraphic look when the pen tip is held at a constant angle. The basic principles of good calligraphy apply to the digital form as well as traditional techniques.

Bitmaps and vectors

A computer handles graphics in one of two ways – as bitmaps or vectors. Bitmaps are made from many little dots or points of light on the screen called pixels, not unlike the dots that make up the pictures in a newspaper. The pixel size depends on the resolution of both the computer screen and the image. They are produced in various colours and intensities to make up the entire image. The only way to modify a bitmap image is to change the colour or intensity of each pixel. Vectors, on the other hand, describe shapes in lines defined by mathematical formulae. Fortunately, users do not have to understand the algorithms, as vector images can simply be shaped by drawing the lines and reshaped by dragging the end points and lines that make up the forms. One of the big advantages of vector images is that the edges remain sharp, irrespective of their enlargement.

Tip: It is worthwhile learning some of the keyboard shortcuts, rather than always relying on menu selections and icons. One of the most important keys is the Delete key, which is used to remove unwanted anchor points from letters.

Using software to create a calligraphic pen

While computerized calligraphy is a unique form of its own, it is perfectly well able to create the look and feel of a traditional square-edged pen – and there is the flexibility to be as individual as you choose.

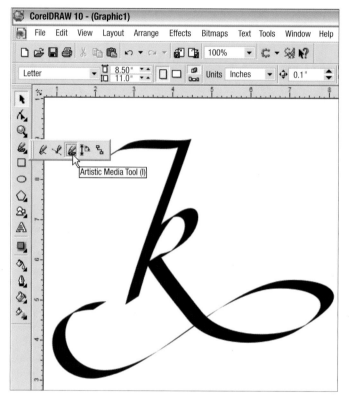

◀ CorelDRAW has an Artistic media tool within which you can select a calligraphic pen, then choose the pen angle and the pen width.

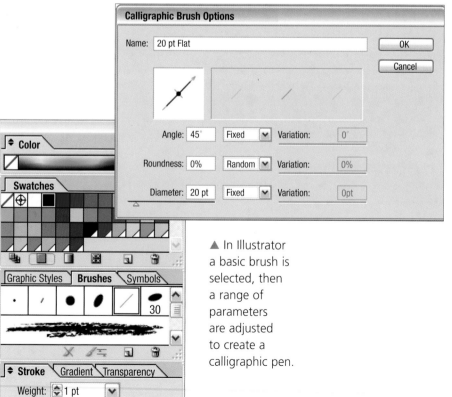

▲ In Illustrator a basic brush is selected, then a range of parameters are adjusted to create a calligraphic pen.

Working with the pen stroke – creating a flourish

As used in traditional forms of calligraphy, flourishes are letter extensions created for added aesthetic value. The same rules apply: the flourish should stem from the basic form of the letter and it should not appear more important than the letter.

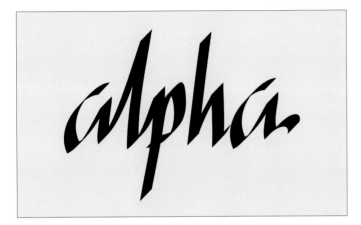

1 Using software that has vector-drawing facilities, write a short word using a calligraphic pen. Set the pen to an appropriate angle, about 35 to 40 degrees, depending on the style you use. CorelDRAW is used as an example throughout the steps, but it is possible to use Illustrator or another vector-drawing program and modify the procedures. The principles are the same.

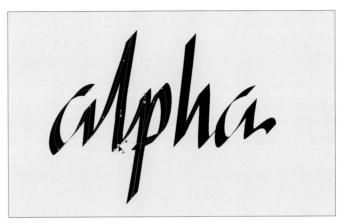

2 Make any adjustments to the letterforms by dragging the anchor points, handles or vectors. Remove any surplus anchor points. Remember that the fewer anchor points there are, the smoother the curves will be. Adjust the letter spacing, if necessary, in the same way. Do not try to make the calligraphy too formal – remember you are not designing a typeface. Keep the forms very calligraphic.

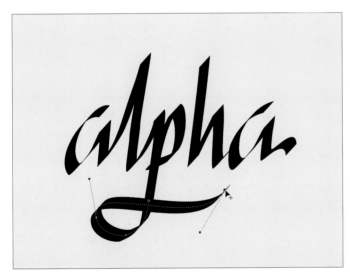

3 This is the most interesting part of creating a flourish, but also the trickiest. Convert the descender of one of the letters to a flourish by extending the line down and to the left, then to the right, finishing with a slight upward stroke. It may be necessary to add more anchor points.

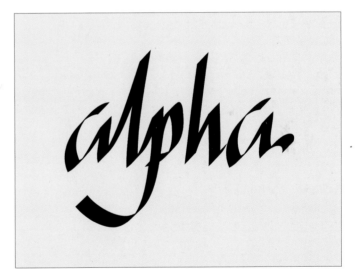

4 This has now produced a word that looks very calligraphic and would be impossible to produce by using a typeface. Try adding a different flourish to this or other letters. Make sure that the flourish does not become more important than the letter. You will find that some letters lend themselves to flourishes, while others do not.

Tip: Have a look at the copy books of some of the masters of Renaissance Italic calligraphy such as Arrighi, Tagliente and Palatino. They used flourishes extensively and can give you ideas on how to form them.

5 These three examples are good starting points for practising your own flourished letters.

Digital effects

Having developed skills in calligraphic design it is useful to experiment with colours and effects. This is one of the big advantages of digital calligraphy. With digital calligraphy this can be done with a click of the mouse – over and over again. In addition, it is easy to apply effects such as textures and even drop shadows that would take a very long time with traditional materials or, perhaps, might even be impossible.

However, although any artistic pursuit should not have restrictions that inhibit the creative process, there are potential dangers that should be taken into account. In the case of digital calligraphy it is very easy to fall into the trap of using clichés such as the over use of certain effects. As with traditional calligraphic methods, restraint is often the wise approach. It is very easy to doodle with a mouse or digital pen then apply effects to the scribble. Try to remember that the basic principles of good calligraphy can also be applied to calligraphy in its digital form. Every graphics software application has its own way of letting you change the colour and effects such as textures, patterns, fills, outlines and drop shadows. Try experimenting with these using your software.

Adding effects

Take full advantage of the many style effects that can be applied to digital calligraphy by getting to know your style menus; experiment with the fills, filters and colour effects introduced below.

1 In Photoshop the Layer styles can be selected by clicking on the small icon at the bottom of the layer window while the active layer is selected. This gives access to an extensive range of effects.

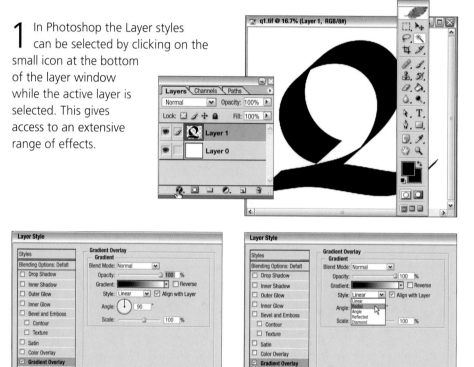

A linear gradient fill

A radial gradient fill

A reflected gradient fill

A diamond gradient fill

2 One of the useful Layer style effects is a gradient fill. This is selected from the list of styles on the left of the submenu window that is displayed when the Layer style icon is selected.

3 It is important that the gradient style in the Layer style window is selected first. This determines the type of fill, be it linear, radial, angle, reflected or diamond effect, and its direction.

4 Clicking on the gradient preview in the Layer style window brings up another submenu within which a number of stylistic parameters for the gradient (including colours) can be set.

5 There is a good range of preset styles in Photoshop. Each can be modified to change the filter and colour effect. With a layer active, click on the style that you want in the Styles palette.

6 The style effects can be accessed in Illustrator in the same way. However, the presets are more limited and you have the opportunity to explore them in your own way.

Colourizing lettering

In digital calligraphy, certain colours, such as red, make letters appear bolder. Black letters on a white background look much thicker than white on a black background and striking colour effects are created by using contrasting coloured letters.

1 The simplest way to add colour to lettering in Photoshop is to select the lettering with the Magic Wand tool. Choose a colour from the Swatches palette and fill the selected lettering with the Paint Bucket tool.

2 The procedure is similar in Illustrator. Ensure that the lettering has been selected and choose a colour from the Swatches palette. In Illustrator the lettering will change to the new colour as soon as it has been selected from the palette.

Adding drop shadows

The three-dimensional look of the drop shadow helps create effects that cannot be produced using conventional calligraphy techniques. This flexible digital effect can be created in any colour and it may appear sharp or blurry.

1 Provided the text can be selected, a drop shadow can be applied to a single letter, a word or a whole block of calligraphy. In Photoshop there are several ways to apply the effect. The simplest is through the Styles palette.

2 Drop shadows can be used in different ways. Here, a simple shaded shadow is applied below and to the right of the original letter. The distance from the letter, as well as the shadow width and spread, can all be adjusted.

3 A drop shadow does not have to be offset from the original letter. It can be used effectively to create a soft shading behind a letter, word or text block. Experiment using a shadow that is lighter or darker than the lettering.

4 The drop shadow facility can be used to produce a duplicate of the original lettering in the same or a different colour. In Photoshop, this is done very simply by setting the spread to 100 per cent.

5 In addition to changing the colour of a drop shadow a texture can be applied to it. In Photoshop this is called 'noise' and is a texture effect that may be useful in your artwork.

Digital calligraphy output

When calligraphy has been entirely generated with a computer and is not printed, it can be described as 'virtual'. Your work can be saved permanently, perhaps for later development or you can easily distribute your design to others as a computer file (although viewers will be confined to those who have access to a computer). More often than not, you will want to print your work. Traditional writing on surfaces other than smooth papers, card or skin (vellum or parchment) with pen and ink may be difficult or even impossible. With an inkjet printer it is possible to produce calligraphy on a whole range of papers and materials, limited only by the capability of the printer. The restriction of print size, usually limited to standard sizes, can be overcome to a certain extend by designing your calligraphy in several parts. Each part can be gathered together in a mount or frame. It is even possible to print the calligraphy so that that the paper sheets butt up against each other and the joins become part of the design. A more complex solution is to make your design a montage with some of the elements laid over the paper joins.

Concealing paper joins ▼
A large calligraphic design, printed on several separate pieces of paper, combining text and illustration. The vertical paper strips that are part of the design conceal the joins between sheets.

Illustration and digital calligraphy

It can be challenging to combine traditional hand-rendered calligraphy with illustration. Very stylized illustration and heraldry work best. As digital calligraphy combined with images or scanned traditional calligraphy can be printed by the same inkjet process, it is easier to produce designs in which calligraphy and illustration complement each other.

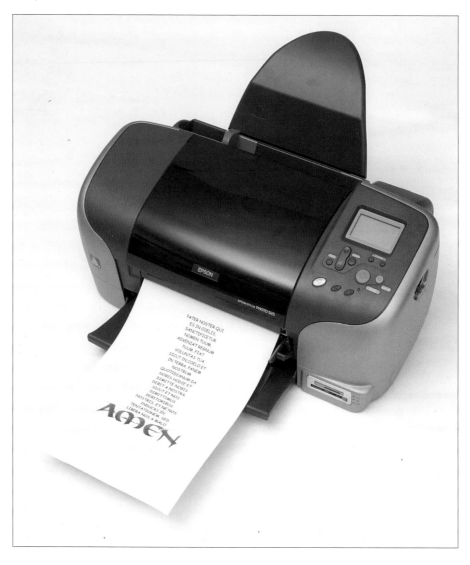

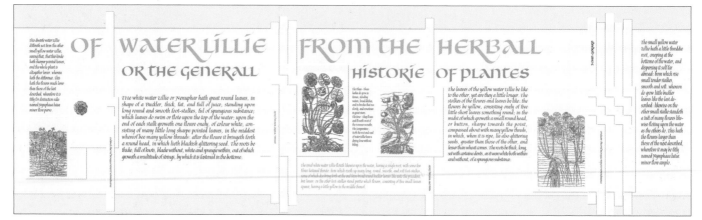

Papers for digital printing

Printing digital calligraphy on quality paper gives it a special finish. There are many suitable types of paper available and the ease of printing means it is possible to try out the same piece of calligraphy on different surfaces. Experiment with colour and texture, but be aware that some papers will fade, so prints should be protected from prolonged exposure to sunlight. For a classic effect, white watercolour paper works very well.

> **Tip:** Always read the printer manufacturer's manual to check whether the material will feed through the printer. You may find the maximum paper thickness specified is very conservative in order to protect the manufacturer's warranty. If the material is correctly picked up by the printer's grippers and feeds through you should be safe. Be very careful not to use materials with loose particles that might come off inside the printer.

Wrapping paper ▲

As well as plain white papers, it is possible to print on many other papers, including readily available materials such as brown wrapping paper. Make sure the paper is not too absorbent.

Textured paper ▲

There are some beautiful papers from Thailand, many of which are thick and highly textured. However, if the texture is too strong it could impair the legibility of the calligraphy.

Lightweight paper ▲

Japanese papers can be very thin, some are even as thin as tissue. To print on these feed the paper through the printer with a sheet of plain white paper behind it.

Hard surface ▲

If the surface of the paper is too hard, for example a coated art paper, the ink will not be absorbed and will take a long time to dry. It can spread and may even smudge in the printer.

Absorbent paper ▲

If the paper is too absorbent the ink will spread and the sharpness of the letterforms will be lost. There will be a similar effect if thin paper is used.

Inkjet printing ▲

If the paper is suitable for inkjet printing the lettering will be very crisp and sharp with no ink spread. The best materials are hot pressed acid-free mould-made papers, the same as is commonly used for traditional calligraphy.

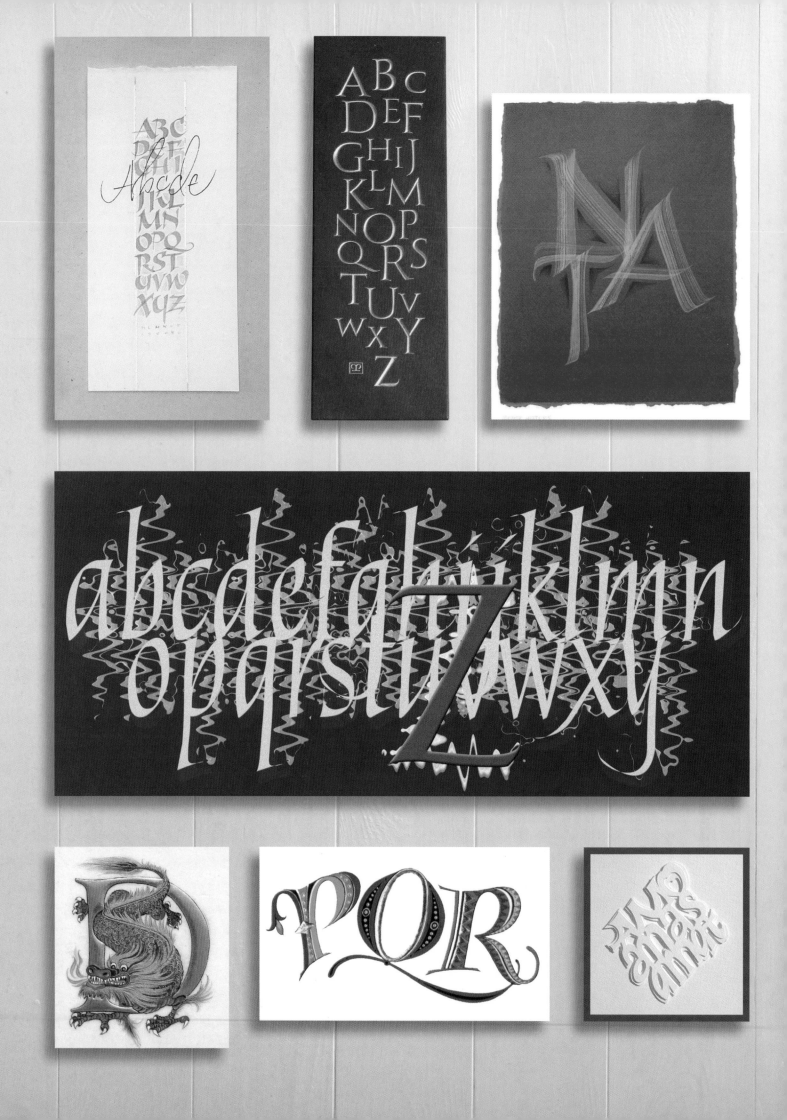

Gallery

This book would not be complete without a tribute to the many faces of calligraphy in today's world. The following pages showcase the different ways in which calligraphy has been put to use, stepping beyond conventional applications to incorporate less obvious techniques and materials such as slate and stone. The result is a stunning gallery of work from a range of contemporary artists that shows off calligraphic techniques in the most inspiring way.

▲ **'The Deep Blue'**
Three Roman Capitals are blended in
this haunting electric blue design, painted
in gouache with an edged brush.
Jan Pickett

▼ **'Autumn'**
A gilded Versal letter 'A' illuminates this
miniature from a hand-written book on
the poem *The Pageant of the Season
and the Months* by Edmund Spenser.
Janet Mehigan

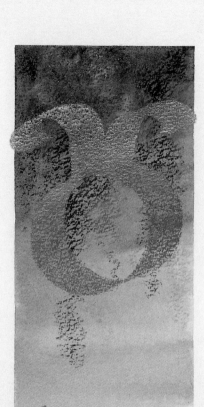

Giunt'è la Primavera e festocetti
La salutan gl'Augei con lieto canto,
E i fonti allo spirar de'Zeffiretti
Con dolce mormorio scorrono intanto.

▲ **'Spring'**
A piece from a series based on the
four seasons in a hybrid Italic script
using metal nibs on a textured
background of acrylic paints,
pastels and gold stencilling.
Penny Price

◄ **'Celtic Blessing'**
The Celtic blessing 'Deep peace
of the quiet earth to you', was
carved in an ammonite form in
Welsh slate for an exhibition in
Nevers, France.
Celia Kilner

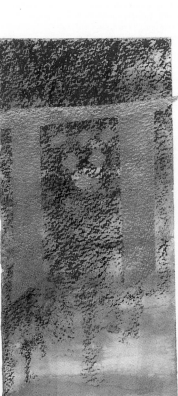

Aggiacoiato tremar trà neri algenti
Al severo spirar d'orrido Vento,
Correr battendo i piedi ogni momento;
E pel soverchio gel batter i denti

◄ **'Winter'**
A piece from a series based on the four seasons in a hybrid Italic script using metal nibs over a textured background of acrylic paints, pastels and gold stencilling.
Penny Price

▲ **'Fire Dragon'**
Entwined letters and images give this design added impact. This dragon was painted on stretched vellum, using gouache, gilded with leaf gold on gesso.
Jan Pickett

▼ **'Letterform Exploration'**
Roman Capitals and Italic are created using broad-edged and pointed brushes with minimal pre-planning. Black Sumi ink was used on Khadi handmade paper with red gouache in the counter for extra embellishment.
Mary Noble

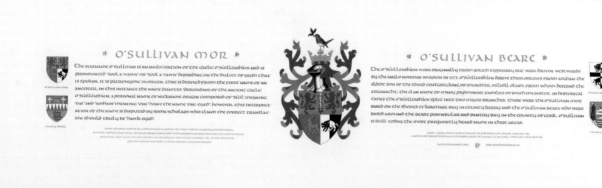

▲ **'Sullivan Family History'**
Uncials written in gouache on watercolour paper are used as a decorative means of showing the Sullivan family history.
Maureen Sullivan

▲ **'Letter A'**
Using Chinese ink and an automatic pen this bold letter 'A' was created using several large sweeping movements of the hand and arm.
Michelle Golder

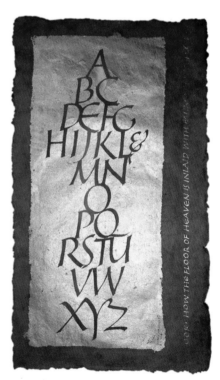

▲ **'Dancing Alphabet'**
Imperial Roman Capitals are used in this alphabet, incised and gilded in slate.
Rosella Garavaglia

▲ **'Woodland Dragon'**
Gouache on stretched vellum with a gilded 'J', using leaf gold on gesso.
Jan Pickett

▲ **'Julian's Alphabet'**
This striking design on Nepali paper shows the effective use of gold leaf and oil pastel.
Peter Halliday

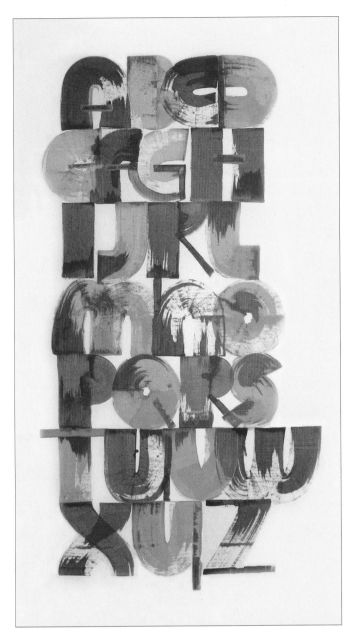

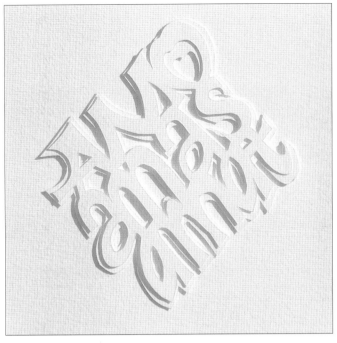

◀ **'Blue and Yellow Alphabet'**
Experimental script written with a piece of large heavy card and inks on Fabriano paper.
Rosella Garavaglia

▲ **'Amo, Amas, Amat'**
The design (meaning 'to love' in Latin) is cut from two layers of Bockingford paper and incorporates free majuscules, Foundational hand and Italic hand.
Viva Lloyd

▼ **'Digital Alphabet'**
A dark green backdrop provides an effective contrast with the gold lettering of this alphabet design. In an unusual twist on the conventional alphabet layout, the letter 'Z' has been made a focal point of the design. The alphabet is 'virtual' calligraphy in Italic to be viewed on screen.
George Thomson

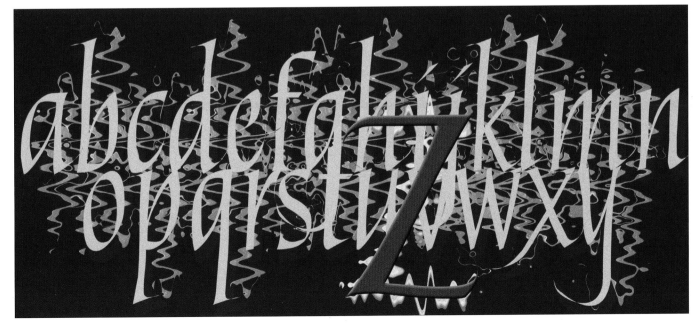

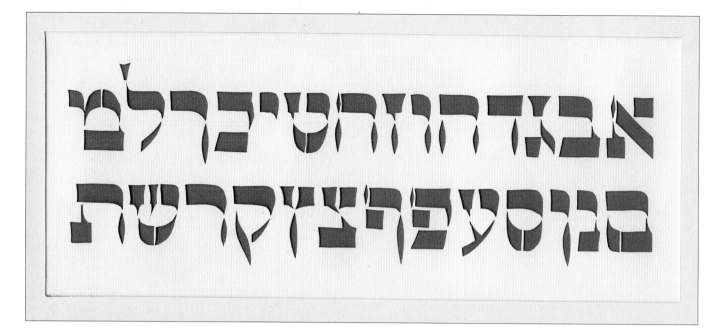

▲ **'Hebrew Alphabet'**
Ashkenazi script has been created by carefully cutting out Hebrew letters from cream paper, which has then been mounted on dark green card.
Sylvie Gokulsing

▲ **'Scorpio'**
A gold Versal 'S' on raised gesso base. Painted using traditional egg tempura and watercolour washes on stretched vellum over wood.
Janet Mehigan

◀ **'Scene from Metz Pontifical'**
This religious scene has been copied from the early 14th-century Metz Pontifical. It has been written on vellum using quills and iron gall ink in Quadrata Gothic script.
Penny Price

◄ **'Jester's Letters'**
Part of a complete alphabet book, initially painted in gouache then embellished using raised gold on gesso and shell gold.
Jan Pickett

▼ **'Arlecchino'**
Experimental alphabet using a round brush and water, then inks, on Fabriano Artistico paper.
Rosella Garavaglia

▲ **'Earth'**
Artist's own script and taken from a series on the four elements, using a ruling pen on torn handmade paper.
Penny Price

► **'Glory of the World'**
Carved in Portland Stone is the message 'Thus passes the glory of the world', echoing the broken stone.
Celia Kilner

▼ **'Fan book'**
A sonnet in the Italic
hand in red gouache
on Ingres paper,
folded to form
an elegant fan.
Viva Lloyd

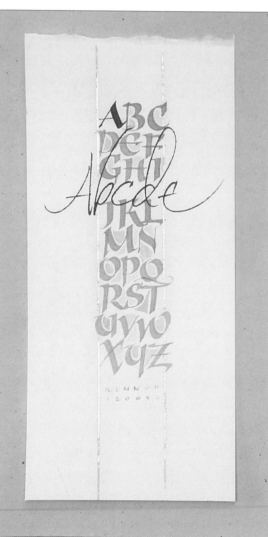

▲ **'Nanc Scio
Quid Sit Amor'**
Sand-blasted
Welsh slate has
been used as the
medium for the
poetic words
*Nunc scio quid sit
amor* meaning
'Now I know
what love
should be'.
Celia Kilner

▲ **'Swirling Alphabet'**
A Flourished Italic alphabet design for a
calligraphy festival T-shirt; using an edged pen,
originally on paper.
Gaynor Goffe

◄ **'Escape'**
Heavy Roman
Capitals are used
with Italic script.
Diluted Sumi ink,
gouache and gold
leaf have all
been used on
printmaking
paper.
Mary Noble

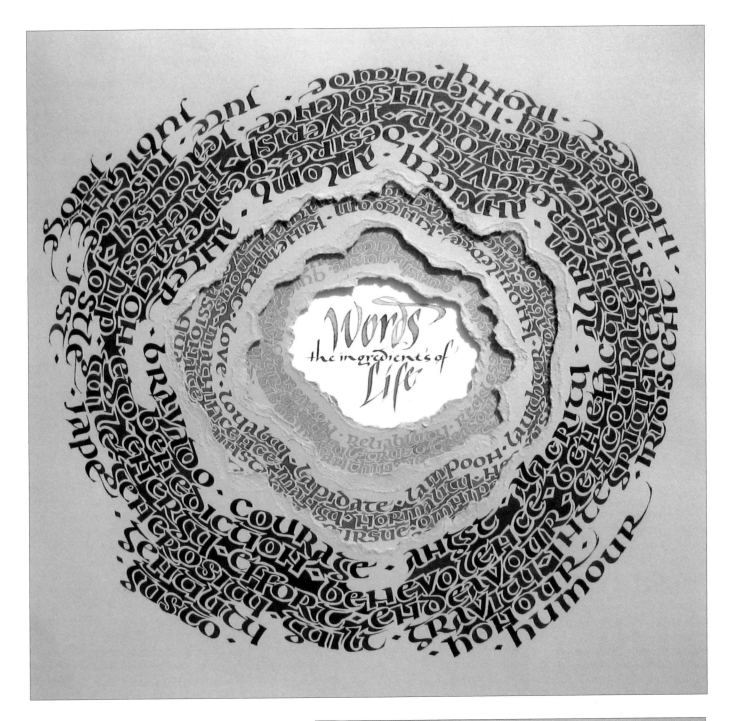

▲ 'Ingredients of Life'

Half-Uncial script written in walnut ink on layers of paper with gradually decreasing circles torn away. The design suggests the rings of a tree and notes all the emotions felt on our journey through life.
Jan Pickett

▶ 'Aries'

A gold Versal 'A' on a raised gesso base. The illustration is painted on stretched vellum over plywood using traditional egg tempera and watercolour.
Janet Mehigan

Glossary

Acrylic medium
A modern adhesive that dries clear, used for sticking metal leaf.

Anchor points
In digital calligraphy, the points on or at the ends of a segment or path that control the shape of a vector line.

Arch
The curved part of a letter as it springs from the stem.

Ascender
The rising stroke of the letter which extends above the x-height.

Automatic pens
Poster pens ranging in size from 1 (smallest) to 6A (largest).

Baseline
The bottom writing line on which the lettering sits.

Body height
This is also called the x-height and is the height of the whole letter not including the ascender and descender.

Book hand
Any style of alphabet commonly used in book production before the development of printing. Also called a script.

Bowl
The round or oval part of the letter formed by curved strokes, as in 'R', 'a', 'p' and 'q'.

Brause pen
A German-made steep-nib dip pen. Nib size ranges from $1/2$mm ($1/64$in) to 5mm ($1/4$ in).

Broad-edge pen
A pen with a square-edged nib.

Burnish
To rub a surface in order to make it shiny, normally using specialist burnishing tools.

Codex
A book made up of folded and/or bound leaves forming successive pages.

Cold-pressed paper
Paper with a medium-textured surface.

Counter
The space that is contained within round parts of letters.

Cuneiform
Early script in the form of wedge-shaped signs, used by the Sumerians.

Cursive
Linked or joined writing formed by rapid hand movements creating a fluid effect.

Descender
The tail of the letter which extends below the line, as in 'y' or 'p'.

Diaper patterns
Designs created to ornament a surface with small patterns laid out on a grid. Very useful to illuminators as the patterns can cover plain painted backgrounds, to adorn and enhance painted objects and materials, and to emboss gold surfaces.

Egg tempera
Egg yolk added to ground pigment colour to make paint.

Emboss
To indent a mark on gold or to create a raised or indented surface on paper with a blunt tool through a stencil – from the opposite side of the surface.

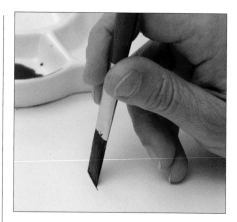

Flourish
An extended or exaggerated ascender or descender which is used to embellish the basic letterform.

Gesso
A compound made from plaster of Paris, glue and white lead. Can be used to form a raised surface on which layers of gold can be attached and polished.

Gild
To apply gold to a surface using either loose leaf, transfer or powdered gold.

Glassine paper
A transparent paper with a non-stick or resistant surface used for protecting gold surfaces. Also called crystal parchment paper.

Gouache
An opaque watercolour paint used when flat, dense colour is required. Also called body colour.

Gum ammoniac
A resin in crystal form that can be activated with hot water to provide a sticky gum base for flat gilding.

Gum arabic
Viscous substance from the acacia tree. Can be used as a binding agent, to aid paint adherence and as a resist.

Gum sandarac
Lumps of gum which, when ground to a fine powder, can be dusted lightly on to paper or vellum to improve the surface.

Hot-pressed paper
Paper with a smooth surface.

Illumination
The decoration of a manuscript, often using gold leaf burnished to a high shine.

Indent
An additional space added to the usual margin at the beginning of a line of writing.

Interlinear spacing
The spacing that occurs between two or more lines allowing sufficient space to accommodate ascenders and descenders.

Layout
The basic plan of a design showing spacing and organization of text.

Logo
A word or combination of letters designed to be used as a trademark, symbol or emblem.

Lower-case
Small letters as distinct from capitals or upper case. Also called miniscule letters.

Majuscule
A capital or upper-case letter.

Manuscript
A handwritten book or document.

Nib width
The width of the writing end (nib) of a broad-edged pen.

Palette
Traditionally, the surface used for mixing paint. In digital calligraphy, the range of colours and brushes that can be used in a graphics application.

Papyrus
Paper-like substance made from the papyrus plant. Commonly used until the 3rd century AD, particularly in Egypt.

Pen angle
The angle that the writing tip of a broad-edged pen makes with a horizontal writing line.

Pointed nib
A nib with a sharply pointed end, such as those manufactured by Gillott. These are used for copperplate writing.

PVA (polyvinyl acetate) glue
A clear adhesive which dries clear and can be used for sticking paper to paper and as gum to attach gold to paper. Also called white glue.

Resist
A substance that prevents paint or ink from reaching the underlying material. When the resist is removed, a pattern or design is left.

Rough paper
Paper with an extremely pronounced texture.

Sans serif
A term denoting letters without serifs or finishing strokes.

Scriptorium
A writing room, particularly that of a medieval monastery in which formal manuscripts were produced.

Serif
The beginning and the end part of the letterform. See also sans serif.

Skeleton letter
The most basic form of a letter demonstrating its essential distinguishing characteristics.

Speedball nibs
American nibs ranging in size from C–0 (largest) to C–6 (smallest).

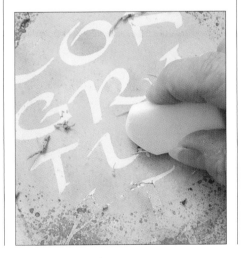

Stem
The main vertical stroke of the letter.

Swash
A simple flourish.

Uncials
A very rounded hand that is composed entirely of capitals.

Vector image
In digital calligraphy, a graphics file that uses mathematical descriptions of lines, curves and angles.

Vellum
Parchment made from calfskin which has been limed, scraped and prepared for either writing or painting.

Versals
Elegant capital letters made by compound pen strokes.

William Mitchell pens
Dip pens with nibs ranging in size from 0 (largest) to 6 (smallest).

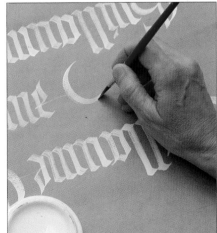

Index

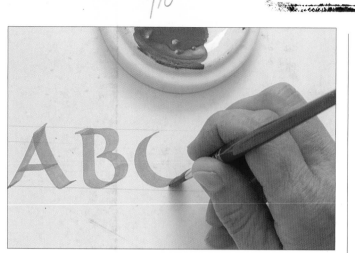

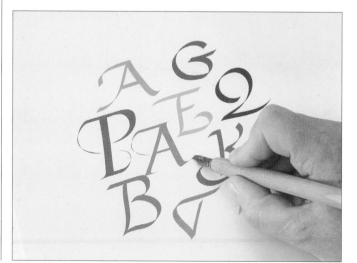